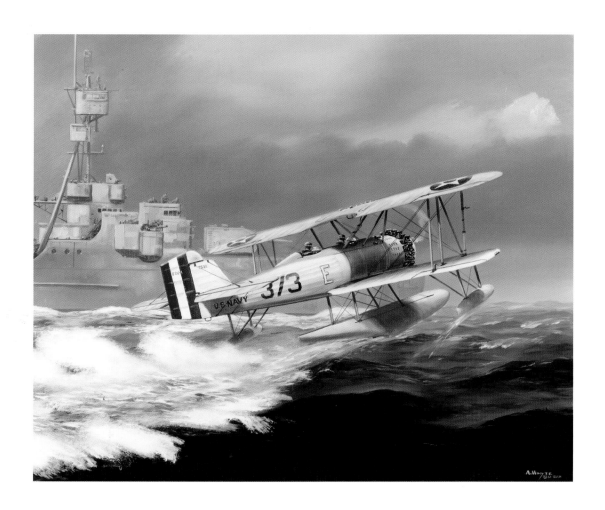

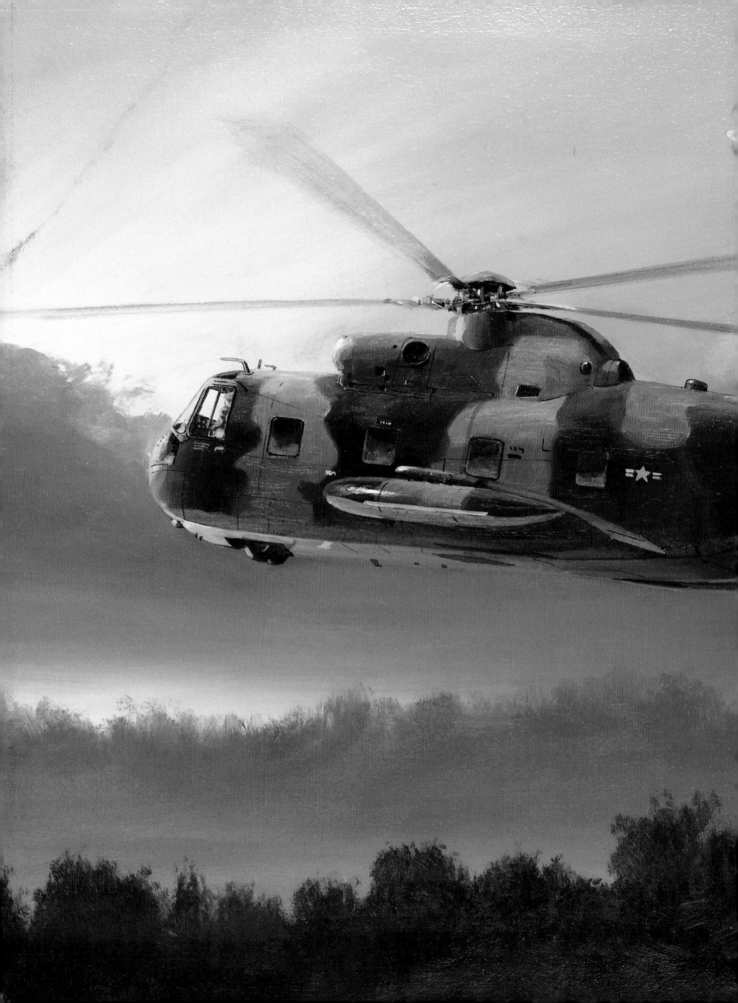

HOW TO DRAW AND PAINT
AIRCRAFT
LIKE A PRO

ANDREW WHYTE, ASAA,

WITH TEXT BY CHARLIE AND ANN COOPER

ZENITH PRESS

First published in 2008 by Zenith Press, an imprint of MBI Publishing Company, 400 1st Avenue North, Suite 300, Minneapolis, MN 55401 USA.

The information in this book is true and complete to the best of our knowledge. All recommendations are made without any guarantee on the part of the author or Publisher, who also disclaim any liability incurred in connection with the use of this data or specific details.

This publication has been prepared solely by MBI Publishing Company and is not approved or licensed by any other entity. We recognize that some words, model names, and designations mentioned herein are the property of the trademark holder. We use them for identification purposes only. This is not an official publication.

Zenith Press titles are also available at discounts in bulk quantity for industrial or sales-promotional use. For details write to Special Sales Manager at MBI Publishing Company, 400 1st Avenue North, Suite 300, Minneapolis, MN 55401 USA.

To find out more about our books, join us online at www.zenithpress.com.

Front cover: Superimposing a fine-art depiction of a de Havilland DH-9 on a cutaway drawing of the same aircraft serves to accentuate essential shapes, materials, equipment, and the unique characteristics of the aircraft— all of importance to an aviation artist. Andrew C. Whyte created the cutaway and painted the DH-9 in memory of his father, who flew the aircraft as a member of the British Royal Flying Corps during World War I.

Unless otherwise noted, all artwork
© Andrew C. Whyte, ASAA

Frontispiece: The Chance-Vought O2U-1 was the first of many Chance-Vought aircraft to bear the name Corsair. It was also the first application of the famous Pratt & Whitney Wasp engine. Introduced in 1926, it served the U.S. Navy and the Marine Corps as a light bomber and observation platform.

Back cover, top: Highlighting the negative and positive dihedral of the F4U Corsair wing is a better compositional choice. Here the characteristic gull-wing is apparent and the aircraft is easily recognizable.

Back cover, middle: Detail is the goal in a cutaway drawing of a Chance-Vought F4U Corsair with aluminum structural members painted with zinc chromate, a preservative. Note carefully drawn particulars of the engine, the cockpit, the landing gear, and the tail hook for catching the arresting gear on an aircraft carrier.

Back cover, bottom: A scale side view, one of three prepared to demonstrate aircraft dimensions, is another rendering of a Chance-Vought F4U Corsair.

Library of Congress Cataloging-in-Publication Data
Whyte, Andrew C. (Andrew Crawford), 1926–
 How to draw and paint aircraft like a pro /
artwork by Andrew C. Whyte ;
text by Charlie Cooper and Ann Cooper.
 p. cm.
 Includes bibliographical references and index.
 ISBN 978-0-7603-3391-4 (sb : alk. paper)
 1. Airplanes in art. 2. Drawing—Technique. 3. Painting—Technique. I. Cooper, Charlie, 1933- II. Cooper, Ann, 1934- III. Title.
 NC825.A4W49 2008
 743'.8962913334—dc22

 2008020058

Editor: Steve Gansen
Designer: Liz Tufte, Folio Bookworks

Printed in Singapore

CONTENTS

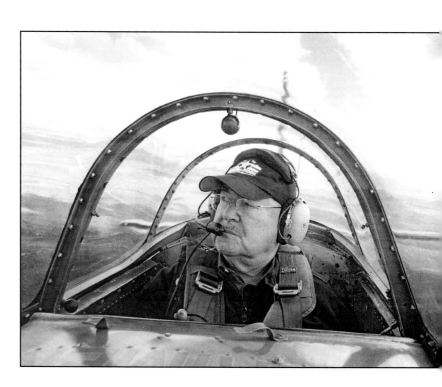

FOREWORD

The challenge and the beauty of flight have fascinated mankind for tens of thousands of years. In ages long past, flight was the exclusive privilege of gods and angels, supernatural creatures and demons. Then, some one hundred years ago, the brothers Wilbur and Orville Wright built and flew the first aircraft, and an impossible dream became reality.

Shortly after the birth of the airplane, the first poets, writers, and artists began to record their impressions of this new, exciting, and beautiful experience—the wonder and drama of flight.

In the mid-1930s, I believe aviation literature and aviation art came of age with the arrival of a new generation who knew aviation both professionally and artistically. I grew up reading the works of Charles and Anne Lindbergh and Antoine de Saint Exupéry, memorizing the poem "High Flight" by John Gillespie Magee, Jr., and studying the artworks of Charles Hubbell, Clayton Knight, and Frank Tinsley of "Air Trails." Intoxicating stuff for a teenager hopelessly in love with aviation!

In World War II, the combat artists of the warring nations documented what the camera missed, often producing a visual impact that no photograph could duplicate. And who can ever forget the cartoon images created by the army's Bill Mauldin in *Up Front*, the U.S. Army Air Force's Bob Stevens in *There I Was . . .*, and naval aviation's Bob Osborn with his "Dilbert the Pilot" and "Grampaw Pettibone" characters? Today, the aviation artist faces the challenge of painting for an audience far more experienced in aviation than was the case before

➥ Sergei Sikorsky is pictured in the rear seat of the Nanchang CJ-5 primary trainer aircraft, a Chinese variant of the Yak-18.

World War II. As a result, the rapidly growing field of aviation art has bred a new generation of artists who grew up exposed to aircraft. Some engineers while designing an aircraft can predict by "feel" if a subtle change in a wingtip or a rudder fairing could increase the speed of the aircraft or make it uncontrollable in a stall. Some pilots have a "sixth sense" when looking at an aircraft for the first time and can predict the handling qualities even before flying it. And a gifted few can put that feel and sixth sense onto a piece of canvas and make it fly.

Three such people have combined their professional and artistic skills to create *How to Draw and Paint Aircraft Like a Pro*. They are Andy Whyte and Charles and Ann Cooper. I am pleased to enjoy their friendship.

The other contributing artists are most impressive and include leading talents active in the aviation art scene here in the United States. To all of us interested in the history of aviation, and the art that documents that history, this book will be a valuable source of inspiration. To Major General and Mrs. Cooper, my sincere thanks. To a very good friend and fellow naval aircrewman, Andy Whyte, a sincere "well done!"

—Sergei I. Sikorsky
Surprise, Arizona

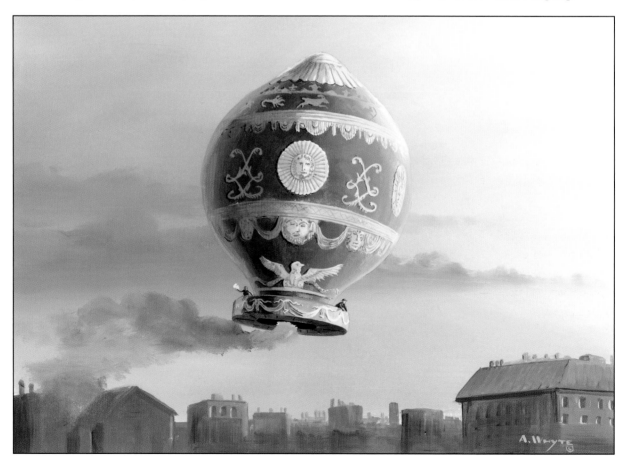

INTRODUCTION

↓ *Montgolfier Balloon*: From 1782 to 1783, the Montgolfier Brothers of Annonay, France, sons of a prosperous paper manufacturer, designed and built the first practical lighter-than-air craft. Buoyed with heated air, their early balloons excited huge crowds. (10x14 tempera)

Welcome to the world of aviation art. As you work to develop your artistic skills, and the crucial word is *work*, we trust you'll make a companion of *How to Draw and Paint Aircraft Like a Pro*, a basic, complete and newly revised guide to this exciting art form. The lure of aviation is compelling and its appeal extends to art, the drawing and painting of streamlined shapes, inventive ideas, unpredictable atmospheric conditions, blurring speeds, varied altitudes, and limitless exploration. If you have been doodling aircraft on the edges of your school papers since grammar school, you have something in common with known and admired aviation artists. Congratulations on choosing to draw and paint aircraft, a special genre and a vital and rewarding career and/or hobby.

Aviation is young. In this century since Wilbur and Orville Wright developed the first working flying machine, major changes have occurred. Aviation has evolved into a primary means of transportation. Designers, engineers, and operators have combined their capabilities in a constant quest for aircraft that can fly faster, climb higher, and travel farther. Such new materials as metals and composites have made aircraft lighter, stronger, and more economical. New manufacturing methods have helped the aircraft industry meet demands of airlines, general aviation, and the military. Ever-evolving computer technology has introduced sophisticated avionics in manned and unmanned aircraft. Significant advances are ongoing.

Aviation is challenging. After early successes with lighter- and heavier-than-air aircraft, scientists, designers, and inventors responded to special needs and specific customers. World War I focused on aerial battles characterized by "dogfights." After the war, aircraft manufacturers concentrated on creating the best machines for a variety of purposes: transport, aerobatic aircraft, fighter, trainer, rescue vehicle, crop duster, or airliner. A Golden Age of Aviation was born in the United States. It corresponded with a surplus of aircraft built for the war, a return of experienced pilots, a wide variety of new aircraft, an airmail system, better aids to navigation, and, following Charles Lindbergh's transatlantic solo flight in 1927, the growth of transcontinental airlines. In the military, Gen. Billy Mitchell demonstrated strategic bombing, aircraft carrier operations added a new element in naval warfare, and observation planes replaced balloons in supporting ground troops.

War clouds again darkened the skies during the 1930s, and World War II introduced a new and alarming set of challenges. Allied forces developed new tactics to counter enemy forces, and new technologies resulted in a wide variety of aircraft that flowed from the "arsenal of democracy." It took four long and costly years for victory to be achieved, another challenge successfully met with a unified spirit, hard work, and immense courage.

After World War II, the development of the jet engine and the harnessing of rocket power led to new ways to meet new demands in commercial aviation, the military, general aviation, and the realm of aerospace. The sound barrier was broken, Mach 3 was achieved, the supersonic transport took wing, and the jumbo jet was christened. Humans flew in space, landed on the moon, created the International Space Station, and put countless satellites into orbit. Amazing progress defined this

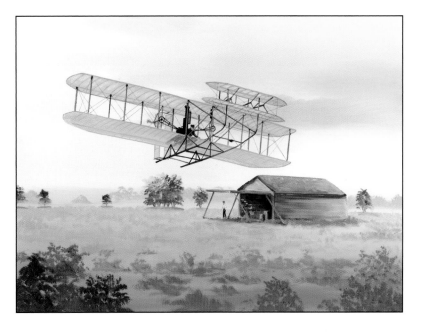

↑ *Wright Flyer*: Having succeeded in piloting the world's first powered heavier-than-air craft at Kitty Hawk, North Carolina, on 17 December 1903, Wilbur and Orville Wright practiced over Huffman Prairie, Dayton, Ohio, to conquer turning flight. (24x18 oil)

↓ *Dog Fight—World War I:* As few photographers were available in the combat arena, it was up to artists to depict World War I aerial dogfights. In this historic scene, a Royal Flying Corps F.E.2b of Number 25 Squadron, piloted by Lt. G.R. McCubbin and gunned by Cpl. J. H. Waller, tangled with a German ace flying an Albatros D.III. (24x20 oil)

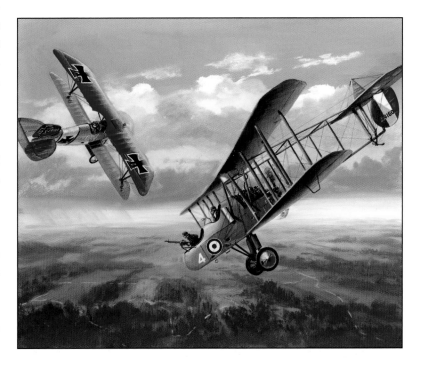

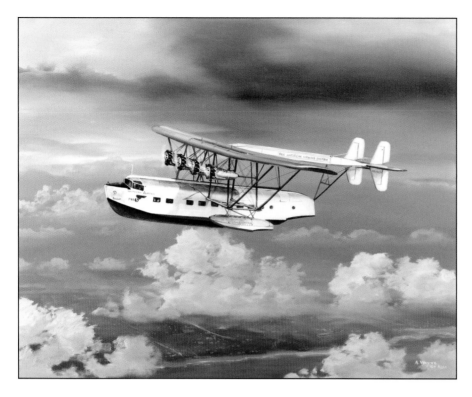

▲ *Sikorsky S-40 Flying Boat*: Igor Sikorsky's S-40 flying boat, in the livery of Pan American Airways, brought elegance in air travel. His *Clipper*, which first flew in 1931, was one of the flying boats used for the exploration of international airline routes. (24x29 oil)

century; yet new challenges continue to lead to new efforts and new discoveries.

Aviation is complex. Since the beginnings of powered flight in 1903, aviation developers have faced technological, economic, and geopolitical complications. Modern aerial warfare focused the vision and efforts of thousands of men and women around the world. An expansion of an international network of airlines with bigger, better, and safer aircraft; longer route structures and interrelated business agreements made global travel possible for a substantial portion of the world's population, and added layer upon layer of complexity.

In part, the challenges of aviation and aerospace led to advances in material science, manufacturing methods, computer-aided design, physiology and medicine, and communications that affected most aspects of modern life in developed countries. Unique applications have enabled vertical takeoffs and landings, flight at three times the speed of sound, flight by unmanned aircraft capable of gathering intelligence data, the development and deployment of communications and navigation systems orbiting the earth, and a host of other achievements. There are many more: the antimissile missile system; the hypersonic space plane; laser applications for peace and war; improved reconnaissance systems; bigger, safer, and more comfortable airliners; manned flight to Mars; and, perhaps most critically, systems to manage the increasingly crowded airports, skies, and outer space.

There have been failures, many harmless, some deadly. It is a tribute to the human spirit that failures have been treated as learning experiences, new data points from which to work, and, in spite of the complexities, to succeed.

Aviation is competitive. In every aspect of aviation's development, competition has spurred individuals, groups, and nations to levels of achievement long held as impossible. The race to be first and best has motivated people key to aviation's progress. Competition has driven nations in both peace and war, and organizations still strive for international recognition and superiority. Individuals compete for trophies and prizes and seek national and global records in speed, distance, altitude, and endurance. Tightly structured aerobatic competitions pit highly skilled pilots against one another, and aircraft manufacturers compete for

lucrative contracts. Some fight to represent their countries in building and marketing new aircraft and new components.

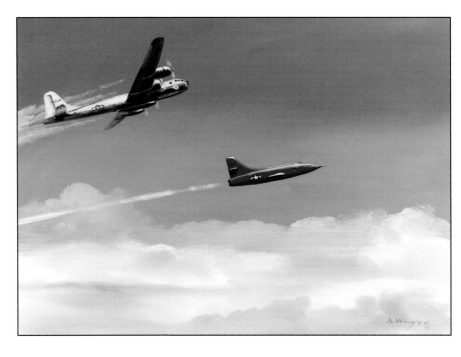

In spite of, or perhaps because of, its youth, its progressive challenges, great complexities, and its highly competitive nature, aviation often is surrounded by beauty. Machines designed to operate in the earth's atmosphere and in outer space have streamlined, dynamic shapes. Among the admirers of these succeeding generations of aircraft types are aviation artists. Some draw for the fun of it, to capture challenges inherent in depicting rapidly moving, three-dimensional, interesting machines on a two-dimensional surface. Others draw aircraft as a profession, striving continually to use their artistry to make better pictures and to meet the demands of the markets they serve. Some focus their efforts on imaginative futuristic interplanetary vehicles, some on modern jet transports, and others on military aircraft of an earlier day. While seeking excellence in their drawings and compositions, some aviation artists provide intensely detailed and accurate backgrounds for their paintings. Others concentrate solely on the aircraft itself, engaging the viewer in the dynamics of flight. Depictions of weather and atmospheric conditions, of clouds and storms, are uniquely important to aviation artists as are the abilities to project the bird's-eye view, altitudes, and speeds that are characteristic of aircraft.

The attributes of aviation and aerospace—youth, challenge, complexity, and competition—characterize the art it has fostered. Aviation art is relatively new and, as primarily representational art, it battles for a place in the fine-art category. Many aviation artists enjoy the challenge of advertising and book and magazine illustration.

Although the work of an artist like Henry Farré proved exceedingly valuable in depicting the air war of World War I, it was the air war of World War II that truly fired the admiration and imagination of the public. Artists in the 1940s were essential in providing the rich, heroic, and often terrifying scenes of this tumultuous war's history. To date, paintings and drawings of World War II aircraft in historic settings continue to be popular and important. The most popular and widely known World War II aircraft—American Mustangs, Corsairs, and B-17s; British Spitfires, Hurricanes, and Lancasters; German Messerschmitts and Focke-Wulfs; and Japanese "Zeroes" and "Kates"—are a few of those researched for yet-untold images to be created and new heroes to be drawn, painted, and preserved on canvas for posterity.

Bell X-1 and *B-29*: Now displayed in the Milestones of Flight Gallery of the Smithsonian's National Air & Space Museum, the Bell Aircraft Company X-1 departed its B-29 mother ship on 14 October 1947 with Capt. Chuck Yeager at the controls. The X-1 rocketed to seven hundred miles per hour at forty-three thousand feet, the first manned airplane to exceed the speed of sound. (10x14 acrylic)

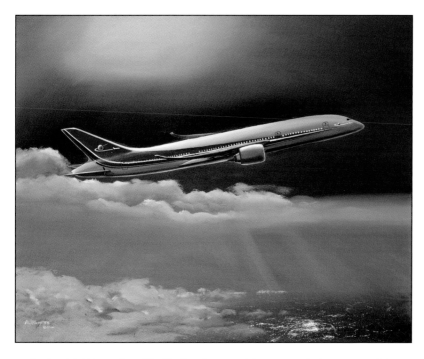

↟ *Boeing 787 Dreamliner*: The Boeing Company's latest entry in its commercial airplane line is the 787 Dreamliner. A highly efficient aircraft, it is expected to use 20 percent less fuel than other airplanes its size while carrying up to three hundred passengers in a twin-aisle configuration. (24x30 oil)

↡ *Shuttle* Discovery *Docks with the ISS*: With the planet earth in the background, the Space Shuttle *Discovery* performed the twenty-third mission to the space station and delivered the Italian-built U.S. multiport module for the International Space Station. (26x30 acrylic)

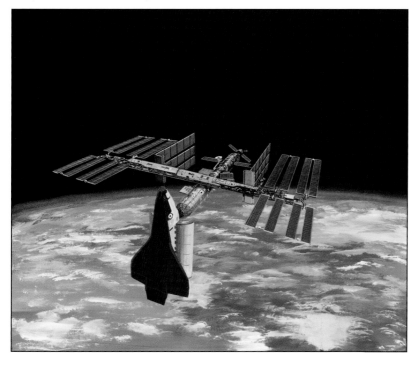

In addition, there has been increasing interest in new developments of military and naval aircraft, including cargo, tanker, and surveillance planes and unmanned aerial vehicles and helicopters; new transports for airlines and for corporate flights; and a wide variety of light and very-light sport aircraft. Space programs have inspired some artists to specialize, and their realistic and imaginative artworks have gained well-deserved attention. Manufacturers have long used art to depict their new projects, and current aerospace vehicles from concept to flight are such subjects. Other organizations, both civilian and military, contract to have their stories told in new ways through art. New aviation artists should be encouraged to know that many aerial scenes can be captured *only* in drawings and paintings.

Aerospace art is part of the challenging world of the future. Researching new aerospace vehicles and components, heroes and heroines has burgeoned in the ever-expanding information available on the Internet. As it has become easier to gather information to serve as the basis for a painting, it has become more important to cross-reference and verify the accuracy of the information. New tools and mechanisms have given an aerospace artist a wider range of choice in materials and colors. An artist is challenged to select the accurate combinations from among the many options available.

A range of computer-based support for artists is relatively new and sometimes controversial. Importantly, digital art must begin with drawing. A wide range of computer hardware and printers and the variety of art-oriented software programs offer artists the opportunity to enhance his/her work without affecting the essential need for originality and

creativity. It is vital to an artist's reputation and success to meet the challenge of ethical artistic behavior and to conscientiously create strictly original artwork. The watchword always must be: "Do your own work."

Artists compete. They compete for placement of their work in art shows, both juried and unjuried, and for the prizes awarded. They compete for commissions to do artwork for individuals and organizations. They compete for corporate contracts to create drawings and paintings to be used in advertising, on book covers, and in magazine articles. Artists compete to see their work placed in galleries and museums. And, they compete to work with prestigious publishers of fine-art prints. Most of all, artists compete with themselves, striving to make the current painting better than previous ones. Most artists are learning, observing, practicing, experimenting, and continually honing their skills. Recognition and reputation are rewards for doing the best possible job each time.

The choices are up to you. It is essential to choose an appealing subject and to research it thoroughly. Having selected an airplane, spacecraft, combat scene, or a landscape, observe that subject's shape and determine the source of the light. Observe various reflections and how shadows are cast, and maintain the proper and consistent perspective. Follow preliminary sketches of the subject, perhaps in a variety of settings, by a detailed drawing that includes a distinct foreground, middle ground, and background. Determine a preliminary and then final composition that best tells your story with consideration of its appeal to your viewers. Choosing an appropriate medium, selecting the right colors, and completing the painting are complex tasks. In the modern world, an artist can consider whether the painting can be enhanced by use of a digital application. Each step requires skill, patience, and perseverance, to say nothing of talent and a commitment to doing the best possible job.

This book is intended to help you meet your artistic goals. It is a primer, discussing in broad terms the essential elements of aviation art. The artist and authors have sought to provide an outline, examples, and discussion of those elements. It can be an introduction, a text, or a reference for your artistic journey. We hope you can benefit from it and, above all, that you will enjoy your work. As the first step in any artwork is a drawing, we urge you to draw, draw, draw.

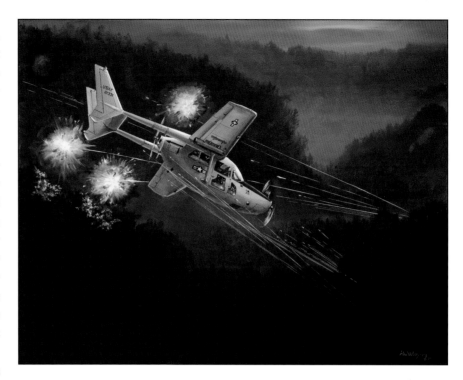

▲ *Cessna 0-2 Skymaster*: A U.S. Air Force Cessna 0-2 Skymaster twin-engine Forward Air Control pilot barely escaped with his life from attack from ground fire during a night mission over Vietnam. Heavy enemy fire lit the skies and made this mission extremely hazardous. (23x18 oil)

UNDERSTANDING FLIGHT PRINCIPLES
The Wright Brothers to the Dreamliner

➤ (Upper Image) – All aircraft must deal with the same opposing forces: *lift* to overcome *weight* and allow the craft to move upward, and *thrust* to overcome *drag* and allow the craft to move forward.

➤ (Lower Image) – Wings and rotors are built in *airfoil* shapes in order to create *lift.* Airflow follows the upper contours of the airfoil, with increased velocity over the upper surface, and is deflected downward at the trailing edge. Airflow coming into contact with the lower portions of the airfoil is also defected downward. In accord with the laws of physics, these downward deflections result in an opposite, upward, reaction, and *lift* is created. *Airfoil* shapes have evolved over time.

Aeronautical design is something any other engineering discipline can do for twice the weight.

—Andrew Whyte

WHY DO AIRCRAFT FLY?

Aircraft fly thanks to airfoils—the wings, tail surfaces, canards, and rotors—that use the movement of air flowing over and beneath their surfaces to create lift. Lift plus power (thrust) from an engine or engines combine to overcome the natural forces of weight (gravity) and drag. All aircraft have the same opposing forces: lift and thrust versus weight and drag.

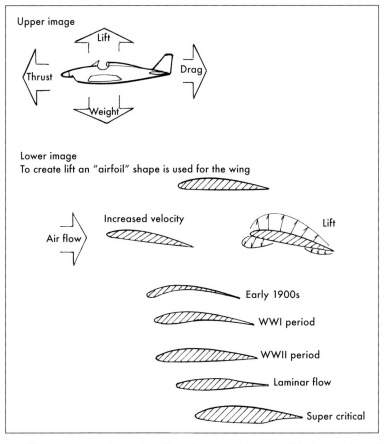

If you want to draw aircraft well, start with a careful observation of the shapes involved in your subject, whether static or in flight, and observe the way light strikes the airfoil shapes and the shadows that are cast.

THREE AXES OF MOVEMENT IN FLIGHT

As aircraft are designed to move through the atmosphere and into the far reaches of outer space, they are designed to move through three axes—pitch, roll, and yaw. To understand the terms, picture yourself as the pilot and relate movement to that position in the cockpit.

Pitch, the first axis, is the upward- or downward-acting movement that enables an aircraft to climb or descend. It is controlled by the use

of stabilators or elevators that are connected to the yoke or control stick in the pilot's hand. Pushing the control forward will move the elevators down, increasing the lift of the tail. The nose of the aircraft will move away from the pilot resulting, in basic terms, in a descent. Conversely, pulling the yoke or stick back will raise the elevators, reducing the lift of the tail, and the aircraft nose will appear to come toward the pilot, to initiate a climb. This movement is along the aircraft's lateral axis, an imaginary line drawn from the tip of one wing, through the craft's center of gravity (CG) to the tip of the other wing.

Roll, the second axis, is the banking movement around the longitudinal axis, an imaginary line extending from the nose of the craft through its CG and through the tail. Roll is controlled by ailerons installed on the trailing edge of the wings near the tips that are also connected to the control yoke or stick in the pilot's hand. The amount of control input will determine the steepness of the bank. Ailerons move in opposite directions to one another to establish the bank angle. Moving the yoke or the stick to the right initiates a right turn. An artist should know that the aileron deflection is generally neutralized after the turn is established or the desired bank is achieved. A pilot applies the opposite aileron, in this case the left aileron, to return to straight-and-level flight once the desired turn has been achieved.

Yaw, the third axis, is controlled in most airplanes by a hinged control surface, that is, the rudder, which is attached to the vertical stabilizer at the tail of the craft. In trainer planes, the rudder is connected to foot pedals. When the left foot pedal is pushed, the rudder moves to the left and the aircraft nose moves to the left. Yaw acts around an imaginary line, the vertical axis, which extends from the top of the craft through the CG and out the bottom of the craft. The primary purpose of the rudder is to counteract aileron drag and to provide stability in turns.

In your drawings and paintings, it is important to assure that the positions of the elevators, ailerons, and rudder are consistent with the maneuver being depicted.

AIRCRAFT DESIGN—
From the Wright Brothers to the Dreamliner

Although man's search for mastery of flight began initially in balloons and gliders, the world celebrates the famous

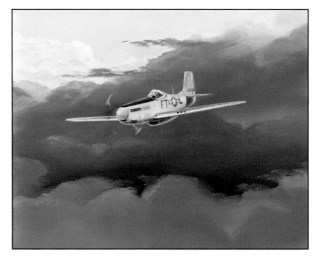

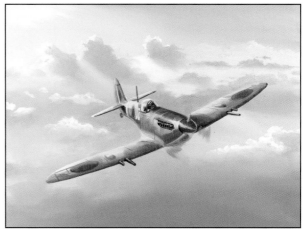

⬥ These paintings of two famous World War II fighters, a Mustang and a Spitfire, illustrate the ways in which light and shadows impact on the curved *airfoils*. An artist needs to note the wings and the horizontal stabilizers.

⬥ *Pitch,* the axis of flight that acts to move the aircraft up (to climb) and down (to dive), is controlled by the airplane's *elevators,* shown in orange. Moving the control stick back raises the elevators and causes the tail to move down, thus raising the nose to climb. Moving the control stick forward has the opposite effect and results in a dive.

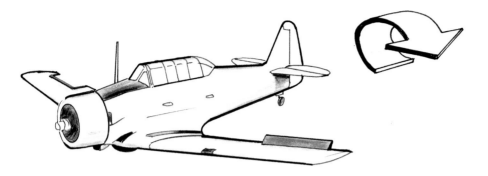

Wright Brothers' flights of 17 December 1903 as the first sustained, powered, controlled flights. Until then, mankind had a limited bird's-eye view of the earth and the sky. In addition to a new perspective of atmosphere and geography, the first flight unleashed an ongoing search in aircraft design. Design answers the question, "What is to be the aircraft's use?"

Aeronautical-design engineering is a precise and highly complex subject. The process for creating a new aircraft to meet potential users' requirements requires a detailed understanding of four interrelated and interdependent topics: aerodynamics, propulsion, structures and materials, and manufacturing capability. Because there are some inherent limitations in each, the engineers' designs require a series of progressive compromises to meet the client's requested specifications within budgetary constraints. Famed aircraft designer Igor Sikorsky said, "In the early days of aviation, the aircraft designers were also the test pilots. This had the automatic effect of weeding out the bad designers."

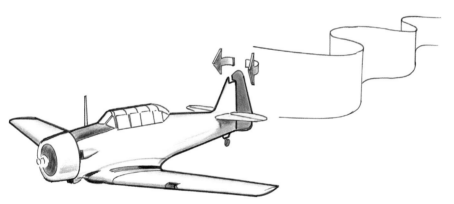

▲ *Roll,* controlled by the *ailerons,* is the axis of flight that acts to bank and, therefore, to turn the aircraft. Shown in orange, the ailerons move in opposite directions under the control of the pilot's stick. As shown, the left aileron is up. This moves the left wing down and initiates a turn to the left.

An aviation artist seeking to master the craft will better depict the subject if there is understanding of the designers' problems and solutions. To a large extent, accuracy in aviation art may be one key to a successful artistic career. McDonnell Douglas aeronautical engineer and renowned aviation artist, the late Robert G. Smith, a founder of the American Society of Aviation Artists (ASAA), said, "Achievement comes from hard work, discipline, and a constant program of practice and learning. Aspiring artists want to know how to draw and paint, but very few want to take the time to learn. . . . a key to success is to refrain from ever being satisfied with your work. Never stop rehearsing your craft. Every [drawing or] painting is another step in an endless learning curve."

▲ *Yaw,* the third flight axis, acts to move the airplane's nose from side to side and is controlled by the aircraft's *rudder,* the vertical surface shown in orange. The rudder is generally controlled by foot pedals in the cockpit. Pilots use the rudder to maintain alignment of the airplane with the direction of flight. An artist should keep in mind that the position of the control surfaces should be in accordance with the maneuver depicted in the drawing.

Urging a thorough knowledge and understanding of the construction of aircraft, he added, "This applies to any subject matter. If you want to draw figures or nudes, learn the structure of the human body first. . . . I am convinced that if you gain knowledge of the inner workings of your subject, you can literally give it life."

HOW AIRCRAFT DIFFER

Balloons

The earliest of flying machines, dating to the Montgolfier Brothers' ascent in 1783, were hot-air balloons, which continue to delight huge numbers of people. Crowds gather for such festivals as that held annually in Albuquerque, New Mexico, where vivid colors and uniquely shaped balloons fill the skies against the rugged backdrop of the beautiful Sandia Mountains. The air inside the balloon, heated by burners controlled by the pilot, is lighter than the surrounding ambient air, causing the balloon to rise. Air is expelled manually to descend. Balloons are propelled by air streams, and astute balloonists seek the flow of air at varying altitudes to obtain directional control of their craft.

A team of enthusiasts in Australia built a balloon using three-fourths of a mile of aluminum-coated polyester film, sixteen strips for each gore. Using two miles of tape, they laid the strips along a school hallway to attach them, adding thirty-two tether points. Sixteen gores were joined and taped. The cap, designed to be pulled downward to empty the balloon after flight, was eighteen feet in diameter and was attached last.

Thanks to the advances in science and technology, we can move between those earliest homebuilt crafts to military uses of the hot-air balloon in the French Revolution and by both sides in the American Civil War to modern record-shattering inventions. On 20 March 1999, Bertrand Piccard and Brian Jones circumnavigated the earth in their *Breitling Orbiter* in nineteen days, one hour, and forty-nine minutes. They became the first aviators to circle the globe nonstop in a hot-air balloon. In 2002, a daring adventurer, the late Steve Fossett, completed the first solo round-the-world balloon flight in fourteen days nineteen hours, and 50 minutes, and covered 20,626 miles. During that flight, Fossett reached a top speed of two hundred miles per hour, a speed faster than anyone previously had flown in a manned balloon. In 1960, a daring balloon flight took place when U.S. Air Force Capt. Joe Kittinger rode a balloon to more than 102,000 feet in altitude before he jumped. Remarkably, he became the first man in space and the first to break the sound barrier without an aircraft. He landed unhurt after opening his parachute at a much lower altitude. Modern ballooning flights and records no doubt will continue to offer aerospace artists thrilling and beautiful opportunities for depiction in drawings and paintings.

Airships

In the 1920s and 1930s, blimps and dirigibles were widely used for carrying passengers and for military purposes. The tragic crash and explosion of the hydrogen-laden *Hindenberg* at the conclusion of a transatlantic flight in 1937 brought on a hiatus in the use of those airships. More recently, Goodyear blimps have been widely used in the United States and in Europe. Their primary purpose is for advertising, frequently while carrying television cameras to cover a variety of news events. With a swiveling single-wheel undercarriage and two engines that can tilt to assist in takeoff power, the Goodyear blimp can accurately be described as a giant gasbag filled with helium. Because the hull must be kept under pressure, air-filled ballonets transfer pressure to the helium without mixing air with the helium.

In Germany in 2002, new lighter-than-air ships, CargoLifters, were predicted to start a new era, restoring the airship to a greater role in air transportation. Designed to carry up to 160 tons, CargoLifters, had airtight, multilayered films that reduced helium loss and used tougher, more long-lasting, flame-resistant, and lighter fabrics. They were to be another example of an aircraft design made possible by improvements in science and technology, but insufficient funding stalled the project.

Airplanes

A great deal has been written about the design developments of the airplane, the principal focus of the world aircraft industry. Starting with the wood- and canvas-covered planes designed and built at the beginning of the twentieth century by the Wright Brothers in Ohio, Glenn Curtiss in New York, Louis Blériot in France, and Brazil's Alberto Santos-Dumont, each new demand for speed, altitude, and endurance has been met. Those demands have been catalysts generating innovations to keep aircraft weight down and to stay within budgets. Wartime necessities have encouraged these innovations, as has the continuing competition among nations to provide the best fighters, bombers, transports, and reconnaissance craft.

Given the huge cost associated with each new aircraft, competitions among manufacturers is a factor in the choices offered to military and naval aviation, to the commercial airline industry, and to the small aircraft market. New demands arise for stealthy military airplanes, for capable and independent unmanned intelligence-gathering craft, and for

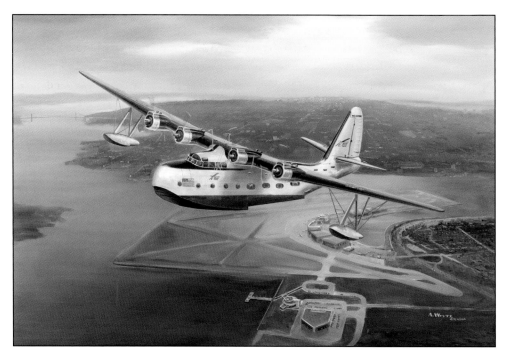

↑ *Sikorsky S-44 Flying Boat*: In the early days of commercial aviation, the S-44 Flying Boat was one aircraft of choice to passengers. Here it is shown over LaGuardia Seaplane base in New York. Only three were built.

new and more sophisticated space vehicles, for example. New materials and manufacturing methods combine in the production of the newest airliners. The Airbus A380, the largest double-decked airplane built, and the Boeing Dreamliner, with major components made of composite materials, both have been built in pieces by a host of manufacturing subcontractors operating at diverse locations around the globe and brought together at the prime contractors' locations in, respectively, Toulouse, France, and Everett, Washington. Advances in design, in propulsion, materials, and manufacturing provide the aerospace artist with a flow of new subjects to draw and paint.

Helicopters

Stemming from the highly imaginative drawings of fifteenth-century genius Leonardo da Vinci, serious experimentation on helicopters began in earnest early in the 1900s. The German Focke-Achgelis Fa-61 was successfully piloted in 1936 and 1937. In the United States, after having attempted an earlier model, Igor Sikorsky flew his first practical single-rotor craft in 1939. The helicopter is a heavier-than-air craft that derives lift from a power-driven rotor or rotors that revolve horizontally on a vertical axis. A rotor generally has four blades or airfoils.

Since its introduction, the helicopter has been used for a variety of purposes, many of them in highly dramatic situations facing the military and civilians. From clandestine combat operations to air-sea rescue and the movement of combat troops and outsized cargo, a variety of helicopter designs have become a mainstay of military and naval operations. In June 1967 with the aid of nine aerial refuelings, two Sikorsky HH-3Es performed the first nonstop helicopter crossing of the Atlantic Ocean. This historic flight clearly demonstrated the capability of the modern rotary-winged craft.

In a variety of civilian roles, helicopter crewmembers fight forest fires, transport critically injured people to hospitals, chase criminals, report on traffic conditions, cover developing news events, and carry passengers on intracity routes. The helicopter's versatility seems endless and is a great source of dramatic drawings.

Gliders

Although there were many gliders, such as the Waco CG series that was used extensively during the World War II D-Day invasion of France and in the Pacific Theater, gliders today are primarily beautiful sport craft that are flown solo or in dual flight. Gliding or soaring craft have long wingspans that enable them to create lift. They rise on thermal columns of warm air, use the lift of wind flowing upward along mountain ridges or the wave lift that occurs when strong winds that are perpendicular to the mountains are deflected upward. In the latter circumstance, great altitudes can be achieved. The world record is more than fifty thousand feet.

For those who don't want to rely upon being towed aloft or on the crewmembers required to assist in the launch, there are self-launching motor gliders. Some have foldaway engines that can be retracted into the glider once airborne. Like other aircraft, gliders are interesting and beautiful, great subjects for artists.

Space Shuttles

Since the first satellites were launched and Yuri Gagarin and Alan Shepard joined Joe Kittinger as the first men in space, the race to space has occupied a great deal of time, expense, and energy and has supported major technical breakthroughs that have benefited a range of other valuable developments in science, in medicine, in communications, and in weapons of war.

The highly complex space shuttle, first launched in 1981, has been among the key space-oriented developments. Referred to as an orbiter vehicle, it was designed as a reusable vehicle for the exploration of outer space under the auspices of NASA, the National Aeronautics and Space Administration. The space shuttle *Discovery* is OV-103, the third orbiter built. On 11 October 2000, with an empty weight of 151,419 pounds at rollout and 171,000 pounds with main engines installed, its mission was the continuing construction of the $60 billion International Space Station (ISS). In October 2007, *Discovery,* with a crew of seven led by Cmdr. Pam Melroy, launched as STS-120. It was the 120th space-shuttle mission, bringing the Italian-built *Harmony* module to enhance ISS capability. With Burt Rutan's privately developed manned spacecraft, space flight took on a new dimension.

NASA's space shuttle blasts off vertically as a rocket and lands horizontally as a glider. With a pressurized crew compartment for up to seven, the orbiter has a large cargo bay upon which is mounted a remote manipulator system, including a robot arm and hand with three joints analogous to the human shoulder, elbow, and wrist. Solid rocket boosters provide most of the launch power and much of the drama of launch—often the aerospace artist's favorite image—before they separate. Three main engines then continue to provide thrust until the shuttle reaches orbit. Orbital engines power major changes in orbit and forty-four small rocket engines can make more exacting maneuvers. The shuttle's largest single piece is the external fuel tank, which holds separate tanks of hydrogen fuel and oxygen oxidizer that power the shuttle's three main engines.

The space shuttle lands without power in a manner similar to an airplane "dead stick" landing or the landing of a glider or sailplane. Experimental craft known as lifting bodies were investigated in the late 1960s as potential space vehicles that could be used on a gliding descent from orbit. The entire undersurface of the craft has to function as a lifting surface; this concept formed the design basis for the space shuttle, which can be considered the ultimate glider. Space vehicles have become popular subjects for many gifted artists. You might wish to follow in their footsteps as the exploration of space continues.

The renowned Robert McCall, a founder of the American Society of Aviation Artists, said, "In the 1930s, even the most optimistic did not dream that mankind would ever travel in space. Today, following. . . decades of incredible achievement, humanity is on the threshold of a new era in space exploration. . . . The wonderful possibilities are endless, as endless as the infinite regions that surround Planet Earth."

In his depictions of the vast reaches of interplanetary and extraterrestrial scenes, Robert McCall has researched and witnessed the tools, machines, and theories of space exploration. Space artists like John Clark also have a great deal to teach. He said, "To a painter, there is more to it than just presenting planetary landscapes and a starry background. You have to fall back on the history of art and the works of great landscape painters."

You can improve your drawings and paintings by studying the mastery of aerial perspective. These and several other artists have mastered spatial depths, varied light sources, reflective light, and dramatic intensities.

> Acquaint yourself fully with
> the design of the aircraft.

AERODYNAMICS, MATERIALS, AND MANUFACTURING: LIMITING FACTORS OF AIRCRAFT DESIGN

In the design and building of aircraft, nothing is added that is not absolutely necessary. An aircraft designer deals with lift, weight, thrust, and drag and how they interrelate. A change in one affects each of the others; weight is always a major consideration.

Lift can be increased temporarily through the use of flaps, slots, and/or slats, high-lift devices that complement each other. However, the addition of the high-lift-device operating mechanisms causes increased weight, and any increase in lift results in an increase in drag. In extending the flaps, lift is increased. By adding slots or slats to the flap-equipped wing, a further increase in lift occurs. Recognizing these devices, when they are used and why, and placing them properly will enhance the accuracy of your drawings.

When lift is created, upward swirls of air at the tip of each wing known as wingtip vortices also are created. The swirls of air flow from the higher pressure beneath the airfoils to the area of lower pressure above the airfoils. To counteract wingtip vortices and their ability to affect the ailerons, designers shortened the length of the ailerons. They also placed such functional devices as fuel tanks, armaments, and winglets at the wingtips. On some commercial jet aircraft, winglets are ten to twelve feet high. As with understanding the use and results of the major control surfaces—ailerons, elevators, and rudders, knowledge of the use, the shape, and the placement of the flaps, spoilers, winglets, and trim tabs will increase artistic accuracy.

Objects moving through the air create a turbulent flow of air, a boundary layer, around an airfoil. Air intakes, which work best with a smooth air flow, find this turbulence detrimental to performance. Therefore, inlets for air intake to engines, oil coolers, and so forth, are separated from the fuselage or wings. Be aware of these separations when you are drawing aircraft, especially jets.

Propulsion

Propulsion is the action of moving an aircraft through the air. An aircraft designer has to select the right propulsion system for each particular design; the goal is to achieve fuel efficiency, a low engine weight-to-horsepower

↓ Temporary increases in *lift* can be achieved through the use of *flaps* and *slots,* which can be movable or fixed. The added weight of the devices necessary to move flaps and slots represents another tradeoff. Recognizing the degree of flap and slot settings is important to the artist.

30 degrees

Flaps

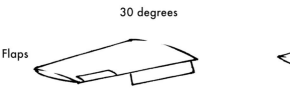

Increase drag for landing

10 degrees

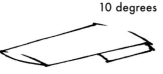

Increase lift for take off and maneuvers

Slots

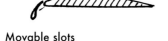

Movable slots

Fixed slot

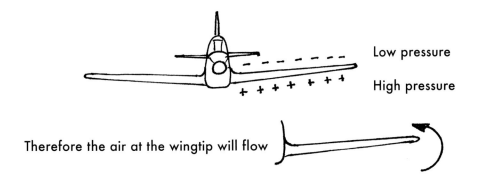

Low pressure

High pressure

Therefore the air at the wingtip will flow

To counter this drag-producing flow, many different wingtips are used. As an artist—look carefully to see which shape is used.

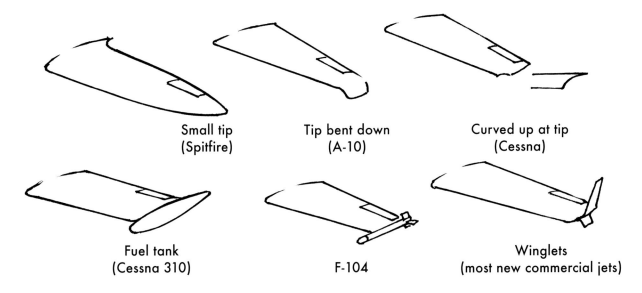

Small tip
(Spitfire)

Tip bent down
(A-10)

Curved up at tip
(Cessna)

Fuel tank
(Cessna 310)

F-104

Winglets
(most new commercial jets)

ratio, low total system weight, reliability, ease of maintenance, and noise reduction.

The earliest forms of propulsion were simple, low-horsepower piston engines that turned propellers. Radial and inline are the two main types of piston engines. This refers to the placement of the cylinders in relation to each other. Each design has its merits and its deficiencies. The radial has higher drag but it is a more compact unit, requires shorter engine mounts, and is less susceptible to battle damage. The inline has less drag, but requires a radiator for cooling and longer engine mounts.

More powerful and mechanically simpler jet engines were first used during World War II and entered service on commercial airliners in the 1950s. A jet takes in air, compresses it through a series of compressor blades, mixes fuel with the hot, compressed air, and ignites the mixture in a combustion chamber. The resulting explosion of hot gas from the rear of the engine creates thrust, pushing the aircraft forward. The hot gas also simultaneously turns a turbine wheel that is connected by a

▲ *Wingtip vortices,* the swirls of air at the tip of each wing where the areas of higher (+) and lower (−) pressure meet, can adversely affect airplane control. Designers have used a number of techniques to counter this phenomenon.

continued on page 26

➤ ↓ Objects that move through the air create a turbulent *boundary layer* along their surfaces. This turbulence is detrimental to engines and oil coolers, which need a smooth air intake to perform well. Designers have separated the intakes from the surfaces for this reason, and artists need to be aware of these separations, especially with jet aircraft. The following drawings show some examples. Below, P-51 Mustang; middle right, DC-3 Transport; lower left, DC-10 Airliner; lower right, F-4 Phantom fighter jet.

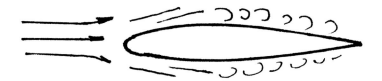

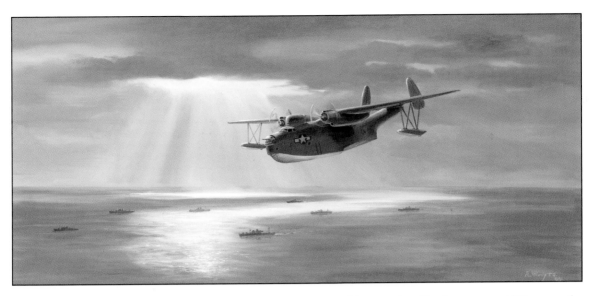

↟ *Martin PBM Mariner:* Martin's sturdy PBM Mariner saw action as maritime patrol and in air-sea rescue. With crews of eight to ten, PBM Mariners were capable of long overwater flights. Artist Andrew C. Whyte served as a flight engineer/gunner on Mariners in the Pacific Theater.

↡ *Two Hellcats*: The Pacific-based Task Force 58 proved potent in battles in the South Pacific. Grumman F6F Hellcats, the U.S. Navy's highest-scoring fighter during World War II, were representative of the formidable airpower that accompanied carriers, cruisers, destroyers, and battleships.

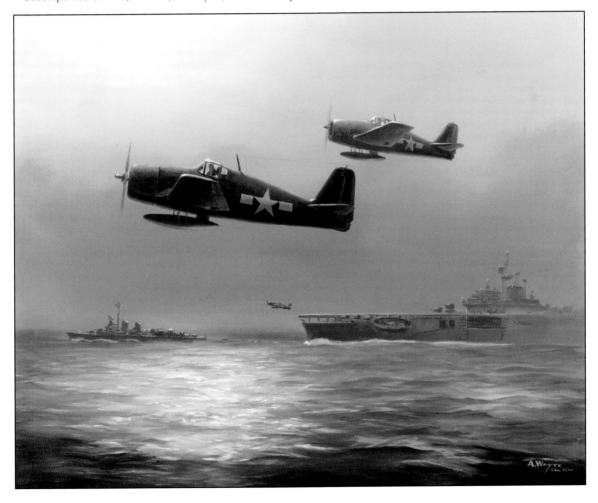

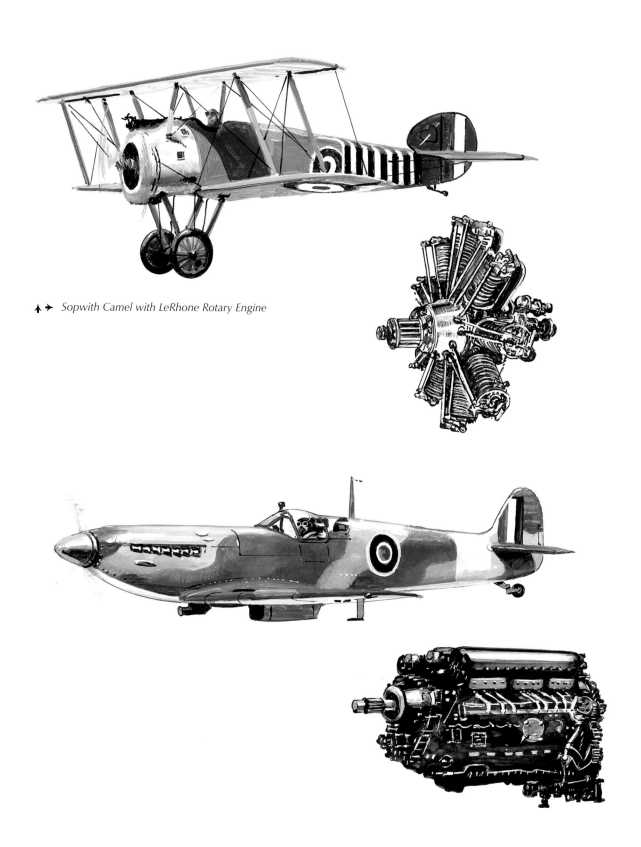

↟ ↦ *Sopwith Camel with LeRhone Rotary Engine*

↟ *World War II Supermarine Spitfire with a Rolls-Royce Merline Inline Engine*: Prior to the widespread introduction of jet engines, airplane designers relied on two main types of reciprocating or piston engines—the *radial,* shown on the Sopwith Camel, and the inline, shown on the Spitfire. Each type had advantages and disadvantages.

↟ *Boeing 787 Dreamliner with Turbofan Engines*: In developing the Dreamliner, its next generation commercial airliner, Boeing has selected engines to be built by General Electric and Rolls-Royce. These turbofan engines are derivatives of engines that are already in service powering many modern airliners. They take in more air and operate more quietly. Their shapes are distinctive.

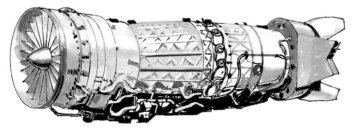

↟ The ultramodern Pratt & Whitney F119-PW-100 engine combines features of both the turbojet and the turbofan and powers the Boeing/Lockheed-Martin F-22 Raptor, the first fifth-generation fighter aircraft. The engines are reliable and have evolved to higher thrust/weight ratios and overall smaller size.

continued from page 21

center shaft to the compressor blades and keeps the compressor blades spinning.

The three basic types of jet engines are the turbojets, turbofans or fanjets, and turboprops, also called propjets. The turbojets use exhaust thrust to propel the aircraft. The turbofan, or fanjet, engine has a larger fan at the front. While it takes in more air, it diverts some of the air around the combustion chamber and later mixes it with hot exhaust gases escaping out the back. This lowers the temperature and speed of the exhaust and results in a quieter engine. The turboprop, or propjet, uses a jet engine to turn a propeller; consequently, thrust is generated both by the propeller and the exhaust gases of the jet. The turboprop is less efficient at high speeds and high altitudes than the others.

Since World War II there have been great advances in aircraft design, materials, and manufacturing capabilities. Space programs initiated many advances, and supersonic flight now is an everyday occurrence; man has walked on the moon, and the International Space Station is a reality. Wide-body commercial transports carry more passengers over ever-greater distances. Military aircraft range has been extended through aerial refueling. Air-sea rescue capabilities have expanded through the teamwork of airplanes and helicopters, and short takeoffs and landings have enabled aerial delivery of critical supplies to even the most remote locations. Spacecraft, airplane, helicopter, dirigible, and blimp design has kept pace, and new capabilities are enabling improved mission performance. Acquaint yourself fully with the design of the aircraft that you are drawing, and practice drawing exacting portions of the craft as avidly as did the design engineer who originally created it.

Knowing basic aerodynamics and its influence on the design of aircraft helps an aviation artist capture a craft's history, beauty, and functionality. Keeping pace with its continual evolution is not only intriguing, it is an inspiration to further drawing and painting. Urging artists to recognize hard work and discipline needed to excel in their craft, R. G. Smith said, "Some artists only see airplanes as mechanical objects. As a result, their depictions of them become mechanical, stilted portraits rather than a picture with character, motion, or some measure of dramatic quality." He urged budding aviation artists to "Put the subject matter *in* the picture, not *on* it." Your drawings and paintings will improve with your practice, if you take these wise words to heart.

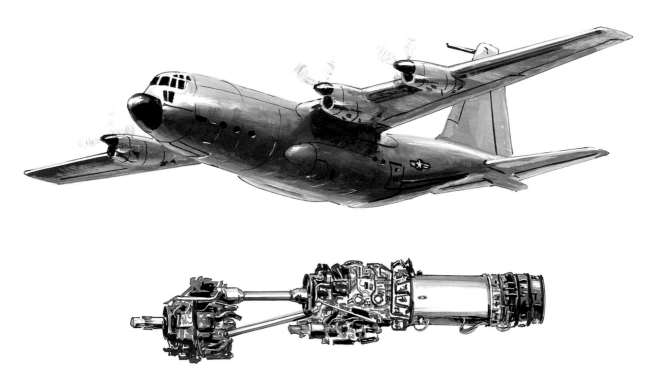

▲ *Turboprop* engines have found wide use on short-range commercial aircraft and on military cargo carriers like the Lockheed C-130 Hercules. Also highly reliable, they combine the propeller's thrust with that of the jet's exhaust gases.

◄ *Straight-wing* fighters like the Lockheed F-80 Shooting Star were the dominant design in the early days of the war in Korea. They were not, generally, a good match for the swept-wing, Russian-built, MiG-15.

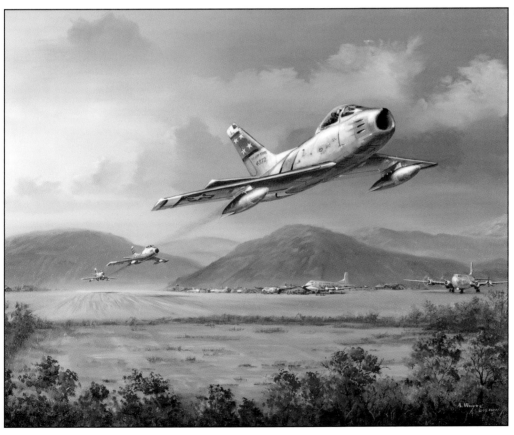

◄ *Swept-wing* combat aircraft exemplified by the North American F-86 Sabre were a far better match for the Communist MiGs. As pilot experience developed and as Sabres increased in numbers, America began to control the Korean skies.

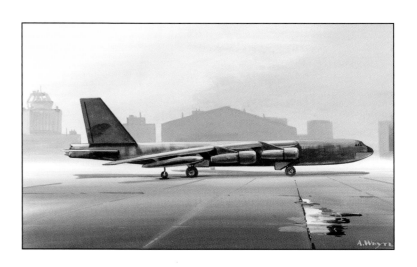

*I*f you watch an aircraft fly past, the craft is fairly detailed and sharp and the background is blurred. That is because your eyes are focused on the aircraft.

— *Andrew Whyte*

SPECIAL CONSIDERATIONS IN AVIATION ART
Know Your Subject from the Ground Up

Drawing aircraft and spacecraft introduces unique problems. There can be major differences between an aircraft idle on the ground and that same craft when airborne. For your drawings, beware of relying too heavily on photographs and on model aircraft when you choose a particular view. A craft photographed parked on the ground doesn't necessarily represent that same craft in the air and vice versa. Know your subject. Do your homework.

MAJOR DIFFERENCES BETWEEN IDLE AND FLYING AIRCRAFT

Aerodynamic changes occur as an aircraft takes to the air. Wing positions of aircraft will be different in their static positions compared with how they look in flight, although it will be less noticeable with aircraft with shorter wingspans. A long-winged B-52 bomber, fully fueled and parked on the ramp, will have wings bent downward with the pull of gravity, their weight supported with outrigger landing gear. The wings bear the structural weight and the weight of the loaded fuel tanks and four engines. The tires and the landing gear struts are depressed.

The B-52, once airborne, will have dropped the outrigger wheels and will display wings that rise with the lift that carries the craft upward. All wings have to flex with aerodynamic changes and may flex a matter of feet in some aircraft. Immediately after takeoff, the aircraft wingtips, though heavily loaded, will rise, the landing gear struts will extend, and the wheels, no longer bearing the weight of the craft, will be rounded ellipses, still spinning with the roll of the takeoff. Then, on retractable-gear aircraft, the gear will start rotating into wheel wells or openings in the fuselage.

➜ The B-52 Stratofortress on the ramp shows the downward deflection of the wings with the weight of the structure, fuel, and engines. Note the landing gear and the landing-gear door as well as interest created by the lighting and cast shadows. Note, too, the diffused haze and the remaining puddles left from a recent rain. The buildings in the background keep the viewer's eye moving throughout the drawing.

KNOW DIFFERENCES IN LANDING GEAR CONFIGURATION

There are dramatic differences in landing gear as well. The landing gear consists of wheels, tires, brakes, shock absorbers, axles, and other support structure. Know whether the subject aircraft has main gear and a tailwheel, commonly known as a "taildragger," or whether it has main gear and a nose wheel. Most commercial jet aircraft, for example, have nose wheels with two tires and have two or more main-gear assemblies with as many as sixteen tires.

Know whether the gear is fixed, whether it retracts, and, if so, *how* it retracts. Know the design configuration of the subject craft. How is the gear stowed in the belly of the Cessna 210? When cycled, it appears to elongate directly below the craft, each gear leg rotating inward before both slide into the fuselage below the cabin. Some aircraft have gear doors affixed directly to the struts; some wheels disappear completely into wheel wells beneath the pilot position and have separate gear doors that close after the wheels are up and locked; some are not covered; and some wheels, when retracted, still extend below the lower curvature of the wing.

USE PHOTOGRAPHS AND MODEL AIRCRAFT AS TOOLS

Photos and models are valuable tools, but know their limitations. Don't depend upon one photograph of an aircraft to show these dramatic changes, and don't depend upon a model of the aircraft to show the dynamics of flight. If you photograph your subject aircraft on display at a museum, beware of using the photo as a sole reference for drawing the craft. The tire pressure alone can throw the drawing off. Consider what weight difference exists between the museum craft and the fully loaded combat-ready warplane and how much more compressed the tires of the heavier aircraft are.

When using an aircraft model, consider it a secondary aid. Observe it outside in the sunlight conditions that you have chosen for your drawing to help you, for instance, determine what parts of the aircraft will be

Drawing aircraft and spacecraft introduces unique problems.

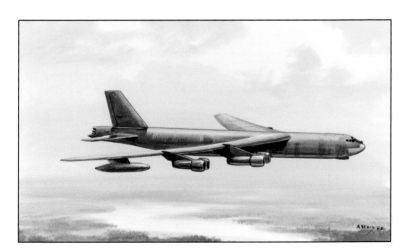

← The same B-52 Stratofortress has different characteristics when airborne. The wings flex and are deflected upward. The light and the shadows differ, too. Note the terrain, the winding river, and the horizon in the distance.

▲ Demonstrating the changes in the configuration of the landing gear, the strut extension, and the tire depression is a major clue to the aircraft's position in respect to the ground. The strut is fully extended and the tire fully rounded, as it would be just prior to touchdown.

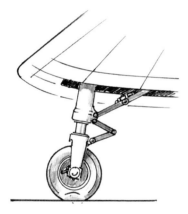

▲ After landing and in the sequence of rollout or taxi to parking, the gear shows some strut deflection and a slight flattening of the tire.

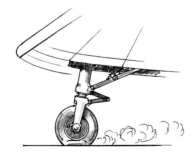

▲ As the heavy craft descends to the runway, the strut is almost fully depressed and the tire flattened upon landing. Note the dust raised at impact.

shadowed by others. It will help to define the best angle to highlight the craft for dramatic appeal. It will *not* show the flex in the wings, the retraction of the wheels, or the *action* of flight.

Recognize that some ancillary equipment that is visible on the idle aircraft might not be when the craft is in the air. For example, such items as streamers, Pitot covers, control locks, air-intake protectors, and wheel chocks are removed before the craft flies, and therefore cannot be included in a drawing of airborne craft. Know and understand aircraft equipment and its uses. Inclusion of some equipment can enhance your drawing or it could be completely out of place in your scene.

OTHER DIFFERENCES UNIQUE TO AVIATION ART

What about depicting an aircraft that has just lost one of its propeller-driven engines? It is the artist's responsibility to understand aerodynamic factors. An aircraft that suddenly loses an engine has a tendency to yaw toward the wing with the dead engine. The pilot counteracts the yaw by depressing the opposite rudder pedal to full deflection, flattens the pitch of the propeller on the dead engine (that is, aligns the blades with the direction of flight to reduce drag), and maintains directional control by neutralizing any bank, thereby maintaining a zero degree of aileron deflection. In a sudden engine-out situation, even a slight amount of bank can result in a wicked and rapid snap of the aircraft into the wing the pilot is trying to lift. In discussing flying the B-24, celebrated landscapist, pilot, and aviation artist Wilson Hurley noted ". . . even as little as a 10-degree deflection in the down aileron caused an abrupt separation of the airflow over the wing—an aileron stall. . . . If I were to show a B-24 with an outboard feathered, I'd paint opposite rudders fully deflected and ailerons flat."

In drawing the vortices of air that stream from a fighter aircraft like the F-16 during a high-g maneuver, understand that the air spirals occur first at the strakes that are the juncture of the wing and the fuselage. There are also wingtip vortices that rotate inward toward the fuselage. Both depend upon the water vapor content and air temperature, and condensation of that water vapor. If you include these vortices in your drawing, be sure that high humidity is visible; for example, include puddles showing recent rain, a nearby waterfront or river, or moisture-laden clouds.

Aircraft have exhaust nozzles that can be controlled by the pilot's use of the throttle. Know some of the differences when drawing fighter jets. In an AV-8 Harrier, the downward vectoring of the exhaust thrust gives the unique capabilities of vertical takeoff, hover, and rotation in a horizontally stable position. Vectored thrust in the F-22 Raptor gives the heavy fighter nimble agility in turning flight. Some exhaust nozzles are shrouded and not visible, as in the A-7, the A-10, and the T-38. Some, as on the F-16, are visible. Usually the F-16 nozzle is tightly closed in normal cruising. When throttled back for a descent for a landing or taxiing and when the jet is thrust into afterburner, the nozzles are open.

When aircraft fly at high altitudes, there is little to indicate speed. Showing speed requires some specialized techniques, such as blurring the exhaust gases. As aircraft fly closer to the earth, relative speed is more obvious. Consider blurring the background when you depict an aircraft close to the terrain.

Strive for accuracy.

EFFECTS OF WEATHER

When drawing any means of transportation accurately, the artist must have studied the environment in which it operates, such as tracks and roadbeds for trains, streets and racetracks for cars, and sea conditions for ships. The same is true for aircraft. To draw aircraft is to draw them in their element, the air. If you have never flown, take a few flights with instructors from your local airport. Tune your senses to see, hear, and feel some of the sensations of flying. Get an appreciation for the major elements of the weather—temperature, pressure, and air masses— and some indications of certain weather conditions. Cloud types are specifically linked to atmospheric conditions, heights, and the pressure differential. Cumulus clouds, great for background for dynamic aerial

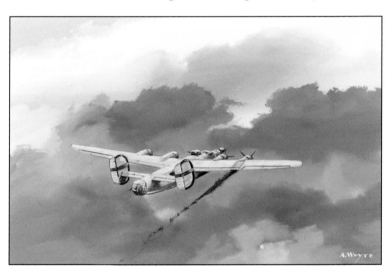

◄ Andrew Whyte's B-24 Liberator is depicted in hazardous weather, with two engines out on the right wing. The propellers are feathered to reduce drag, the ailerons are neutral, and the rudders are fully deflected to the left, the opposite side from the inoperative engines, in order to maintain directional control. Notice the reflection of the atmospheric coloration in the surfaces of the aircraft.

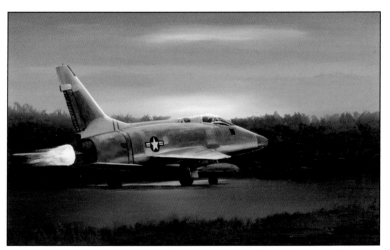

◄ The F-100 Super Sabre is streaking for takeoff at twilight with full afterburner engaged. The engine nozzle, which would be tightly closed in cruise configuration, is fully opened when the jet is in afterburner.

Drawing, a Foundation

Drawing is of primary importance to a representational artist. ASAA artist fellow Konrad Hack said, "Drawing is the first teacher of observation. It is the basic foundation with which to convey structure and form. Drawing is the basis for all painting. One cannot save a bad drawing with paint."

Hack, who teaches drawing and practices what he preaches, says there are no shortcuts. Some artists emphasize that you must observe in order to draw, while Hack suggests that you draw in order to learn to observe.

"My secondary concern," said Hack, "is good composition —getting a drawing completed that will hold together and have impact as a shape or movement. Drawing and composition are the skeleton of every work of art."

Hack carries a sketchbook and uses it regularly. His sketchbook provides stimulus to observation and it also helps him recall important details when he starts to improve on a sketched composition. He said, "The camera is an important tool for gathering information to support my ideas and to supplement my sketchbook. But, it is only that — a tool. Firsthand observation and sketching are essential bases to good drawing. To develop a composition, I combine several photos with sketches. I make numerous thumbnail sketches on vellum, working out the best balance of shape and form, working positive and negative space. Vellum gives me versatility in overlaying my sketches."

"Finally, it depends upon the use of color to create a mood," explained Hack. "Good use of color can heighten and develop an interesting painting."

F6F Desert Hellcat
Konrad Hack

Discovered at Davis-Monthan Air Force Base at the Military Aircraft Storage and Disposition Center in Arizona, this forlorn craft had been salvaged. Hack explained, "The aircraft had crashed into the ocean during World War II. In addition to all the paint having been eaten off, the engine and cowling were bent. I felt the plane had character, standing there all propped up, yet abandoned, forgotten in the desert. I was left with patterns and textures that inspired me. She spoke to me more of her majesty than the combat role that she played."

Forget-Me-Not
Konrad Hack

Hack's drawing of the SPAD XIII was discovered at the Garber Facility of the Smithsonian's National Air & Space Museum. This particular SPAD, from the 20th Pursuit Squadron, was one of the last airplanes to see combat in World War I, still proudly bearing the original canvas patches over bullet holes sustained during her short but distinguished career. "I took photographs," said Hack, "as I crawled around the wings, careful not to touch her or to disturb this fragile piece of aviation history. I mentally formulated the multitude of possible artworks that could result from this wondrous encounter. This beauty spoke to me of the past and reminded me of how she survived both combat and the ravages of time.

"I completed a number of pencil drawings on Arches water-color paper, showing her fragility from different views. The painting, *Forget-Me-Not*, is a broad view showing all the scars, patches, and insignia of a vintage fighter. I placed the plane in a field of forget-me-not flowers that are growing wild and untended around the wheels, a symbolic reinforcement of how often the past *is* forgotten."

Forget-Me-Not **by Konrad Hack**

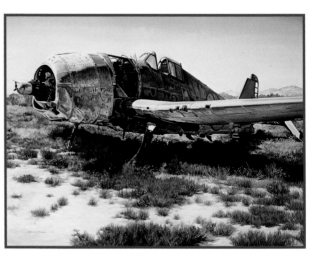

F6F Desert Hellcat **by Konrad Hack**

images, are indicative of instability, updrafts, turbulence, and, outside of the clouds, good visibility. Stratus clouds, which indicate very little vertical movement, can be linked with haze, fog, and poor visibility. Stratus clouds can offer a calming image for your drawing.

Learn about hazardous weather, such as heavy winds, rain, hail, and the turbulent air found in thunderstorms. Most weather conditions occur in the troposphere, which extends to an average of approximately thirty-five thousand feet. Many commercial jets fly above these altitudes over the contiguous United States. General-aviation aircraft are limited primarily to flight well below those levels, which means they will be dealing with the weather conditions that can affect flight. Military aircraft that are designed to be all-weather craft still face limitations in extremely severe

and violent storms. Renowned author Richard Bach said of painting his experience in a fighter jet in the midst of a vicious thunderstorm, "All you would need is six tubes of black paint." As you draw and paint a variety of aircraft, recognize the element through which it is flying and depict the weather conditions realistically and accurately.

TWO FINAL THOUGHTS

When you are fortunate enough to be commissioned to draw or paint an actual historic scene, avail yourself when possible of personal interviews, and then be certain to verify the facts. Alex Durr, a pilot, former U.S. Marine, and member of the American Society of Aviation Artists, personally knows the challenges and experiences of piloting military fighter aircraft. When commissioned to depict the

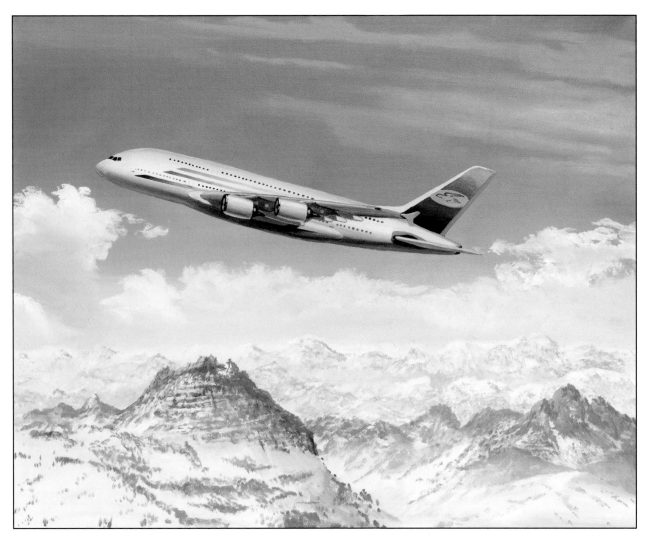

▲ Cumulus cloud formations, such as these depicted with the Airbus A380 over the mountains, are sky signs that indicate instability of the air, vertical—updraft—conditions, clear flying weather outside of the clouds, turbulence, and good soaring conditions for gliders.

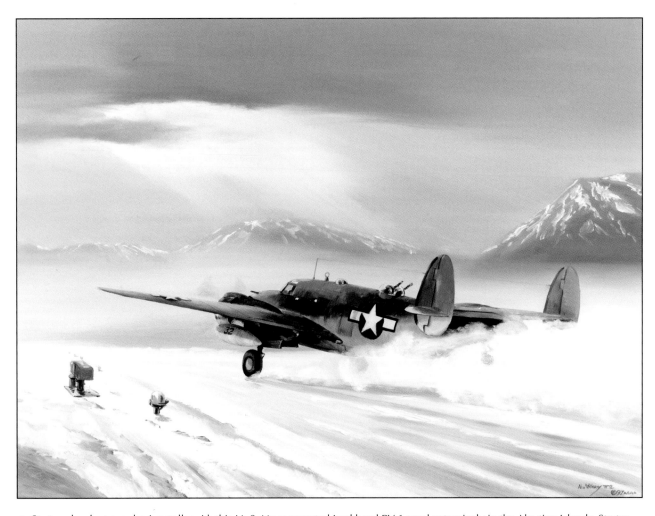

↑ Stratus clouds stream horizontally with this U. S. Navy-operated Lockheed PV-1 used extensively in the Aleutian Islands. Stratus clouds are indicative of relative stability, overcast conditions and low visibility, little vertical development and, often, rain or snow.

downing of a Japanese Kawasaki Ki-45 Toryu "Dragon Slayer" by a World War II pilot in his F4U Corsair, Durr not only interviewed the pilot, he researched his memorabilia and performed a research crosscheck with military records, log books, and printed material. In truth, all guns were frozen because of the high altitude of the fighters. The Corsair pilots daringly destroyed this reconnaissance aircraft, which was charged with directing deadly Kamikaze attacks, by chewing into the Ki-45's vertical stabilizer with the propeller of the Corsair. The scene was historically accurate and the resulting artwork was filled with action.

Be fully aware that the design configuration of the aircraft you are drawing will undoubtedly be well-known to someone who views your work. Strive for accuracy in portrayals of historic moments and in any portraits of aircraft, yet don't neglect the tension, the apprehension, and the mood of suspense that accompanies harrowing flights, nor the ecstasy that can be felt in a magical and pleasurable flight. You are learning to draw aircraft and are hopefully on the way to truthfulness and competency in artistic representation. Failure to convey feeling is a failure to interest and involve your viewer.

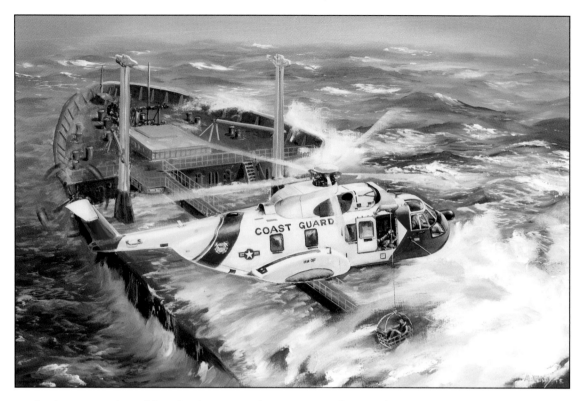

▲ Like the crewmembers of this Sikorsky HH-3F Pelican, coast guardsmen and –women risk their lives in dramatic lifesaving situations that often are a result of hazardous weather conditions.

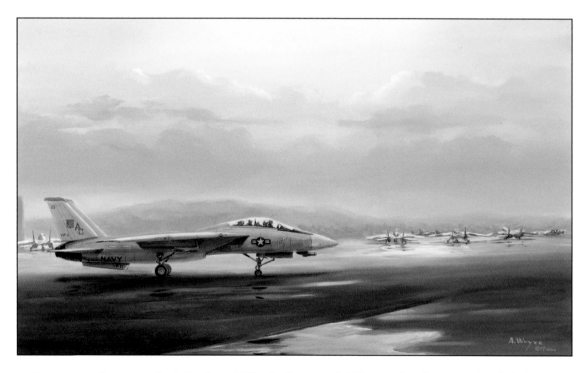

▲ On an unusually overcast day in Southern California, Grumman F-14 Tomcats line the ramp at Naval Air Station Miramar, longtime home to the U.S. Navy's "Top Gun" training establishment. Now at Naval Air Station Fallon, Nevada, the U.S. Navy's Fighter Weapons School includes top-gun training.

> With a pencil, you can create perspective, light, and shade. You can create a three-dimensional look by using different weight to the penciled lines.
>
> — *Andrew Whyte*

From the outset, a pencil and paper are all you really need to start drawing. But, later you'll decide *which* pencil and *which* paper. Drawing requires developing a successful eye-to-hand coordination and the ability to reproduce what your eye or your mind's eye sees. Although you may eagerly look forward to using paints and color, first concentrate on learning to draw and on light, shade, and value. Start modestly with pencil and paper and work your way to the materials that fit your increasing ability and developing style.

PENCILS

Pencil manufacturers use a ratio of graphite-to-clay in creating pencil lead; the more graphite, the blacker and softer the grade of pencil. Hardness is designated by letter with softer leads indicated with B (for black) and harder leads with H (for hard), plus there are F and HB designations in the middle. Most are further delineated combined with a number. This results in designating pencils from the hardest (9H), down to 2H, H, and F, and from HB, B, 2B, and so on up to 9B (the softest). Part of the fun in choosing various combinations of pencils and paper is that the experimentation itself can add variety to your practice in drawing. Start out with pencils graded from 2H through 2B for sketching.

For shading and tonal values, some artists prefer crosshatching—making firm, rapid, and strong, sharply defined lines that give form, shape, and value throughout a picture. Using a 2B lead that is conducive to shading and blending, tonal values also can be achieved by blurring, smoothing, or defining the penciled strokes with a combination of the use of erasers and/or tightly wound paper spirals called blending stumps, or tortillions.

PAPER, BOARD, AND SKETCHPADS

Remember: *Before* you leap into the world of painting, first learn to draw. You may soon begin a search for canvas, wood, and Masonite surfaces on which to work in color, but we urge you to start at the beginning. Practice drawing and choose the best surfaces for drawing and sketching: paper, boards, and sketchpads.

Interestingly, cartridge paper is named for its original use, which was as packaging to hold a charge of powder in a weapon. Cartridge paper is used for pencil drawings and for charcoal. This acid-free paper is reliable for permanence and is available in pads and in single sheets.

When selecting a board, choose one with an alkaline buffering or one that is acid-free or has a substrate that uses a starch-based, acid-free adhesive. Hard-surfaced papers offer a smooth, dense surface upon which to draw.

TOOLS OF THE TRADE FOR DRAWING
To Start, You Need a Pencil and Paper

↟ The variety of pencils and papers available to the artist is almost overwhelming. This is a small sample of the essential elements needed by the beginning artist—a pencil and a drawing pad. Visit an artist supply store and select from the vast array.
Courtesy of www.mccallisters.com

For variety, try vellum, oil-painting paper, and Ingres paper, all of which lend themselves well to pastels, pencils, and crayons, and give a texture for a variety of techniques. Try charcoal and pastel papers in a variety of colors or watercolor paper that is available in rough or smooth surfaces. Pure linen and handmade papers, calligraphy paper, and blotting papers might interest you and challenge you. For layout and compositional work, tracing and graph papers are useful. You will want a supply of masking tape or drafting tape for securing these papers to your drawing surface.

CHARCOAL

Charcoal is a form of carbon that is created by partially burning or oxidizing wood. Artist's charcoal generally comes from willow. Natural charcoal sticks can be messy for an artist, and some varieties are wrapped with peel-off paper covers for ease and cleanliness of use. Spray fixatives can help control the dust. Artists' charcoal is also available as powder or in compressed sticks or pencils. The compressed forms range in grade, can be purchased in thick, medium, and thin widths, and are available in soft, medium, and hard. Charcoal can achieve dark shades, can be easily blended with a finger or a stump, and highlights can be picked up with an eraser.

PENS AND MARKERS

A wide variety of pens also exists. Use inks that will not fade when exposed to sunlight, and experiment with dip and reservoir pens. Dip pens, the most basic, are easy to use. Brush pens come in single, double, and fine-line forms. Fiber- and felt-tip pens give dense black lines. Fine fiber-tipped pens respond well to rapid sketching and have the added strength of a tip supported by a metal sleeve. Some pens are useful for thumbnail sketches and allow an artist to quickly establish tonal and linear compositions with a minimum of detail. Thumbnail sketches, as you will see, are crucial to your development of pictures and paintings.

Felt-tipped markers, which come in an array of colors, are alcohol- or chemical-based. The former are safer for your health. Charcoal, pens, and markers will allow you to develop different styles for your art, but can be more challenging than pencil drawings in that they cannot be erased. On the other hand, this experimentation can lead to even greater eye-hand coordination.

AIRBRUSHES

Starting with appropriately large pieces of paper, some watercolor airbrush ink, an air supply and a double-action airbrush, you can master another useful tool. Like every other art form, learning to paint with an airbrush requires an interest, the equipment, research, and study of the various techniques practiced by experts.

Chad S. Bailey, artist member of the Society of Aviation Artists, said, ". . . the airbrush, an atomizer using compressed air to spray paint, has developed into a unique and useful tool. Using masks, stencils, or free

▲ You don't need to purchase everything on the market but you will need a variety of erasers and, perhaps, a stump, or tortillions, to blend and soften your drawings and, heaven forbid, to correct any miscues.
Courtesy of www.mccallisters.com

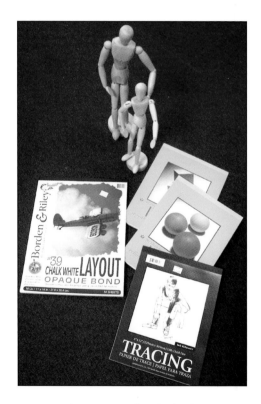

▲ Art-supply stores carry hundreds of paper types in an array of colors. Within limits, each type—each surface—can meet a specific purpose. Through practice and discussion with artists and knowledgeable store managers, you will learn which best meets your needs.
Courtesy of www.mccallisters.com

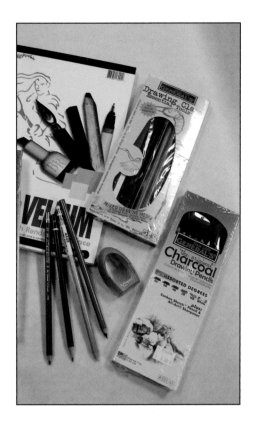

↟ For charcoal drawings and pen-and-inks, buy a few of the many choices offered and experiment with as wide a variety as your drawings require and your budget permits. *Courtesy of www.mccallisters.com*

hand to direct the paint and to prevent overspray on the surface of the painting, an airbrush can deliver color from the width of a fine line to a wide spray pattern. There are different types of airbrushes and a variety of airbrush manufacturers. Airbrushes come in a wide range of prices and capabilities. Some mix the paint and air internally inside the head. Some have a gravity system and some a siphon system. Choose the airbrush that best meets your needs. You have a wide choice!"

Andrew Whyte said of his tandem cockpit helicopter portrait, a prototype gunship rendered via airbrush, "Using the airbrush is simply choosing to wield a tool that has been around for many, many years. Airbrush has been a choice of many commercial artists and demonstrates its usefulness in technical illustrations. With an airbrush, I found I could obtain a smooth gradation and shading of values."

COMPUTERS

Like a pencil, pen, marker, or airbrush, the computer is a basic tool. It, combined with appropriate monitors, printers, scanners, pressure-sensitive graphics tablets, and software, offers artists a modern, complex, challenging, and often expensive tool. Applications programs give artists additional choices in selecting the media that best fit each artist's needs. Undeniably, the computer has greatly affected art, as witnessed by its use by many sculptors, filmmakers, architects, engineers, and other visual artists. However, a computer won't make a better artist of you. It is a tool and computer programs can diversify your drawing pleasure, but they are no substitutes for developing your own talent.

Jim Laurier, an artist fellow of the American Society of Aviation Artists, uses several different approaches, sometimes scanning thumbnail sketches to rearrange, redraw, and/or refine his original line drawings. He said, "Sometimes, I scan several separate drawings and compose a final composition on the computer. At this point I may leave the image as a line drawing or I may make it a grayscale image by adding in shaded areas to work out my value patterns and lighting scheme. I may also go all the way to a full-color comp to work out all the problems before painting." Although Laurier would be the first to say that the computer is simply another tool, not a substitute for learning to draw, he joins a growing number of those who continue to learn how to best utilize this technological tool. He said, "The computer is a real time saver. The ability to experiment with sketches reveals possibilities that otherwise may have been overlooked."

Later chapters take an in-depth look at the tools of digital illustration—the hardware and some of the software programs that are on the market in 2008, including Adobe InDesign Creative Suite 3, which includes Dreamweaver, Illustrator, Acrobat, Photoshop, Flash, and more, and NewTek's LightWave 3D. Chapter 14 addresses some of the techniques graphic artists use to create imagery. Before you invest money and time

in digital illustration, do your homework, research the market, and avail yourself of advice from experts.

Aviation artist John Sarsfield created his own computer program, entering his aircraft into the program with the use of illustration software and mastering the capability of moving his image of the craft through the axes of yaw and roll to select the view that best enhances his compositions. He said, "My usual practice is to work with small, crude thumbnails until the general idea of the composition appeals to me. I follow that with a computer-generated outline. That outline is fleshed out directly on the painting after I complete the background."

His computer program doesn't create the drawing. In a very real sense, John is using the computer as a tool that aids his drawing and the composing of his scenes. Remember, the use of computers can help develop your eye and your eye-to-hand coordination. The computer can be a useful tool, but it is just that: a tool. The final word will still be, "Learn to draw!"

STARTING A STUDIO

Don't let the lack of a studio hold you back. You can draw outside, *en plein air* in French, studying daily and seasonal changing light and shadows. You can draw in a limited space. Sure, in the best of art worlds, your own studio is desired. If you should be so lucky, equip it with a large surface upon which to draw and with adequate room for your miscellaneous aids, such as sketches, photographs, and reference materials. Plan to include a good source of natural light, preferably north light, and good overhead lighting.

Among the supplies you'll need are a spray fixative (an over-the-counter hair spray will work for starters) for pastel, charcoal, and pencil drawings and a solvent or thinner to use as a cleanser for equipment. You'll also want pencil sharpeners and a supply of erasers, perhaps including putty rubber, white erasers that fit the palm of the hand, kneaded erasers, and/or slices of ordinary rubber eraser that are trimmed to a chisel shape for erasing in a thin line. That edge, when dirtied, can be shaved for reuse with another piece of useful equipment, a sharp craft knife. A large, soft watercolor wash brush can be used to disperse eraser debris.

For circles, ellipses, and curved surfaces, you may want sets of stencil templates and sweeps. T-squares, straight edges, and French curves can be added to your toolbox as the needs arise. Use these as aids and not as substitutes for the practice of freehand drawing.

▲ Fiber- and felt-tipped color markers come with tips of varying widths. From a health standpoint, the alcohol-based marker ink is preferred. Many sizes of marker paper are available for sketching quickly and for finished drawings.
Courtesy of www.mccallisters.com

▼ An airbrush, an atomizer that uses compressed air to propel, or spray, paint, is another useful tool for aviation art. Andrew Whyte selected an airbrush to paint his helicopter. Choose the product that best accomplishes your goals.

An image can be indicated without drawing an outline. Draw the background, contrast light against dark, and the aircraft shape emerges.

— *Andrew Whyte*

PUTTING YOUR PENCIL TO WORK
Developing Skills

Teachers of beginning art classes often launch their students directly into creating full-color paintings. This approach might be more fun, but it can lead to frustration or, worse, to a student giving up art completely because so many required skills have to be mastered at once. If you are serious about learning to become an artist, forget color until you have mastered the skill of drawing.

Basic to most art, drawing forms the cornerstone upon which painting can rest. Drawing can be a prelude to a more finished work (and, as a rule, most successful paintings are begun as good drawings) or drawing can be an end in itself. With deft lines, a full range of values, good shapes, positive and negative areas, good composition, and good perspective, a drawing can be equated with a fine painting.

Drawing is a skill to be learned. Anyone with manual dexterity and desire can learn to draw. It is important to recognize that there are no shortcuts.

← ↑ Andrew Whyte sketched live models quickly to capture a human figure at a moment in time; sketches can help you emphasize body positions, actions, or articles of clothing for later improved drawings or paintings.

◄ ♠ More detailed and more carefully worked sketches of a person can be hastily drawn to capture an action or a pose. Note that there are very few straight lines to the human figure.

SKETCHING

A sketch is a concise and brief drawing that summarizes an idea. Start with a sketchpad and some pencils. Train your skills of observation. Learn to look and really *see*. All aviation art is not realistic. Artists express themselves as they see fit. You will see visual interpretations of the impressions of flight in a variety of forms, including modern art, fabric, and folk art. However, if your goal is representational art, you join a large cadre of realistic artists whose goal is to adhere to accuracy.

Fighter pilot and artist Paul Burrows said, "Accuracy is the challenge. An artist is creating a world—not adapting it. In a landscape, I can draw a mountain or trees, change them and adapt them to suit my composition. But when I am drawing an airplane, perhaps depicting a moment in aviation history or in personal history, the research has to be accurate and it should be as factual as possible. Much of the challenge in drawing and painting airplanes is that there is so much to consider."

To practice sketching, choose a variety of subjects—human figures, aircraft, airport buildings, gas trucks, clouds, and so forth; fill your sketchpads with rapidly drawn studies, sketches of shapes that are interesting to you. Sketching can be an excellent way to develop your ability to catch the essence of a scene or an object. The intent is not to achieve an elaborate or finished drawing, but to quickly capture essential features that can serve as guidelines and inspiration. Sketching helps to train the hand and the eye. Sketches can be of any size and, done outdoors and on scene, can capture elusive shapes that might not easily be reconstructed in the studio or after the moment has passed. Thumbnail sketches as preliminary drawings are useful forms of preparation for compositions.

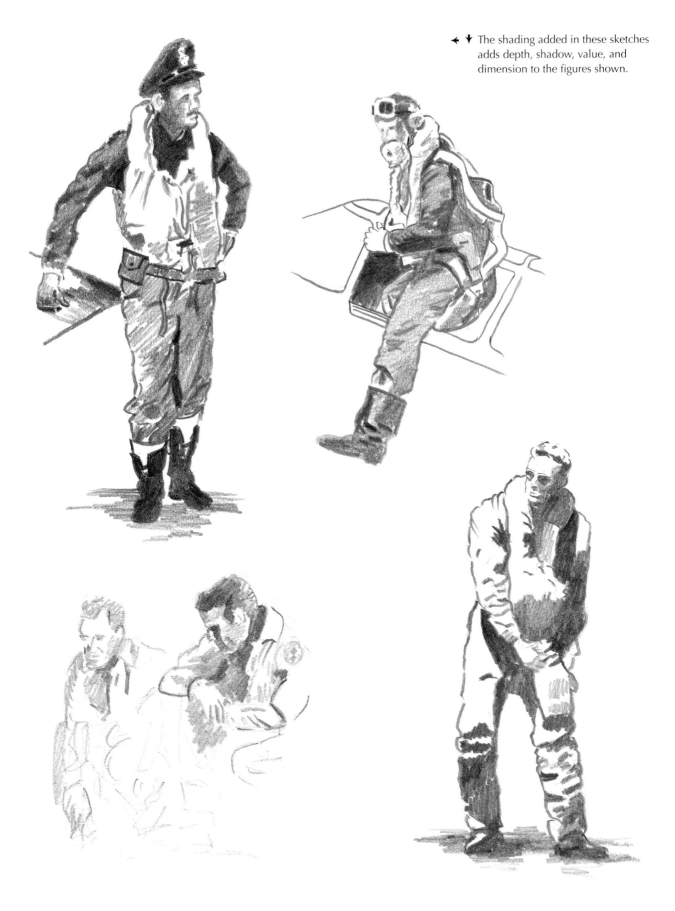

← ↓ The shading added in these sketches adds depth, shadow, value, and dimension to the figures shown.

LINE DRAWING

In its simplest form, a line drawing is one expressed by line alone. With little attempt to distinguish between light and dark, line drawings express understatement. In addition to perspective and foreshortening (see the Glossary at the end of the book), line drawing uses differing weights of particular lines to create or emphasize depth.

Lines define shape. Straight or curved, delicate or bold, lines can be visible or can be suggested to the viewer by the use of shading. Horizontal, vertical, or diagonal lines suggest mood, emotion, or movement. With crosshatching, shading, and rubbing, lines can create shadows, depth, and an entire range of values.

Form, shadow, and highlights can be indicated by tints and shading. Darker masses can be composed by areas of many lines and by drawing lines of heavier width. Emotional effects can result by using short, jagged lines versus the use of broad, sweeping curves.

Because form is the foundation of visual arts, drawing is essential to an artist. Choosing what to depict and what to omit is the artist's challenge.

DRAWING TECHNIQUE

Training the eye to *see* is essential to drawing successfully. Discipline yourself to repeatedly sketch new drawings, fresh angles of familiar subjects, and, for practice, studies of problem areas in drawings. Although your primary reference material for aircraft may be photographs, there is no substitute for sketching from life. As on-the-spot sketching can be frustrating at times because people or aircraft might not remain stationary, quick drawings can be an excellent practice in developing your ability to catch the essence of a scene.

Try to add actual flight to your studies. It takes one practiced in the skill of *seeing* to appreciate aircraft fully and to complement the art of drawing. Artist Paul Burrows cautioned, "A pilot is busy; a pilot isn't there to analyze the quality of light, shadow, contrast, or value. Yet, from a technical point of view, there are some things that have to be seen to be learned. Flying is one of the only platforms for such a view."

Drawing is a skill to be learned.

↓ This sketch, done at Naval Air Station Miramar, shows F-104 Tomcats against the distant mountains. The use of midrange values for the mountains establishes the distance from the aircraft.

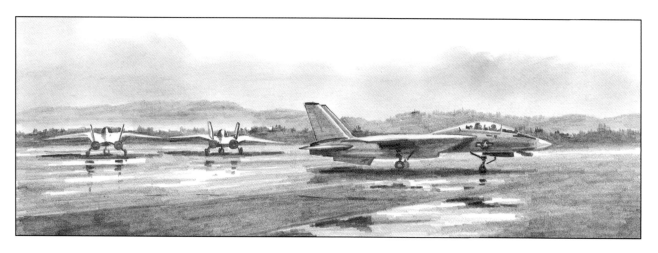

Value scale

➔ Values are essential to all works of art. Ranging from black, at the low numbered end of the scale (one), to white, at the high end (ten), values encompass the darkest darks to the lightest lights. The value scale applies to colors as well as to black, white, and the intermediate shades of gray.

➔ Artfully and accurately using a full range of values will enable an artist to transform a flat circle into a solid sphere.

After choosing the aircraft that will be the focus of a drawing, try to view the craft on the ground and in the air. Analyze the important structural forms of the craft and, with rapid strokes, sketch its essential shapes. View the craft from several vantage points and become so familiar with it that its structure becomes committed to memory. After sketching the basic outline shapes, add important details, leaving minor details until last.

ASAA founder Keith Ferris believes that a person with enough information can draw anything. He also insists that to draw well, one has to look very carefully and accurately assess what is seen. He said, "An artist must train his or her memory and critical eye. Start with analysis. With an airplane, for example, estimate the length: The nose may stick out for a quarter of the length, the chord of the wing, another quarter. Figure it out. Investigate the aircraft very carefully while challenging yourself with questions. How was it built? What about the control surfaces, the proportions, the various parts? Start thinking three-dimensionally. Where is the light, the cast shadow? Everything you see can be pictured in terms of light and shadow, lines and spaces, verticals and horizontals. You train yourself to analyze what you see and you are actually seeing more than anybody else."

VALUES

Varied gradations of light and dark are known as values. This is true not only for color paintings, but in gradations in the black and the white tones of a drawing.

Compton's Encyclopedia describes value as, ". . . the amount of light reflected by a surface." Although some value scales differ in their assigned numbers, our study of values begins with a scale from black, assigned a value of one, to white, assigned a value of ten. The graying process from black to white moves numerically through that scale.

SPHERES

Values are at the core of all artworks. Values gradually change, from black (a low value) and the darkest dark through gray to white (a high value) and the lightest light. This value scale applies to all color pigments as well and a pale red or a pale blue will have a value as surely as a pale gray. Form

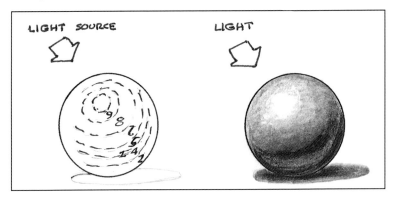

is expressed by values. Contour and shadow are essential in creating form.

When a drawing or a painting is viewed, higher values (lighter lights) come forward while lower values (darker darks) recede. Perspective and how the viewer's eyes move throughout the work are controlled by the adjustment of values.

Choose a simple subject for your first drawings. Learn that the direction of the pencil strokes can contribute to depth, especially when considering the number of curved lines that are found in an aircraft. Ensure that your lines follow the curves you are establishing as form. Initially, start with an outline, knowing that you can create that outline with shading as you gain experience.

Pilot, aircraft builder and artist Paul Rendel approaches his aviation art as that of the story-teller. He believes that "a good painting starts with a vision of a moment in time and, supported by the truth, it seeks an emotional response."

He suggests, "Start with the shape. . . . Many artists want to start drawing details, hoping the completed work will end up as a masterpiece. The correct way is just the opposite. Start with the overall shape or silhouette of the subject. If your drawing is correct, it will be easier to place the details." He also recommends leaving the placement of some of the details to the viewer, taking an artistic approach rather than a photographic representation. He said, "Remember, the choices you make will distinguish you as an artist from others. The camera deals with what is; the creative artist deals with what it could be."

TONAL VALUES

Establish the tonal values for your drawing, noting the location of the darkest darks and the lightest lights. Build up tone with the point of the pencil as well as the flattened edge. Practice pencil strokes on a separate piece of paper until you have some experience with the weight of lines and ability to draw curves with confidence. An artwork should contain a full range of values, but a single form should be limited to as few values as possible. Use the darkest darks and the lightest lights for the

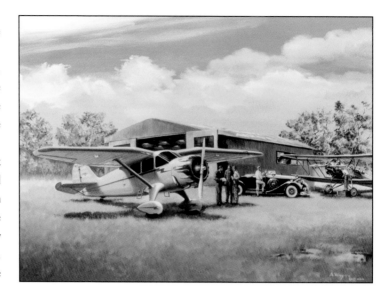

⬆ In a nostalgic return to an earlier era, the artist captured the Norwalk, Connecticut, Airport as it hosted aircraft of earlier times. A vintage Stinson Reliant was readied for flight and, to be able to reach the cylinders of the Travel Air biplane's engine, the mechanic climbed onto a crate.

⬇ Mike Novosel Sr., who piloted fixed-wing heavy bombers for the U.S. Air Force during World War II, was awarded the Medal of Honor as a rotary-wing pilot. During his second tour in Vietnam, Mike and his son flew "Dustoff" helicopter medical-evacuation missions and each saved the other in emergency combat evacuations. The senior Novosel, who died at age 83 in 2006, logged 2,038 hours of combat flight and flew 2,543 aerial missions that evacuated 5,589 wounded.

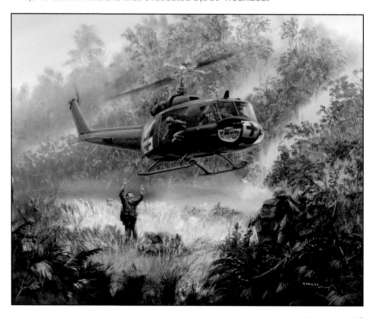

continued on page 49

Values applied to aircraft drawing

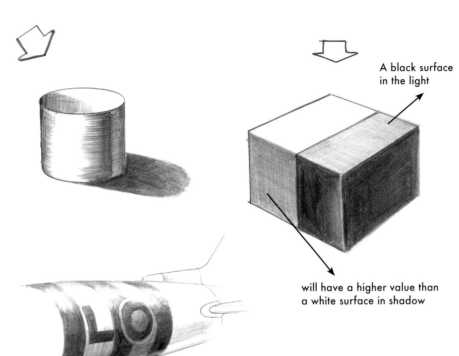

A black surface in the light

will have a higher value than a white surface in shadow

These drawings of DC-3 components offer additional examples of how values define the forms and contours of the lowest values or darkest darks and highest values or lightest lights. Such use of values will help move the viewer's eye to dominant features.

To illustrate the use of values in drawing aircraft, the cylinder and the block show the light source (large arrow) and the shadows. Note the change in values between the areas that are in shade and the areas that receive the direct light. The black surface in direct light has a higher value than a white surface in shadow. With the aircraft cockpit area and the markings, the dark upper cowl and the dark stripes have a higher value in direct light than the white aircraft side and white stripes when they are in shadow.

It is excellent practice to put light against dark and dark against light to illustrate form and contour. Note how a shape or surface can be shown without drawing the edge.

DC-3 nose and engines

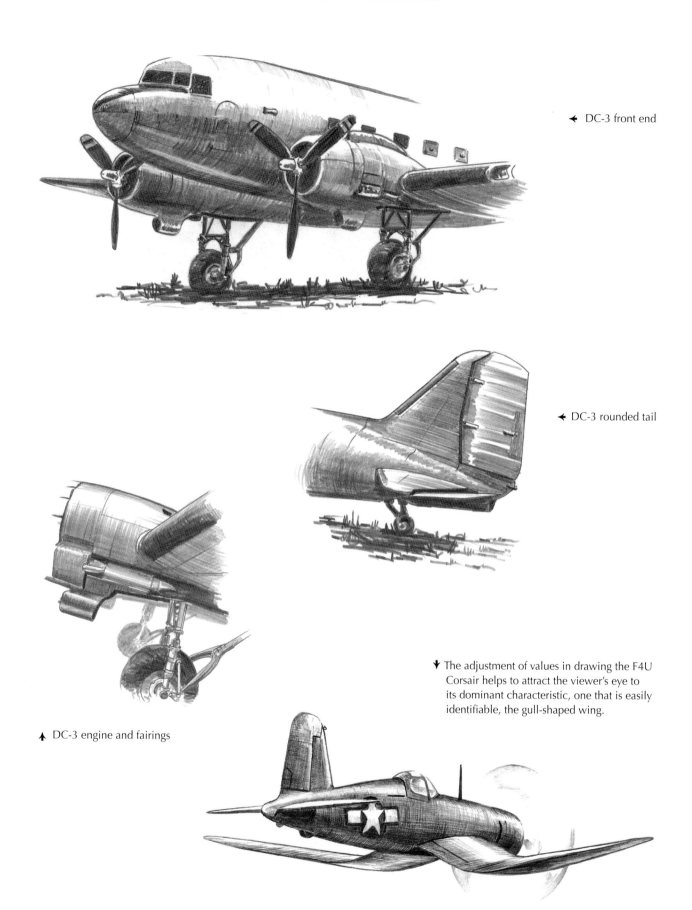

← DC-3 front end

← DC-3 rounded tail

↓ The adjustment of values in drawing the F4U Corsair helps to attract the viewer's eye to its dominant characteristic, one that is easily identifiable, the gull-shaped wing.

↑ DC-3 engine and fairings

◄ ↓ These highly detailed drawings of an A-4 Skyhawk illustrate the full range of values and their use in defining form, curvature, and depth. Note again how the eye is drawn to the darkest darks and the lightest lights.

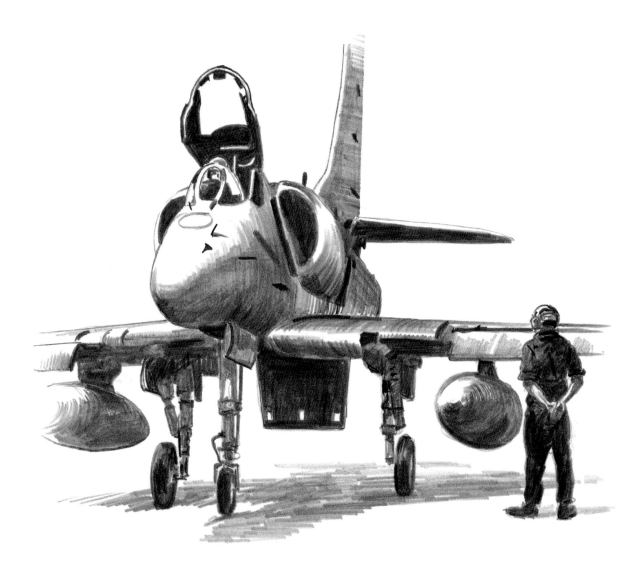

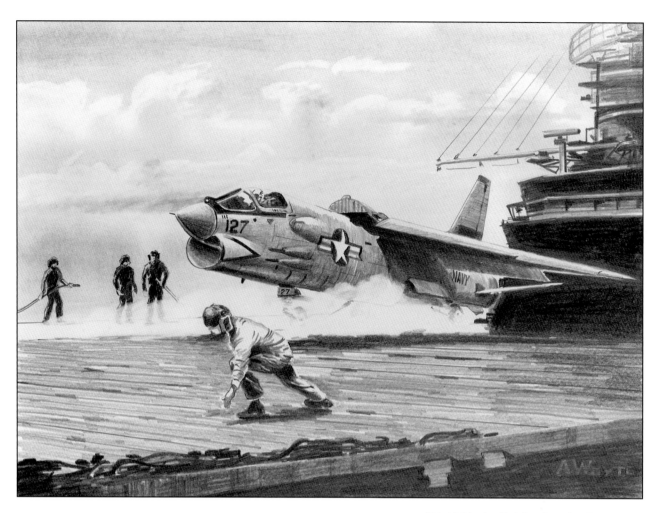

↑ This highly detailed drawing of an F8U Crusader is an excellent example of how deft lines, a full range of values, good shapes, positive and negative areas, and good perspective create black-and-white imagery as fine as paintings.

dominant features of the artwork and, in creating depth and atmosphere in aviation art, know that strong foreground darks contrasted with lighter distant darks will enhance desired spatial relationships. To make a shape recede in space, its value should be similar to the value of other items placed at the same distance. Keep the areas of light and shadow simple.

Hang onto your motivation and desire to draw. Keep your sketchpad handy and draw at every opportunity. The late Nixon Galloway, a highly esteemed aviation artist, rarely left home without his sketchbook. It became his personal diary. Nixon's detailed pencil drawings reflected both his artistic skills and his life's journey. You could do well to emulate his practice. As you train your eye to see, you will also be training your eye-to-hand coordination and developing your own style. Draw, draw, and draw.

continued from page 45

GETTING THE STORY STRAIGHT
Crosscheck the Facts

A s an artist, you aren't "self-made." Your work is based on the accumulation of the work of other artists throughout the centuries and what you have learned from what they have done.

—Andrew Whyte

USING THE SENSES

To draw, study art from centuries past to the present; peruse art books and museum collections for inspiration and information. To draw aircraft, visit the growing numbers of aviation museums and some of the hundreds of air shows and exhibitions to see a variety of aircraft for observation, sketching, and photography. Visit local airports to watch aircraft or, better yet, to fly. Take an introductory flight or take flight lessons, see flying from the ground and from the air. Investigate the Experimental Aircraft Association and become involved with a local chapter, learning about aviation from the builders of plan-built and kit-built aircraft. If military aircraft operate nearby, get a visitor's pass to find a location on the flight line from which to observe, to photograph, and to sketch.

The more you know and learn about aviation, the more authenticity you will bring to your aviation drawings. Visit an airfield early in the morning to see highlights reflecting the natural sunlight and study the shadows cast. Visit again late in the day to see the changes wrought by the evening light. Walk around parked aircraft to select the best angle from which to depict the craft and to see the unique shapes that make it interesting and identifiable. Notice the personnel, trucks, cars, mechanic's carts, gasoline cans, bicycles, flags, windsocks, control towers, and hangars that can add interest to your drawings. Try to see aircraft on display and in action—taxiing, taking off, overhead in the pattern, landing, being repaired, washed, hangared, and tied down.

For additional information, visit a bookstore and your local library to scour books and magazines for images and descriptions. Ask research librarians how best to use their services.

In today's high-tech world, even the newest computer users can obtain information never before so easily accessible. Via Google Earth or Flash Earth, you can download free three-dimensional programs that use satellite and aerial mapping and allow you to circle the globe and to zoom toward and away from virtually any location on the planet. The search for historic facts, specific aircraft, famous aviators, and aviation events has never been so rapidly achieved and richly presented. The modern Internet abounds in available information for the researcher and boasts many aviation-related websites. Some aircraft manufacturers host a range of explanatory topics and make available interior, exterior, airborne, and static imagery. As all serious researchers learn, facts should be checked and double-checked; all information should be cross-referenced for accuracy. Via the Internet, two websites in particular invite your attention: the American Society of Aviation Artists at www.asaa-avart.org, and an aviation art forum at www.ehangar.com.

When you tear yourself from the computer, you'll find valuable information at military archives such as those at Maxwell Air Force Base, Alabama; at NASA; at the National Museum of the U.S. Air Force; or the National Archives in Washington, D.C., and College Park, Maryland.

For the human factor that adds interest to your drawings, look into local groups and clubs. There are reenactors who put on military displays, complete with the uniforms, weapons, aircraft, and utensils. Retired military enlistees and officers may share their stories, their experiences, their scrapbooks, and their photographs. People who work at your local airport generally are eager to talk about aviation, a dynamic career field and exciting activity.

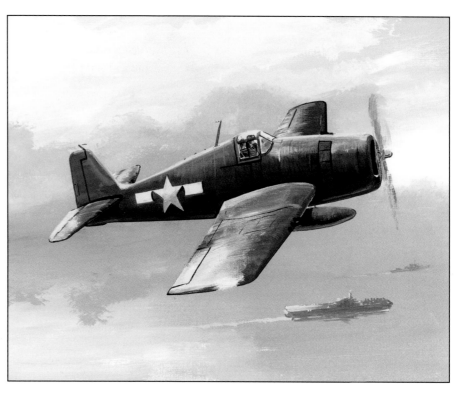

Beware of copying photographs, even those you've taken. Unless the drawing and the photograph are depicted from the same viewing point, distortion can result. Note the difference in the sizes of the wings in this F6FHellcat, a distortion that could have been avoided.

USING CAMERAS AND PHOTOGRAPHS

Be wary! Although using cameras and photographs has become second nature to the artist, there are some advantages and some pitfalls to this medium. Use photographs as reference material only. Know, too, that the eye that spends too much time behind the camera viewfinder is not being properly trained to see.

Some Dos and Don'ts:

Do try to take the photographs you use. That will enhance their use as reference and you will have the advantage of choosing the lighting, the distance, and the choice of lens.

Do recognize that your photo is most accurate when the eye level in the drawing corresponds to the position of the camera in the photo.

Do know that when using a photograph for reference, you should work out the perspective of the photographic image and its translation to the picture plane.

Do use a monopod for photographing airborne propeller-driven aircraft. This steadies your hand while using a telephoto lens and shooting at the slower shutter speeds that prevent "stopping" the propeller action—1/250th or

1/125th of a second. If you are using a digital camera, treat yourself to a single-lens reflex camera (SLR) that boasts optical image stabilization.

Do know that perspective is related to distance from the subject. Take photos in which the image in the viewfinder corresponds with the image you wish to depict in your drawing.

Don't copy photographs. This is especially true when you are not the person who took the photo. It is plagiarism to copy a photographer's shot.

Don't trace photographs. Distortions can creep into your drawings. It is better to learn to train the eye and the hand.

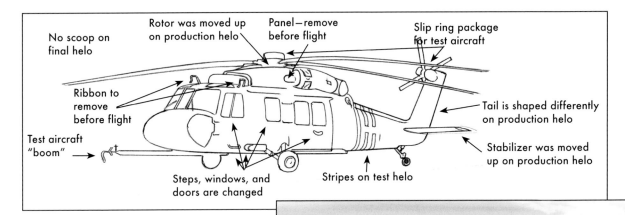

No scoop on final helo

Rotor was moved up on production helo

Panel—remove before flight

Slip ring package for test aircraft

Ribbon to remove before flight

Tail is shaped differently on production helo

Test aircraft "boom"

Stabilizer was moved up on production helo

Steps, windows, and doors are changed

Stripes on test helo

↟ This outline drawing of the UH-60 Black Hawk is labeled to show the major changes that were needed or made to the helicopter as it progressed from the prototype stage to the operational production model.

↦ Here's an example of using a photograph as reference for a drawing without checking the validity of the research. This UH-60 Black Hawk is the initial prototype, a one-of-a-kind aircraft that never was a production model.

Some Dos and Don'ts:

Do consider building model aircraft to enhance your knowledge and increase your enjoyment of aviation.

Do use model aircraft to help you with spatial relationships.

Do learn from radio-controlled model aircraft and from builders of those flying models.

Do use model aircraft to experiment with light and shadow, curved surfaces, and for inspiration and ideas.

Don't assume that model aircraft are completely accurate.

Don't forget the rigidity of airfoils and how they differ from the more flexible airfoils on actual aircraft.

Don't limit your research for a drawing to a model aircraft alone.

USING MODEL AIRCRAFT

Building model aircraft can be a good step toward understanding the form and parts of any aircraft and enhancing the awareness of how engineering challenges have been met. The act of creating a model from a kit can be satisfying and educational.

Using the model should be secondary to analyzing the real craft. Models can help reinforce some of the important structural components that are not shown in photographic reference material. Take a model aircraft outside during the particular time of day and particular weather conditions desired for the drawing; this can help show how shadows fall and how shadows and reflected light highlight the craft. Turn the model to various angles and attitudes to determine the craft's most interesting view or to see less appealing views and flight attitudes that might obscure some aircraft parts. Model aircraft can be decorative and helpful tools. Refer to them and build them for a greater appreciation of the real aircraft, but know their limitations.

ADDING HUMAN MODELS

Seek human models from numerous groups sporting uniforms, equipment, weaponry, and the accoutrements of the U.S. Civil War and the Revolutionary War, as well as reenactors who stage mock battles and historic scenes from World War I and World War II. Often, these people are knowledgeable of their historic periods and can help add

authenticity to a proposed drawing. World War I reenactors gather biennially at the National Museum of the United States Air Force (www.nationalmuseum.af.mil) in Dayton, Ohio, and, in addition to being well-equipped with uniforms and military paraphernalia, they boast more than twenty flying replica aircraft of the World War I era. In Rhinebeck, New York, the late Cole Palen amassed a group of flying aircraft that date to the World War I era, several of which are original (see http://www.oldrhinebeck.org). There, many of the performers dress in vintage outfits to entertain and educate visitors. The Collings Foundation (www.collingsfoundation.org) exhibits aircraft and enhances its exhibits with appropriately attired crewmembers. Its ambitious program is designed to preserve living aviation history.

Using models and reenactors gives the artist a chance to draw from life. To view the subtleties of the human figure in a variety of poses offers an artist a vast improvement over the use of photographs. If you must use photographs, be certain that you first have learned to draw the human figure and are using the photos for reference.

SKETCH, DRAW, AND PAINT OUTDOORS

Aviation artists choose subjects that might be lit by the floodlights of a museum setting or might be in the circle of overhead fluorescent lighting from the ceilings of hangars. Primarily, however, airborne aircraft should be seen in the natural light of the outdoors and in the sweeping distances that represent the atmosphere-bathed light in which they fly. Don't restrict your drawing and painting to the indoors. Take your tools outdoors and seek the light of day and the shadowy light of evening and night. Drawing in plein air generally is dated to the founding of the Cape Cod School by Charles Hawthorne in 1899 and a gathering not long thereafter of the Taos Society of Artists. According to www.pleinairamerica.com, today's leading landscape artists adhere to this art form, and painting in the sun's natural light is "once again at the forefront of American representational art." Go outside. Equip yourself with the necessary mosquito repellent, protective visor, sunscreen, and tools; set up an easel and/or a chair so you can see the aircraft you wish to draw and paint in a variety of conditions. You'll train your eye and add to your ability to look and really see.

➤ *The Crewman* is a fine example of a drawing from life of the human figure. It began as a study for another painting and now stands alone as a fine artwork. *Gil Cohen, ASAA*

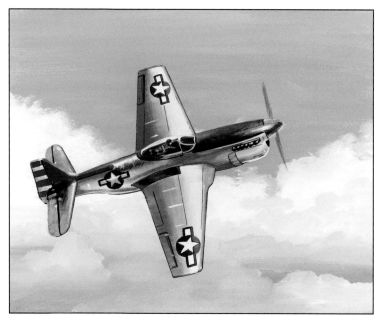

➤ It is vital to do your research carefully and completely. Although it may look familiar, this aircraft does not exist. Unless your purpose is to depict an imaginary aircraft, be sure that you represent your subject accurately. Aviation-art enthusiasts tend to be knowledgeable, precise, and technical.

Doing a Little Research
Gerald Asher

Asked by the Air Force Association in early 1997 to create a painting that would depict early jet aviation for its upcoming U.S. Air Force fiftieth anniversary calendar, Gerald Asher opted for a subject that actually predated the creation of the air force as a separate air arm—the 412th Fighter Group, March Field, California. During May 1946, under the codename *Project Comet*, twenty-nine Lockheed P-80A Shooting Star jet fighters under the command of Col. Bruce K. Holloway participated in a twelve-day, nine-city barnstorming tour of the United States. The highlight of the 412th Fighter Group's mission was a three-day appearance at Washington, D.C., where the unit performed before crowds estimated at one hundred thousand.

With a few photos already on file of the unit's aircraft for that period (some taken at Washington National Airport), Asher wanted to get a better conception of the entire mission. As with other research projects he had undertaken, he sank his teeth into this one and shook it like the proverbial junkyard dog. He examined the mission from every conceivable aspect: official military documents (Air Force Historical Research Agency at Maxwell Air Force Base, Alabama) gave the names of many of the mission's pilots. A number were tracked down through the American Fighter Aces Association (nearly all of the 412th pilots were combat veterans) and those contacted helped locate other surviving unit members. Respectfully, Asher made

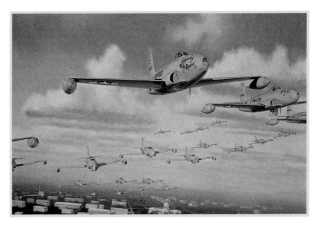

*A **Shooting Star** by Gerald Asher*

contact with the widows of deceased pilots, many of whom were happy to loan their photo collections.

Newspaper photos and articles at the stopover points for *Project Comet*, which he accessed through correspondence with local libraries and newspaper morgues, included more valuable information. Even blind phone calls to locate surviving local residents, in some cases, were fruitful beyond his expectations.

At the end of it all, Asher had more than enough information to accomplish his painting and was confident that he had a clear understanding of his subject. In his opinion, that's the most important aspect of a painting project—it's what keeps the work from being just another airplane picture.

The Human Factor
Gil Cohen

"Figures are what the art of most artists is all about," said Gil Cohen. "If you want to learn to draw the figure, you are going to have to draw the figure from life. Copying a photograph does not make it easier; it makes it more difficult. A photo is a flat image. It cannot possibly show the range of tones and colors that the human eye can see. More importantly, we see in three dimensions and the camera does *not* do that. Learn that the photo is *not* going to do it for you *unless you already know how to draw!*"

Cohen links aviation developments with humans. He said, "An aircraft wouldn't *fly* if it weren't for the persons who designed it, who built it, who maintained it, who took to the skies in it!"

In studying history, Cohen believes that it's as if ". . . we're reading the last page first. We *know* the outcome. Combatants who were fighting wars had no idea as to the outcome of their battles. I approach history as it was at the *moment*. I want

to show heartfelt emotions and have my viewers feel those emotional responses as well. I don't like to glamorize anything having to do with war. Men would have exhibited apprehension and uncertainty, some fear and some giddy elation. The machines would have been grimy, faded, and oil-streaked."

Cohen begins a painting with small pencil sketches. Emulating Stanislavsky, the film director who created method acting and held that an actor's main responsibility was to be believed, Cohen hires reenactors to wear World War II uniforms and model for him. Placing them in and around aircraft and preparing to take a myriad of photographs, he directs them with thoughts and actions that create responses and emotions.

"From among the poses that you achieve," said Cohen, "select those that contribute to the painting. Compositionally, it should not be monotonous. Every figure must contribute to the mood that is to be depicted."

At the National Museum of the United States Air Force in Ohio, he posed and directed models in the cramped front section of a B-17. To create the realities of a bomb run for the navigator and the bombardier, he emphasized to the models his need for them to express a gamut of emotions—a fatalistic determination, exhaustion, an anticipation laced with fear, and/or a proud sense of duty. He watched their bodies, the lift to the chin, or the dropping of the eyes. He gave them suggestions as to what they might be feeling as he photographed each pose and watched for specific emotions in gestures, in body stance, and in his models' eyes. Cohen's research resulted in the fine-art painting, *Mission Regensburg.*

Pencil sketch by Gil Cohen

Cohen wanted to portray the navigator and bombardier and to draw his viewer into the scene with the two crewmembers. He sketched bombardiers and navigators manning their positions and also machine guns—the least-qualified gunners manning machines in the most vulnerable place in that aircraft.

He researched the nose section of the B-17G, photographed the forward smaller window, the bombardier's chair, Norden bombsight, and machine guns. He obtained factory shots of the B-17 with the mechanical apparatus that he wanted and had help with details about the navigator by interviewing Harry Crosby, a World War II B-17 navigator who wrote the book, *A Wing and a Prayer*, and,

Acrylic underpainting by Gil Cohen

incidentally, is left-handed, as Cohen showed in his painting. He located a good navigator's computer, penlight, 50-caliber machine gun bullets, ammo, chute, goggles, and navigational map for authenticity.

When his composition began to jell, he made larger, more detailed drawings on tracing paper. His drawings are intended as preliminaries to a finished painting, but each is a unique work of art itself. After he started drawing on canvas, he said, "I wanted the viewer to be almost dazzled by the light coming through the windows, and left those areas that would be brightest in the picture. I was doing a symphony and couldn't settle for a string quartet."

Oil overpainting detail by Gil Cohen

In his award-winning painting *Mission Regensburg*, Gil Cohen portrayed the navigator and bombardier in their cramped front section of the B-17 and drew his viewer into the scene. He portrayed the bombardier and navigator in their forward positions and emphasized the challenge of their dual roles. They were the least-qualified gunners facing the manning of machine guns as well as manning their own positions and they were located in the most vulnerable place in that aircraft.

Mission Regensburg, **completed painting by Gil Cohen**

← *Old Rhinebeck Aerodrome—Caudron*: Old Rhinebeck Aerodrome in New York's picturesque and historic Hudson Valley provides aviation artists superb opportunities to view, sketch, photograph, and paint aircraft in plein air. Andrew Whyte took advantage of this chance to depict one rare bird in the collection, the World War I Caudron G.III. The Caudron performed as a trainer and an observation craft; it boasted a nimble climb rate and was powered by a LeRhone rotary engine.

PLAYING SLEUTH; UNCOVERING THE STORY

Libraries, museums, archives, military bases, universities, squadron historians, professional researchers, and aviation organizations are willing to help you with research. When you hear a great aviation story that inspires an image in your imagination, use research resources to verify that story and the facts.

As you contemplate your image, arm yourself with more information than you need, such time of day of the scene or event, weather conditions, specific type of aircraft, crewmembers aboard, clothing worn, and other pertinent facts. Conduct interviews, and search for specifics like the insignia on the aircraft and the color scheme of any tail markings. Know the story, know the moment in time when the story unfolded, and decide on the purpose for the drawing.

Then, simplify. Draw hasty sketches that underscore the important facts and keep the drawing uncluttered and specific. Become involved with the emotions of the moment and seek to involve and intrigue your viewer. Draw the image that you'd like to see; tell the story that you want told.

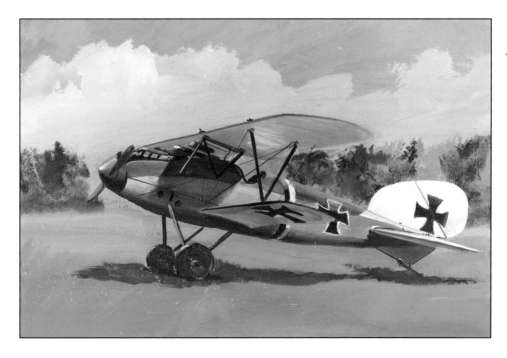

← *Old Rhinebeck Aerodrome—Albatros D.Va*: Some original and replica World War I aircraft models are the treasures of Old Rhinebeck and are flown and displayed seasonally. As inspiration to Andrew Whyte, the Albatros D.Va was flown by a number of noted German pilots, including the "Red Baron" and the "Black Knight." The reproduction aircraft was built for Old Rhinebeck and was powered with an original Mercedes 120-horsepower engine.

➤ *North American O-47B*: Aviation museums are a gold mine to aviation enthusiasts and artists. The National Museum of the USAF is among a growing number where you can research and carefully scrutinize a wide variety of aircraft. Andrew Whyte did preparatory work there for his painting of the O-47B, a ground-support and observation monoplane. Note his treatment of values, shadows, and reflected light.

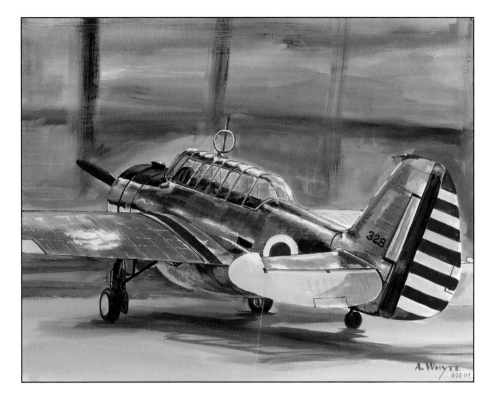

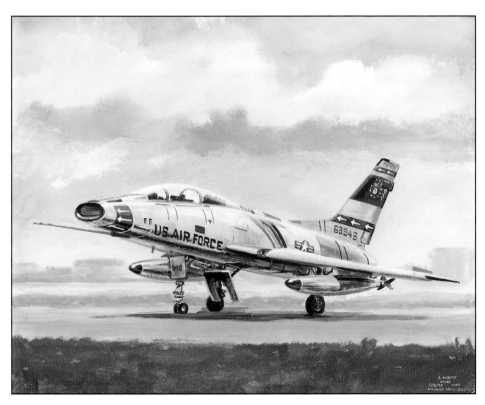

◄ *Dallas/Fort Worth, Private Field: F-100 Super Sabre*: As a basis for his painting, Andrew Whyte saw the F-100 Super Sabre at a private air field and proceeded to add a series of sketches and photographs to his visual examination of the aircraft. Super Sabres were the world's first operational supersonic fighters; the two-seat F-100F models were charged with surface-to-air-missile (SAM) suppression and forward air control (FAC). Whyte posed it on the tarmac as if ready for flight.

P erspective can be a way of trying to visualize an aircraft. It is easier to visualize a box or a cube, so take the basic aircraft and divide it into a set of boxes. This can be a first step toward proper perspective.

— Andrew Whyte

CREATING DEPTH WITH PERSPECTIVE
Portraying Aircraft in Three Dimensions

By developing linear proportionality in the first half of the fifteenth century, Italy's Filippo Brunelleschi spawned the art of mathematical perspective. In linear perspective, objects appear smaller as they recede in the distance. To this day, contemporary artists continue to be challenged with the reduction of physical space to mathematical principles and analysis, to terms of proportion and perspective. Perspective drawing is a method of convincingly representing the three-dimensional aspect of an object on a two-dimensional surface and is a matter of scientific determination. In a perspective drawing, an object is shown as it looks to the eye at the given point of view, but a deliberate process determines the exact angles, dimensions, and foreshortening of each part. A working knowledge of two-point perspective enhances accuracy. Practice drawing with proper perspective to draw aircraft with accurate form, correctly depicting distance, depth, and the proper appearance of shapes.

Aviation artists use a variety of methods to handle proper perspective. The methods range from "eyeballing" and drawing shapes that "look right" to using two- and three-point perspective, and further to a mathematical system—descriptive geometry, and to two systems developed by S. Joseph DeMarco that he labels Geometric Projector Method (GPM) and the Artists' Perspective Modeler (APM). (See his website at http://www.aviart.info.)

Proper perspective creates an accurate basis in form. Detail follows form. Perspective is the tool by which the artist portrays an aircraft that has height and width and looks on its flat surface the way it appears to the naked eye. Proper perspective helps to insure that a wing or a rotor or an arm or a leg is not too long or too short.

In perspective drawing, the picture drawn on a flat surface—the picture plane—is viewed from a particular point known as the station point (SP), according to the Encarta Desk Encyclopedia. Proper perspective features a horizon—the eye level—which can be below or above the aircraft you are depicting, and which is, as the name implies, the horizontal line that divides the scene in the distance. Vanishing points (VP) represent the spot on the horizon line at which parallel lines of the scene appear to converge.

SINGLE-POINT PERSPECTIVE
In one-point perspective, one side of the object is parallel to the picture plane, and two dimensions, height and width, are shown. Drawing a one-point perspective is good practice to develop your eye and your technique.

Picture plane

Vanishing point

▲ A drawing in one-point perspective shows one side of the object parallel to the picture plane and two dimensions of the object—height and width.

▲ The vanishing point is on the horizon (eye level), as shown by the dashed line, and all parallel lines of perspective converge at that point.

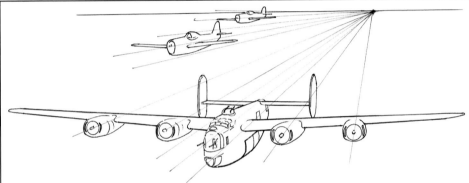

◄ ▼ A Consolidated B-24 Liberator, escorted by fighters, flies toward the viewer from the right. To properly place the B-24 into perspective, lines carefully drawn show convergence on the horizon.

TWO-POINT PERSPECTIVE

Two-point perspective adds a second and different point on the horizon at which parallel lines converge. It gives a view of two sides and three dimensions of the object, adding depth to the height and the width.

THREE-POINT PERSPECTIVE

Three-point perspective is necessary when the picture plane is *not* parallel to any of the three dimensions of the object. Three-point perspective allows a viewer to look *down* upon the object, with the third vanishing point converging *below* the picture plane, or to look *upward* toward the subject, with the vanishing point converging *above* the picture plane.

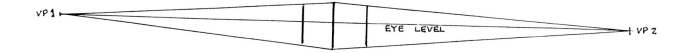

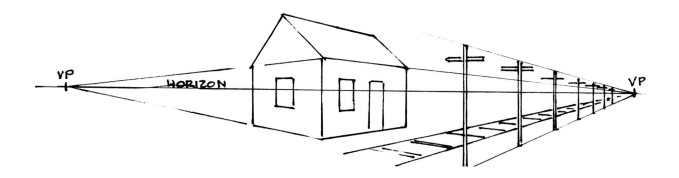

↟ In two-point perspective, two sides of the object and three dimensions of the object—height, width, and depth—are visible. There are two vanishing points on the horizon.

Linear perspective depends upon the lines of the drawing to create the illusion of three dimensions and to give objects the proper size and shape. Practice drawing squares, then giving dimensions to the squares to form cubes or boxes.

As one method for visualizing an airplane, divide the basic craft into boxes. The set of boxes offers perspective, drawing the centerline of the airplane like a flat section divided with cross-sectional cuts. Put sections of the airplane into different cubes. The first cube will hold the

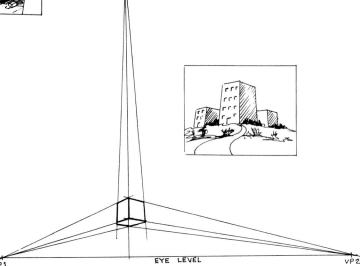

↟ ➤ In three-point perspective, the horizon or eye level is either above or below the object being drawn. Three vanishing points are established and the picture plane is tilted. Small sketches of the buildings help to visualize three-point perspective.

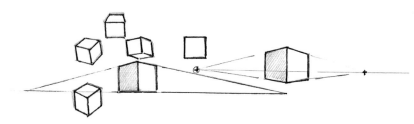

← Visualizing and drawing objects of different geometric shapes within a cube, or box, will help establish proper perspective.

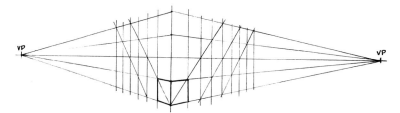

spinner and the propeller, the second will hold the nose and part of the cockpit, the third will contain the cockpit and the turtle deck, and so on. Draw the portion of each circular shape that is not visible from the selected view. That is important to arrive at a three-dimensional figure.

Basic sizes, shapes, and surface forms are essential. Prove the drawing by establishing the vanishing points and be certain that the two horizontal vanishing points are relative to a single horizon, the eye level. Measurement and proportion are important, as is training the eye to recognize both elements.

↑ In order to depict the height, width, and depth of an object in proper perspective, it is helpful to construct a grid of multiple cubes and divide those cubes in half with diagonal lines.

continued on page 65

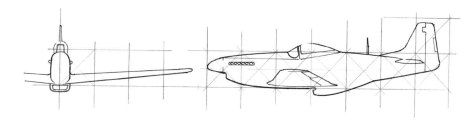

↑ → The artist can establish the correct size and shape for each of the aircraft's segments by drawing a P-51 Mustang on the picture plane (PP) and within cubes of equal size. The aircraft can then be turned and put in perspective maintaining each segment's proper size. Note: As the Mustang is turned to show all three of its dimensions, the segments will decrease in size as they move in the direction of the vanishing points (VPs).

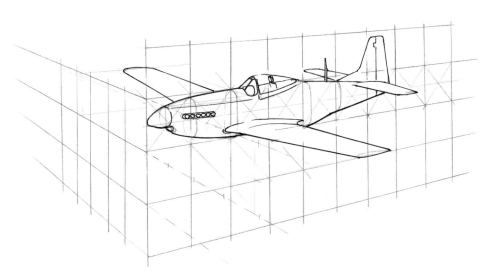

Descriptive Geometry

Keith Ferris, ASAA Founder

At the invitation of U.S. Navy Training Squadron VT-26, based at NAS (Naval Air Station) Chase Field, Beeville, Texas, Keith Ferris departed on a Rockwell T-2C Buckeye mission en route to the training carrier CVT-16 Lexington, 14 July 1982. Flying with the VT-26 Skipper, the mission was to escort a group of solo T-2C students from NAS Chase to the *Lady Lex* (USS *Lexington)* for their "first trap" (their first arrested landing) and catapult take-off for carrier qualifications. Although Ferris had experienced many, many landings in air force jet trainers and fighters, he said, "This was a totally new experience."

The carrier-landing pattern was precise and Ferris timed it at exactly sixty seconds from the beginning of the turn to base opposite the landing signal officer (LSO) and on final to touch down. He said, "The aircraft ahead was to catch the number-three wire only forty-five seconds ahead of us. I had the overwhelming feeling of being way too high and way too close to the ship to ever get our Buckeye safely onto that tiny deck."

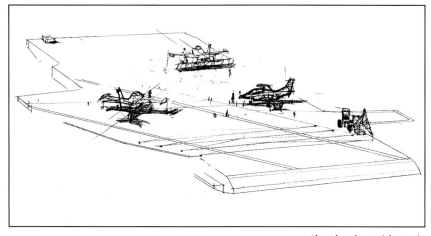

Sketches by *Keith Ferris*

As their aircraft followed the ball down final approach, the other T-2 was still in the way. Yet, the deck cleared and Ferris' T-2 caught the number-three wire at exactly sixty seconds. He said, "That made a lasting impression! I determined that my painting would convey precisely how ship and aircraft would look at approximately half-way through that evolution."

The initial pen-and-marker drawing, made from memory, shows Ferris' basic composition for the painting *First Trap*. The next step was to examine the spatial relationships and timing of the landing pattern. He diagrammed to scale the moving aircraft and ship at their speeds in feet per second. The painting was to depict the twenty-eight-second point in the pattern.

Measurements indicated that the ship moved 1,408 feet from the position seen in the painting thirty-two seconds prior to trap. Deciding to make a painting twenty-eight inches high by fifty-six inches wide, Ferris determined that the preferred viewing position for the painting would be approximately six feet. He explained, "Knowing the size of the T-2 planned in the drawing, the visual angle from the eye to extremities was set. This same angle, superimposed on the top view of a three-view drawing, located the top view of the viewer's position relative to the top view of the T-2. This turned out to be 110 feet aft, 34.5 feet right of center line (CL), and 23.5 feet above the horizontal reference plane. The height of the viewing position was selected to show the solo student and enough of the rear seat to emphasize the solo flight and to show that seat empty."

This is the artist's perspective projection by descriptive geometry. Well above the aircraft is a line that is horizon/line of flight. Because the T-2 is flying at fifteen units angle of attack (AOA), the horizon drops to eye level through the pilot's head. Ferris showed bank angles of 15, 18, 21, and 25 degrees with the horizons for each bank angle on the drawing. He chose the 18-degree bank angle for the finished painting.

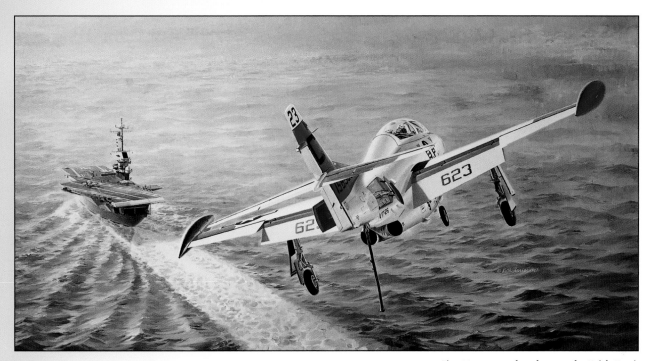

First Trap, **completed artwork. *Keith Ferris***

He said, "Keeping the viewing position constant, the next move was to plot the *Lexington* from the same viewing position as that selected for the aircraft. The distance from the ship at the twenty-eight-second point was determined from the carrier landing evolution diagram."

This view of *Lexington* is seen from a position 425 feet above sea level, 3,300 feet aft of the LSO, and 500 feet left of the center-line of wake. Ferris said, "Note the telescoped effect, much like that seen with a telephoto lens."

It remained for the artist to combine all of this in small scale and to project it onto the gessoed canvas to complete the drawing. Below is shown a copy of the small tracing paper drawings of T-2s on the deck. These are drawings by analysis.

Ferris showed the four pendants, or wires, across the deck. His drawings were traced into position onto the canvas and refined with all the other details of the ship and primary T-2C aircraft. He had to analyze the lighting, establish the background, and begin the actual oil painting. For detailed reference, he projected, above his easel, the many slides that he had taken of the aircraft, ship, water, and wake during his time aboard the vessel with VT-26.

Training his critical eye has been highly successful to Keith Ferris. In calling on his sense of the geometry of flight, he has pictured a sweeping, descending arc from entry into the traffic pattern to touchdown. He said, "Flying is a beautiful aerial ballet and the geometry is something that can be totally visualized."

Keith Ferris paints with a limited palette—the three primary colors plus white. He learned early in his career to avoid copying any photographs. He creates all of his own drawings by freehand, construction by analysis, or perspective projection by descriptive geometry. He maintains an exhaustive research library that includes flight handbooks, maintenance and tech manuals, his own collection of approximately fifty thousand cross-indexed slides, insignia of squadrons that he has flown with in the past thirty-five years, and innumerable books, magazines, and photographs. When Ferris begins to create a new painting, he selects his subject, creates thumbnails for a composition that pleases him, searches his files for material on the subject aircraft, and pulls together the material in quick oil color studies. In his painstaking way, he determines the average viewing position and sets the visual angle from the viewer to the painting.

The description of his creation of *First Trap* is not unique. Ferris, who has been called "the Precise Painter," uses the same careful research, analysis, planning, and painterly construction in all of his paintings.

➤ To draw a house in perspective, first draw a horizontal line to represent the picture plane (PP). Make certain that the closest corner of the house touches the picture plane. Select a station point (SP), an arbitrary point from which the house is to be viewed. Draw lines from the station point to the picture plane that are parallel to the sides of the house and are at 90 degrees to one another. These points of intersection on the picture plane will be used to define the vanishing points (VP) by dropping a vertical line from each to the horizon line (HL).

From the corners of the house, draw straight lines that converge at the station point. When each of these lines reaches the picture plane, drop a vertical line (shown by the dotted lines) down to the horizon line. With this technique, a flat image can be put into perspective and viewed as it would look to the naked eye.

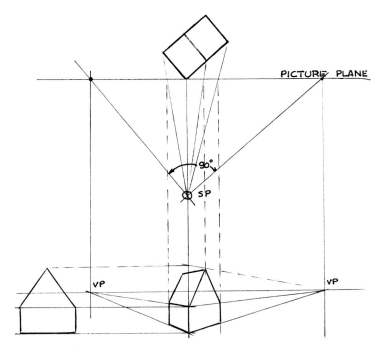

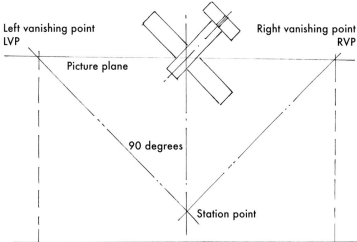

➤ This initial perspective drawing demonstrates the first step in determining the right and left vanishing points (RVP and LVP). From the chosen station point (SP), the view selected by the artist, lines drawn parallel to the centerline of the fuselage and the centerline of the wingspan extend to the picture plane (PP) and are at a 90-degree angle at the station point. At the intersection of those lines on the picture plane, vertical lines are then carried to the horizon where the right and left vanishing points will be located.

➤ This drawing adds a horizon line (eye-level) and additional station points (SPs). To establish vanishing points (VPs), vertical lines are carried from the picture plane (PP) to the horizon line. Note that the vanishing points are the same when the station points are equidistant from the center of the aircraft. Central to this diagram is a 30-degree viewing angle that encompasses the entire aircraft.

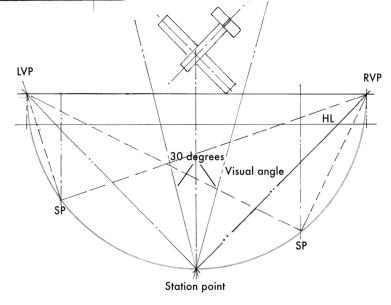

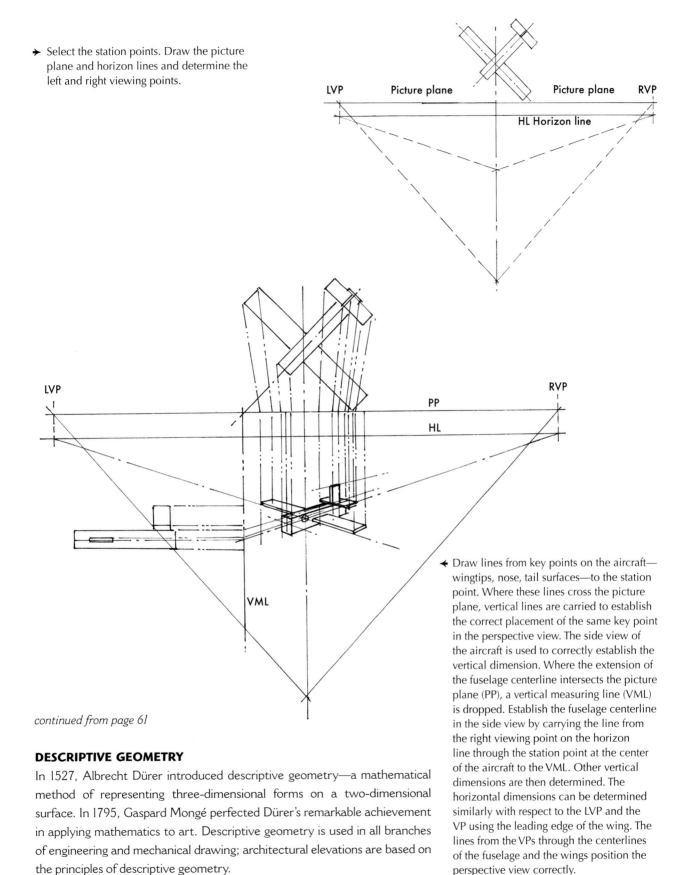

➤ Select the station points. Draw the picture plane and horizon lines and determine the left and right viewing points.

LVP Picture plane Picture plane RVP

HL Horizon line

LVP RVP

PP

HL

VML

➤ Draw lines from key points on the aircraft—wingtips, nose, tail surfaces—to the station point. Where these lines cross the picture plane, vertical lines are carried to establish the correct placement of the same key point in the perspective view. The side view of the aircraft is used to correctly establish the vertical dimension. Where the extension of the fuselage centerline intersects the picture plane (PP), a vertical measuring line (VML) is dropped. Establish the fuselage centerline in the side view by carrying the line from the right viewing point on the horizon line through the station point at the center of the aircraft to the VML. Other vertical dimensions are then determined. The horizontal dimensions can be determined similarly with respect to the LVP and the VP using the leading edge of the wing. The lines from the VPs through the centerlines of the fuselage and the wings position the perspective view correctly.

continued from page 61

DESCRIPTIVE GEOMETRY

In 1527, Albrecht Dürer introduced descriptive geometry—a mathematical method of representing three-dimensional forms on a two-dimensional surface. In 1795, Gaspard Mongé perfected Dürer's remarkable achievement in applying mathematics to art. Descriptive geometry is used in all branches of engineering and mechanical drawing; architectural elevations are based on the principles of descriptive geometry.

➤ Helicopter pioneer Igor Sikorsky said, "If a man is in need of rescue [in rough seas], an airplane can come in and throw flowers on him and that's about all. But, a direct lift aircraft could come in and save his life." His prophetic words rang true on 29 November 1945 during a wild nor'easter. Sikorsky test pilot Jimmy Viner, assisted by Capt. Jack Beighle of the U.S. Army Air Force, piloted an R-5 to an oil barge in danger of sinking in the Long Island Sound. In the first use of a hoist suspended from a chopper and as a harbinger of many dramatic rescues that lay ahead, they brought crewmembers from the barge to safety ashore.

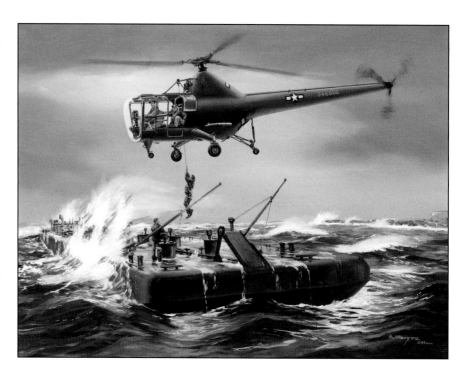

✦ In depicting the Martin B-26 Marauder piloted by the late James V. Roy during World War II, the scene pays homage to the man and to the machine. A longtime benefactor of the American Society of Aviation Artists, Roy regarded the B-26 with justifiable pride. The Marauder had the lowest loss rate, less than one-half of one percent, of any Allied bomber. All of the free nations flew the aircraft to a total of over one hundred thousand sorties.

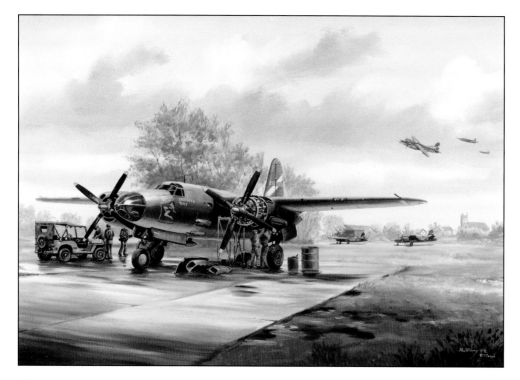

In describing his Artists' Perspective Modeler (APM), Joe DeMarco wrote in *Aero Brush*, Journal of the American Society of Aviation Artists, Vol. 20, No. 4, "The first step, after making a few rough sketches to establish a general viewing aspect. . . Lay a 30-degree triangle over the layout and move it about to bracket [your] aircraft in a suitably inclusive viewing aspect. Make a dot at the apex of the triangle to mark the Eye Position (EP) for a 30-degree Cone of Vision (CoV). Draw a Line of Sight (LOS) that bisects the angle."

He continued by introducing a picture plane (PP) and a center of vision (CV) at the intersection of the PP and the LOS. He added, " 'Everybody' has a formula for determining cone of vision, frame size, window, painting width to viewing distance ratio, etc., etc. My usual rule of thumb ('everybody' knows there are exceptions to rules) . . . is: 1) Images at, or within a 30-degree Cone of Vision are within the comfort range of human vision; 2) 'perspective' begins to become exaggerated (if it's distorted [it] can't be perspective) outside of an approximately 40-degree CoV."

The late Nixon Galloway, a past president of both the Los Angeles Society of Illustrators and the American Society of Aviation Artists, said, "I usually use two-point perspective (using two vanishing points placed on the horizon line). I find that three-point perspective is rarely necessary unless you have buildings or vertical objects below your aircraft."

Some added vertical lines along the centerline of the fuselage are handy for reference points for the vertical lines on the airplane such as an antenna, the vertical stabilizer, or winglets, he said. Know that some of these may or may not be completely vertical in regard to the fuselage, he added.

"A use of aerial perspective is essential. That refers to the graying and loss of distinction with distance that is a function of atmosphere; it is one method of conveying depth in aviation and aerospace art, which involves such vast distances," Galloway said.

All aircraft have rounded forms. In describing how to draw circles and ellipses, Galloway explained, "I use ellipse guides that you can get in art-supply stores. They come in 5-degree increments and varying sizes. A 90-degree ellipse would be a circle. An 80-degree ellipse is slightly oval, and through increments, ellipses become narrower ovals—a 10-degree ellipse is very slim and a zero-degree ellipse would be a straight line. As I arrive at the proper ellipse to use, I often note that on the drawing, for future reference."

CIRCLE AND ELLIPSE

A circle is a figure bounded by a single curved line, every point of which is equidistant from the center. An ellipse is a circle at any angle except when viewed at 90 degrees; in other words, an ellipse is a circle drawn to

↓ Drawing aircraft well requires the ability to draw circular and elliptical figures, flat and rounded surfaces; for example, wheels and tires, engine cowling, jet intakes and exhausts, propeller arcs, canopies, insignia, and airline markings. Use familiar geometric shapes to aid in placing a circle in perspective.

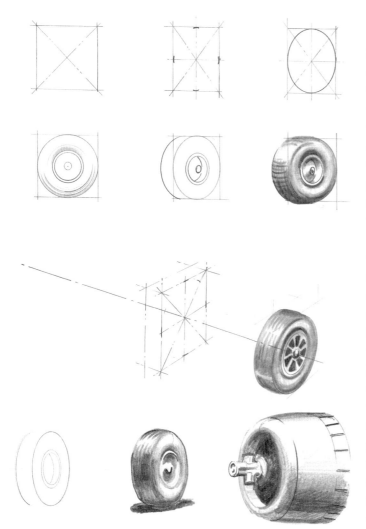

Draw a circle within the confines of a cube or box, which is easier to envision, easier to depict, and easier to put into proper perspective. Cross the center with two diagonal lines. Cross the center again with, first, a vertical line and, secondly, a horizontal line through the intersection of the diagonals. Take lines out to a vanishing point to be sure the horizontal through the center is correct. The angle of the axis gives the shape to the ellipse. Remember, the major axis of an ellipse is never vertical unless the center of the circle is on the horizon or eye level.

The renowned British artist Charles Thompson wrote, "Draw a circle onto a flat card and then cut it out. Draw a straight line across the diameter of the card and through the center of the circle. This line represents the major axis. Draw a second straight line across the diameter of the card at a right angle to the major axis. This line represents the lateral axis. Make a small hole in the center and insert a skewer or long cocktail stick, pushing it through for half of the length of the stick. This stick, which appears as an axle of a wheel, represents the minor axis. . . . To perceive a perfect circle, look directly down the line of the minor axis or axle. . . . Place a finger at each end of the major axis and begin to tilt the plane of the card, pivoting about these two points. The circle will be immediately perceived as an ellipse. . . . The minor axis (axle) is always drawn at right angles to the major axis."

Note the square seen at eye level with diagonals intersecting to determine the center. The figure would be a circle only if seen directly in this square. Any other view would result in that circle becoming an ellipse. Draw your circle within a box. Having determined the perspective of the box, you can center the minor axis. Understanding the several axes involved also helps. The major axis is the diameter of a circle and is at a right angle to the lateral axis on the face of the flat circular form. Thinking of the minor axis as the axle of a tire, remember that the minor axis always pierces the center of a circle at a right angle to the major axis. While the length of the major axis remains constant, the lateral axis will vary in length as the circle becomes elliptical in shape. The curved surfaces of the aircraft—fuselage, engine cowling, insignia, and propeller arc—can be put into proper perspective using these techniques.

In drawing a wheel and a tire, first draw a cube into which the circular form fits. Turn that cube, drawing it at the angle that is in proper perspective for the rest of the aircraft. Use the diagonals to find the center point and then draw the portion of the wheel that cannot be seen. That is, draw an ellipse for the top and for the bottom, later eliminating the line that is "behind" the object and out of the viewer's sight.

It generally takes several ellipses in drawing aircraft to create curved shapes, i.e., the fuselage. Begin by drawing a rectangular form into which the curved form is fit. The center of the rectangular form is as important as was the center of the square. Divide the surfaces with the cross diagonals to establish the center. Prove the drawing by taking lines of the form toward the vanishing points.

COMPOUND FORMS

Most objects are compound forms, that is, the combination of different cubes, rectangles, and ellipses. For compound forms, keep the vanishing points farther apart for more pleasing compositions. Always consider the

station point, vanishing points, and horizon or eye level. All verticals are truly vertical except when a special effect is desired and a third vanishing point is required. This will be necessary in all flying scenes. Remember, compound forms are not complex; they are just multiples of the square and rectangle with which you have been working.

FORESHORTENING

When drawing and painting aircraft, miscellaneous equipment, or adding shapes as well as the human figure, use perspective to keep all objects relative to one another. Place your human figure in the simpler-shaped rectangular cube or box. Whether the object is an aircraft wing or of a human limb, there is a necessity to foreshorten a form when it is aimed at, coming toward, or receding from the viewer. A human leg or arm is a free form, a form composed of several pliable curves. Think of the figure as a cube, a cylinder, a sphere, or a cone, and keep the perspective in mind. In drawing the figure and most small objects, if the station point is too close to the object, distortion will result. Every form has depth. Every form has perspective.

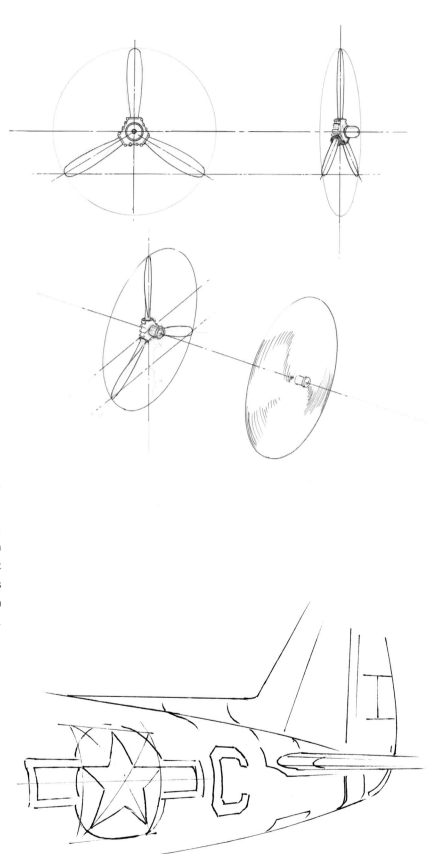

I f a square is painted black and white and illuminated with an obvious light source, the white section in the shadow will be a lower (darker) value than the black section with the light on it. I try to keep this in mind.

— *Andrew Whyte*

A light source, reflected light, shadow, and values are basic to drawing and painting. A value is created *because* of light, and the angle at which light strikes a surface determines the relative degree of lightness or shadow to the form. The more direct the light source, the lower or whiter the value; that is, a surface that is 90 degrees to the light source receives more light than a surface that is at a 45-degree angle.

THREE DIMENSIONS VIA LIGHT AND SHADOW
Know the Light Source, Keep it Consistent

VALUES

Remember that values, that is, the lightness or the darkness of the objects that compose a drawing or a painting, determine the relationships between compositional elements (See chapter 12). Everything in art is relative. An object painted in one particular value can look light or dark depending upon its surroundings. It may be easier to think of values in shades of gray—if you mix a small bit of black with a lot of white, the result will be a very high value. The greater the amount of black, the lower the value. Values play an important part in composition and design. Values set a mood.

| 1 | 2 | 3 | 4 | 5 | 6 | 7 | 8 | 9 | 10 |

➜ Revisit the value scale of ten values ranging from the darkest dark—black—at a value of one to the lightest light—white—at a value of ten. Values set a mood and play an important role in composition and design.

The way we see is dependent upon the amount of light on a subject. Highlights will be brighter and shadows darker on clear sunny days. The effects of atmospheric distance and reduced light will bring values closer together, thus highlights will be reduced and shadows will be lighter. There are a number of factors in creating the illusion of depth in a painting: perspective, overlapping of objects, using hard and soft edges, reducing detail, and changing value and intensity of color. When light values dominate, as in a high key drawing, the contrast between highlights and shadows help to define the shape of the aircraft more clearly.

➜ An object drawn in a particular value is seen relative to its surroundings; that is, it can appear lighter or darker according to those surroundings. The gray square in the center of the larger squares is the same value in all three. It appears darker when surrounded by a lighter value and lighter when surrounded by a darker one.

LIGHT SOURCE AND REFLECTED LIGHT

To draw objects on the surface of the earth, choose the natural light source and establish the natural horizon. Then, depict the source of the light—above, behind, beside, or in front of the object. In drawing aircraft, the third dimension of height complicates that compositional challenge. The aircraft's location and its angle of attack and attitude relative to the horizon might place the natural light *beneath* the craft. Aircraft, with their various shapes, cast interesting shadows that tend to be fluid. The cast shadow will be as aerodynamically sleek as are the parts of the aircraft. Depending upon the materials composing the aircraft and/or a painted or highly reflective surface, there is reflected light to take into consideration. Remember once you have selected the source of the natural light to remain consistent with that natural light source throughout the scene. It can be complicated by the addition of man-made light, such as searchlights, floodlights, the lights of other aircraft, hangar lights, and so forth.

↑ The limited range of values has an effect of reduced light and atmospheric distance in the night scene of the F-86 Sabre.

DIRECT LIGHT AND CHIAROSCURO

Chiaroscuro (key-ah-ro-SKEW-ro), the use of light and shadow in drawing or painting, is necessary to create the illusion of depth, form, and distance and to provide dramatic effects. An artist uses chiaroscuro, which hinges on the selection of the light source and the intensity and angle of that light, to create subtle gradations in value and distinct variations of light and shade.

Direct lighting—from the sun, the moon, a flash of lightning, or from a man-made light source—outlines and shapes an object and gives it form. To create a three-dimensional shape of an object on your paper or canvas, select that light source. By temporarily sketching a series of geometric figures, note the places on the shapes that would take the direct light and reflect a highlight, the pinpoint of the direct light source. Note the portions that are bathed in more subdued light and determine the side of each object that is in shadow, identifying a core shadow that is the center of the darkened side. Notice that on that darkened side some light is reflected from another area or from a secondary light source. This lighter area on the dark side is essential in creating the three-dimensional form on your paper or canvas. The object itself casts a shadow and that cast shadow is essential in creating space for the image.

Doris McCarthy, a Canadian landscapist in her nineties, was quoted in *Aerial Views,* the newsletter of the Canadian Aviation Artists Association. She

↓ Our ability to see an object clearly is dependent upon the amount of light on that object. In bright light, there is a greater range of values.

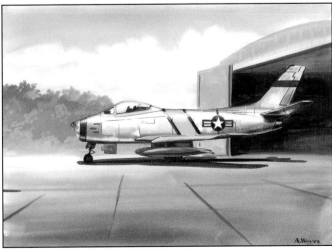

The way we see is dependent upon the amount of light on a subject.

advised, "Aspiring artists should paint, and paint out-of-doors. Paint indoors, too; but, if you are painting indoors, don't copy pictures; set up a still-life group. Work from the real thing because that's how you learn the effect of light and shadow."

Lighting can:
- Define unique features of a particular aircraft.
- Set a mood.
- Establish the time of day, perhaps the low light of twilight or high intensity of midday.
- Cast long, intriguing shadows, create interesting shapes, and create drama.
- Emphasize a scene's areas of interest and effectively lead the viewer's eye throughout the drawing.
- Bring a drawing into balance with either several gradual value changes or with a few sharply contrasting values.
- Create interest with a subtlety that emphasizes a particular form even when that form is in a darkened portion of the drawing.

REFLECTED LIGHT

Light is absorbed, scattered, or reflected as it passes through the atmosphere. Reflected light, a secondary light source, is useful to an artist in creating the remainder of a form. Reflected light helps to define the back shape of an object, the area in shadow. It is important to remember that lighting outdoors always has a reflected light source.

One more consideration is the shape of reflections on rounded surfaces, because many aircraft surfaces are not only curved, but also highly reflective. The more highly curved the surface, the more curved an object's reflection will become. A reflection is being shown from the artist's or viewer's standpoint. Note that the intensity is diminished in a reflection, as is rigidity of a form.

Be consistent once you have decided on the time of day and the primary light source for your drawing. The artist may determine the angle of the natural light, but a composition fails quickly when light and shadow seem to come from different locations in one scene.

↟ Three geometric shapes show the use of direct light and shadows to create three dimensions on a flat surface. Note that the objects themselves and the cast shadows exhibit a range of values.

INDIRECT LIGHT AND SHADOW

Because what you are drawing is light, the darker portions of your scene are indirectly lit and take on lower values. Second and even third light sources are caused by reflection and other light sources present in the environment. In the absence of light, the transition to darker values is sudden. A shadow is solidly black when there is *no* light. In

Glacier Flying—OS2U Kingfisher: **The OS2U Kingfisher was used extensively in the Alaskan theater during World War II, principally for observation and scouting.** *Sharon Rajnus*

Depicting Depth, Form, and Distance

Sharon Rajnus

Sharon Rajnus was an artist before becoming a pilot in the 1970s. When her certificate was still relatively new; she joined her husband, Don, for an invaluable hands-on learning experience. They worked with an airframe and powerplant mechanic (A&P) to rebuild a 1948 Stinson 108-2. When that taildragger had been completed and certified, they flew to Alaska to amass a lifetime of experience in one adventurous summer. Rajnus said, "We witnessed gorgeous country and breathtaking skies—sunrises and sunsets, clouds, rain, and brilliant sunshine."

The aerial odyssey carried Sharon and Don over the rugged land in which most of the United States' seventy-five thousand square kilometers of glaciers are located. Sharon Rajnus couldn't help but be inspired by these immense rivers of ice. She witnessed the incredible calving that transformed a huge segment of ice into an iceberg in a thunderous cracking, splashing birth. As glacial ice absorbs all other colors and reflects the sky and water that surrounds it, she saw dramatic blues—from cobalt to ultramarine

to azure—and values that were the darkest dark in the deep cavities and lightest light where the ice was spotlighted by the sun—the light and shadow that glaciers seemed to embody.

"Aircraft are out of their element on the ground," said Rajnus. "In paintings, I choose to show the *sense* of flight, the *feel* of the air."

Inspired to create a series of glacier paintings, she included the colors of snow that has been compressed into ice that has carved, wedged, plucked, and abraded its way to valleys, cirques, and the sea. She emphasized the blues that are reflected by that ice and the variety of light and shadow that plays across the landscape and creates depth, form, and distance in painting.

If you select backgrounds of natural beauty like glaciers, mountains, seashores, or sculpted desert sandstone, try to visit such environments to *know* your subject. Know what you paint.

← In a "high key" painting, limited to the higher values of the colors, an F4U Corsair is bathed in bright sunlight and tends to look washed out.

↓ By contrast, a "low key" painting utilizes lower values and the darker tones throughout suggest a night scene.

↓ The Corsair painted with a full range of values—from the darkest dark to the lightest light—results in added depth. Note the dark shadow beneath the airplane that contrasts with the higher values of the trees receding into the distance.

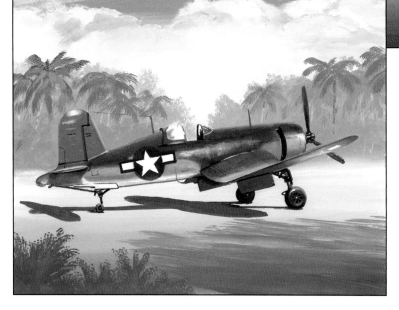

Shadows can:

- Accentuate the light and create a heightened interest in areas of light.
- Offer a balance to a composition.
- Provide the negative space to balance areas of positive space.
- Give a space in a composition for items of relatively less interest, which more fully describe and complete the scene.
- Create more intensity in the light by contrast.
- Be used to create velocity and motion.
- Be contrived rather than natural for emphasis.

a drawing or painting, there must be some source of illumination. Even the most shadowed portion of a form must have enough ambient light to make that form visible or completed in the eye of the viewer.

Shadows differ depending upon the light source. Light rays from artificial sources—flashlight, headlight, overhead light, or spotlight—radiate in all directions. The sun's rays also radiate, but come from so much farther away that they tend to act in parallel lines rather than spreading like a fan from a single source.

Cast shadows, like positive forms, have a separate system of values. The darkest dark will be found in the portion of the cast shadow that is closest to the object casting the

shadow. The lightest light will be at the edge of the shadow.

Shadows have perspective. If the light source is directly above an object, the cast shadows go in every direction. When the light source is the sun or the moon, the vanishing point for the perspective of the shadow is on the horizon directly below the light source.

Backlighting, although it mutes the detail, color, and form of the craft, can heighten interest in an aircraft and create drama. Backlighting creates shadow and reflected light as the light source for the form closest to the viewer.

Use the shadows of clouds to create depth in atmospheric perspective. Use the shadows of mountain peaks to accentuate the ruggedness of the terrain. Use shadows flitting across still water to create interest in the surface of a lake or pond. Use the shadow of the airborne aircraft, distorted on the waves of the ocean, to give height to the waves and to create atmospheric distance between the aircraft and the water.

It is important to balance lights and darks, areas of light and shadow. As you practice with quickly sketched thumbnails to develop good compositions, remember to develop good proportions between light and shadow. Work to create a good scheme for a balance of lights and darks. Create your artwork in three areas: foreground, middle ground, and background.

Be inspired by this quotation from the renowned portrait and landscape artist Richard Whitney, who wrote in his book, *Painting the Visual Impression*, "Leonardo [da Vinci] discovered that the visual world could be separated into two areas of study—light and shadow. The artist must decide whether he is painting light or shadow because each has a different character and method of treatment."

Noorduyn's Norseman made its first flight near its Canadian manufacturing plant in 1935. Widely used to deliver supplies to mining camps, the Norseman saw service during World War II with the Royal Canadian Air Force, the United States Army Air Forces, the Royal Australian Air Force, and in Norway and Brazil. Postwar saw the Noorduyn Norseman continuing to operate resupply missions as well as airline service with rapidly growing commercial carriers.

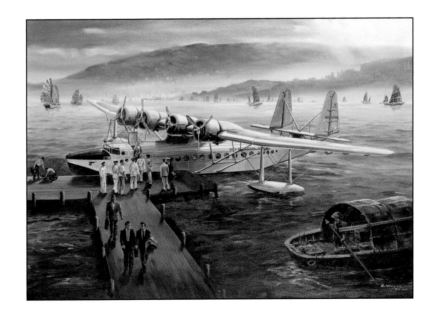

A leap forward in engineering development brought the Sikorsky S-42 from the earlier S-38 and S-40 models. An amphibian with a one-thousand-mile range for thirty-two passengers, the S-42 mounted four Pratt & Whitney Hornet engines with fully controllable Hamilton Standard propellers. Depicting passengers alighting from the S-42 in Hong Kong harbor allowed the artist a full range of values in light and shadow. (26x32)

Home is the Hunter by **William S. Phillips**

Meeting the Challenge

William S. "Bill" Phillips

A wingman is a pilot whose plane is positioned behind a lead pilot in a tight formation. In his evocative and memorable works of art, William S. "Bill" Phillips has often shown us the wingman's view. Phillips takes us into the action and exhilaration of flight by keeping us poised in tight formation, flinging ourselves in air as does the aircraft that has commanded our complete attention.

Although he had always enjoyed drawing and aircraft, Bill Phillips undertook a three-year vigorous program of self-study when he chose an art career. "From the library, which is full of art information, I read every book on art that I could find. Once I had mastered the texts, I kept advancing. I worked at drawing, at painting, and to this day I continue to learn."

His research platform includes obtaining actual flights with experienced pilots. He said, "I use a lot of videos for the continuum of rapid action. Single-frame photos freeze the time and leave no hint as to what continues to happen. In addition to enhancing my memory, film allows me to see again the ground blur, the changing light, and the movement of control surfaces and other aircraft. When I commit a scene to canvas, I don't want a static scene of a flying airplane."

Phillips likes to believe that his art moves beyond what a camera can capture. He said, "With a certain amount of fantasy in the piece, I want the scene to be something neither I nor anyone else has ever seen."

He is an avid participant in the Air Force Art Program, which has charged artists to produce fine art: graphic depictions of missions, locations, equipment, aircraft, crewmembers, and the on-going history of the United States Air Force. As a navy combat artist in 1988, viewing naval operations in the Persian Gulf, Phillips worked from ten different ships. While aboard a cruiser that pulled aft of a carrier, he started snapping photographs. In creating a painting of the scene, the angle of the carrier, the background sunset, and the setting sun's reflection on the water were of his own dramatic imagination and creation.

Learjet over Crater Lake **by William S. Phillips**

Home is the Hunter by William S. Phillips

Phillips said, "Fundamental to aviation art is the chance to contribute a unique perspective to the ancient disciplines of art, for never before has the artist been allowed to place his subject in a painting with such vast distances between subject and background. Never has there been the opportunity to glimpse the earth with its wealth of form and light from this vantage point. There is a challenge to the artist when confronted by flight and its unique opportunities to involve the viewer in a world of grace and fluid motion—a world many people will never experience. The realm of high-performance flight is combined with history and rare beauty."

Learjet over Crater Lake by William S. Phillips

Phillips generally begins his involvement in a scene with a static aircraft walk-around. When airborne, he analyzes light and dark, cloud shadows on the earth, airplane shadows on the clouds, reflections, and the blurring of colors and shapes in motion.

Most of Phillips' paintings start as abstracts. He works to develop a successful combination of form and design. "I analyze where darks and lights should be, how the work comes together best, attention to the line, and a pleasing composition. From there I work it up to decide where the airplane will go to enhance that design."

Bill Phillips pushes his artistic envelope. He continues to draw; he continues to paint. He challenges himself to do his best; then he strives to meet and surpass that challenge.

➤ Notice how ascribing high key values to the Curtiss F-11C Goshawk turning to final approach to the USS *Ranger* emphasizes the painting's primary subject. To place two other F-11Cs in the distance, Andrew Whyte lowers their values and reduces their size. The judicious use of size and values cause the viewer's eye to move throughout the painting to return to the primary navy biplane. (24x34)

➤ In a valuable example of aerial perspective showing vast distances with light, shadow, and changing values, Andrew Whyte's Royal Aircraft Factory's S.E.5/5a rivaled the Sopwith Camel as the best British fighter of World War I. As the German balloon was protected by antiaircraft guns, machine guns, and a fighter screen, the S.E.5 required a daring and experienced pilot to dive for the attack. (30x34)

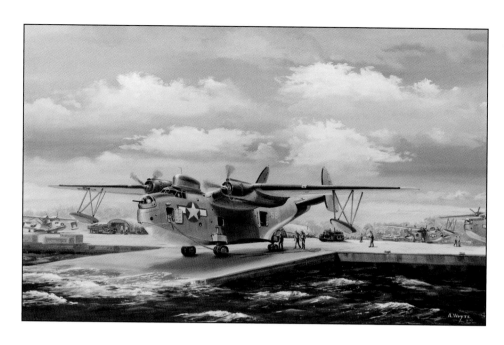

As a flight engineer/gunner aboard World War II Martin PBM Mariners in the Pacific Theater, artist Andrew Whyte paints what he has known. Deftly adhering to his primary light source and using shadow to give shape to the amphibian, which prepares to taxi down the launch ramp for a water departure, Whyte distances the hangar and other PBMs through the use of values. (24x32)

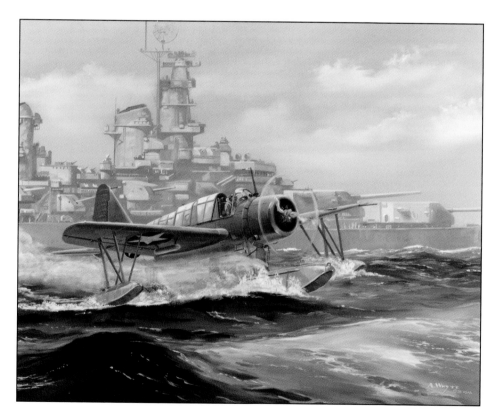

With its home battleship in the background, a Kingfisher returns from a scouting mission. The Vought-Sikorsky OS2U was the U.S. Navy's first catapult-launched floatplane. Drawing seaplanes introduces an aviation artist to the challenge of maritime scenes, and the proper use of light and shadow can create interest on the surface of calm water and give depth to wavy, churning water. (24x32)

AIRCRAFT FROM THE INSIDE OUT
Cutaways and Scale Views, Cockpits and Interiors

I f an artist knows where all the guts are located, where parts are located in relation to others, then the artist has a hint of the knowledge required to portray that subject.

— *Andrew Whyte*

CUTAWAY DRAWINGS

Aircraft use moving parts to perform the work expected of them. As with other machines, aircraft parts are designed to deliver a specific force to cause a resulting specific movement. Some are designed to convert one movement to another. For example, a piston moves back and forth with linear movement as a direct reaction to internal combustion. The piston is linked by a connecting rod to cause rotation of the crankshaft, a circular movement that directs its motion to the propeller. A cutaway drawing, a diagram with part or the entire outer surface removed to expose the internal structure, can illustrate this mechanical complexity.

The late Walter Matthew "Matt" Jefferies, who will always be remembered as the talented artist and motion picture art director who originally designed the Starship Enterprise for the enormously successful *Star Trek*, created cutaway and scale drawings for magazine illustration for more than fifty years. His renowned work was the result of careful research, experienced drafting skills, precise attention to details, and carefully measured and analyzed depictions. Jefferies said, "The most valuable manuals to use as reference for drawing aircraft to scale are one, the erection and maintenance manual, two, the overhaul and structural repair manual, and three, the illustrated parts catalog. The latter is absolutely necessary for inboard profiles and cutaways."

Cutaway drawings can be called skeletal renderings and may be done in black and white lines, monochrome, or full color. Although it will be helpful to refer to the actual aircraft, cutaways are commonly drawn from blueprints, photographs, sketches, an illustrated parts catalog, and aircraft manufacturers' manuals.

The purpose of a cutaway is to depict the machine's internal workings and integral parts. Cutaways of isolated systems are often used in technical manuals to show the interrelatedness of parts of a whole system. In aircraft, cutaways can illustrate the powerplant as well as the controls, hydraulics, and fuel, oil, and electrical systems. Often the use of a single color to denote related components simplifies comprehension.

There is a market for these drawings; they are sought for use as training aids or to illustrate technical manuals; they are used by aircraft-maintenance mechanics, or may be presented as works of art. Cutaway drawings enhance advertising material and create interesting additions to aircraft sales brochures. They illustrate the interior design of the entire spectrum of business, military, and civilian aircraft.

Just as studying the an aircraft's external shapes and characteristics can assist in understanding its interior systems, awareness of internal workings and shapes can assist an artist in properly depicting a machine's unique shapes.

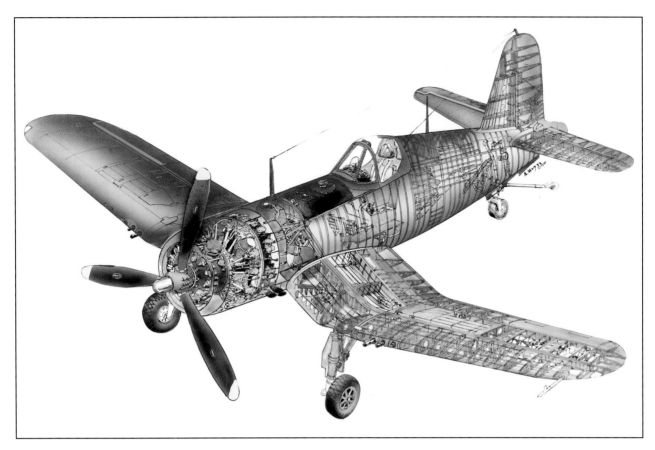

Consider tackling the precision of a cutaway to better understand and correctly paint the shape of an aircraft just as Leonardo da Vinci studied the skeleton of the human body to better depict his figures. Cutaways give you better insight into the hardware and the structure; the more you know, the better your chance of properly drawing or painting your subject. The information shown in cutaways is part of the basic knowledge of the machine that should be in an artist's mind before tackling a painting; it is another source to aid an artist in observation and another source of revenue. An artist can sell well-executed cutaways to magazines that cover aviation topics.

Drawing cutaways can be an artist's training exercise. In his biographical book on his aviation art, Keith Ferris wrote, "The structure of an aircraft very much affects the visual appearance of its external surface. An artist intent on showing texture and material, as well as the surface coating of an aircraft in his painting, finds strange undulations of the aircraft's skin as light is reflected from its surface. Structures also bend under load. Familiarity with structure explains these variations and allows a much more realistic painting."

SCALE DRAWINGS

A scale drawing is another tool to analyze and comprehend objects you are trying to portray. Scale drawings are generally three views of an

▲ Detail is the goal in a cutaway drawing of a Chance-Vought F4U Corsair with aluminum structural members painted with zinc chromate, a preservative. Note carefully drawn particulars of the engine, cockpit, landing gear, and the tail hook for catching the arresting gear on an aircraft carrier.

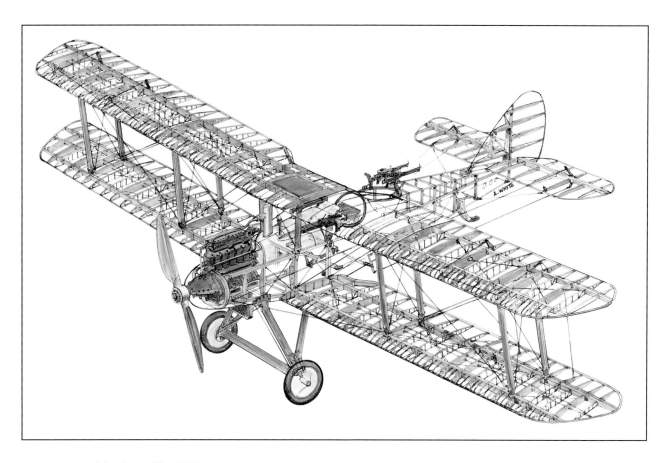

⤴ A cutaway of the de Havilland DH-9 illuminates the internal wooden structural members in light brown and some key external parts—propeller, landing gear, wing struts, and tail skid—in a darker brown. Metal parts, including the engine, are depicted in gray and wires and control cables are shown in black.

aircraft: flat reproductions of the top, bottom, and side views. They are generally drawn to illustrate the correct length, width, and height of the subject and of all of its component parts.

For aircraft modelers, scale refers to the size differential between the actual aircraft and the model aircraft. In the 1:72 scale, popular with builders of model airplanes, the model is seventy-two times smaller than the actual aircraft.

COCKPITS AND INTERIORS

Drawing aircraft interiors is another challenge for artists. You'll see interiors ranging from the rugged, battle-worn cockpit of a World War II F4U Corsair to slick portrayals of a luxury business jet, designed to emphasize beauty and comfort and to entice customers.

To draw interiors, focus on the subject and minimize the distractions that detract from your drawing. Every aircraft interior can be isolated and depicted. Consider cockpits and interiors the way a journalist considers the who, what, when, where, and why of an interview. The artist must answer the questions: Who is your viewer? What do you want the artwork to depict? Where will you set the scene? Why are you creating this particular drawing or painting?

To draw cockpits and interior scenes, climb a ladder to see into the cockpit or enter the aircraft to sketch and/or photograph from a platform

that allows direct views of specific military craft, a commercial airliner, or a private airplane.

- Choose a view outward through the canopy or window as if your viewer is airborne.
- Create the detail of the cockpit or a crewmember's position as your center of interest, or focus on an interior view from outside a craft. Consider differing points of view, such as that of the pilot as a fighter positions behind and beneath a tanker for refueling or the view from the boom operator's position in the tanker. Wrap an open cockpit around a biplane pilot soaring high over craggy mountains or strap a pilot into a fighter flying in close formation with another beyond the canopy. Your choice can focus on an airliner parked at a terminal gate or can depict the orbiting space shuttle as it docks with the International Space Station.
- Fly to add aerial scenes to your memory and to experience the emotions they elicit.
- Sketch, draw, and photograph cockpits to determine their many differences and to learn well the cockpit you've chosen to portray.
- Obtain the valuable reference materials—tech orders and aircraft manuals—that pertain to your particular aircraft. For example, *Cockpits* by renowned photographer Dan Patterson (www.flyinghistory.com) provides artistic renderings of actual aircraft cockpits.

✦ To show engine position and some key structural members, a cutaway drawing enhances an artist's concept of this advanced-design twin-rotor helicopter.

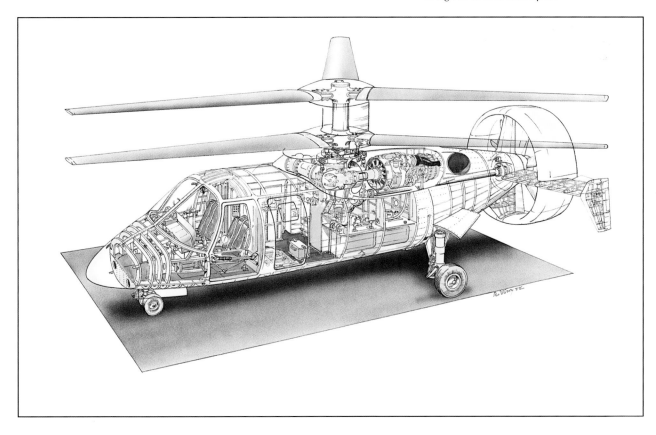

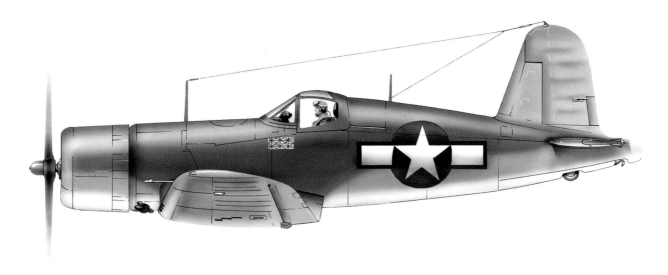

↟ A scale side view, one of three prepared to demonstrate aircraft dimensions, is another rendering of a Chance-Vought F4U Corsair.

↟ In addition to side views, top and bottom views visually describe the HH-60D Night Hawk helicopter.

- Determine the center of interest and use light and shadow to emphasize essentials.
- Use three-point perspective to ensure correct perspective and proportions.
- Allow the purpose of the drawing to dictate the amount of detail that is included.
- Simplify. Everything surrounding the positions of the gunner, the bombardier, the navigator, or the pilot does not have to be depicted. What *is* depicted, however, should be accurately placed and, even if treated with subtlety, correct.

Airliner interiors can be configured for commercial transport, military transport, cargo carriage, as aerial tankers, and for a variety of communication platforms and test beds. The Boeing 707, for example, has been modified to serve widely different missions. From commercial transportation, Boeing's 707 has been modified and equipped as a USAF E-3 AWACS, as a KC-135 tanker, and as the Joint (army and air force) STARS (Surveillance Target Attack Radar System), designated as the E-8C for providing battle management and targeting information. In 1962, it was the first jet aircraft purchased as a presidential carrier as John F. Kennedy entered the age of jets. Operating as VC-137, Boeing 707s operated in this special air mission until 1998. It is customary to designate each aircraft in which the U.S. president is aboard as *Air Force One*.

As another example, the DC-10 served the airlines to carry passengers and cargo and the U.S. Air Force as an aerial tanker. There are vast differences in interiors between aircraft outfitted for passenger use, those designed for presidential assignments, and the military versions. Research the different purposes, missions, and interior designs in order to achieve accuracy in your artworks.

Note that the primary light source for the interior, although highly influenced by sunlight during daylight hours, will be cast by artificial lighting and consequently diffused. Use cast shadows to emphasize and define textures and surfaces, letting those shadows work for you.

Note the similarities and the differences in the layout and instrumentation of civilian general aviation aircraft, civil airliners, and military aircraft. Work at learning to draw the Head's Up Display (HUD) on the fighter cockpit canopy. Use such drawing techniques as cross-hatching, shading, and rubbing to show texture and materials in carpeted and upholstered interiors in business and executive aircraft. When depicting interiors, an airbrush can enhance delicate shading.

When you add color to your drawings, study camouflage schemes for external portions of aircraft. Know that even those bare metal military aircraft generally will be grimy and oil-streaked in a wartime situation. Some will have altered colors; for example, the tan paint on some World War II P-40s became faded to pink in hot desert sunshine. Although there is a preponderance of olive drab and gray in crafts like the C-130 Hercules, there are many variations in the shades of green and gray. Whether working on an interior or exterior image, study the perspective and proportions, the shapes, the shadows, and the colors.

➜ A pencil drawing of the open cockpit of a World War I S.E.5 fighter draws attention to the ring-style control column or "stick" and the relatively few instruments.

➘ *Memories*: On 18 April 1942, sixteen B-25 Mitchell bombers daringly took off from the aircraft carrier *Hornet* to retaliate for Japanese bombing attacks throughout the Pacific on 7 December 1941. Led by Lt. Col. Jimmy Doolittle, the B-25s conducted the first bombing raid on Japan's home islands. USAF Chief Master Sgt. Bud Golem, who served as a flight engineer on B-25s, carefully researched to create his airbrush painting of the instrument panel on the Number 2 aircraft as it followed Doolittle's Number 1. To insure accuracy, Pilot Travis Hoover attested to the instrument readings and other Raiders contributed their special knowledge of takeoff conditions. Lest we forget, Golem titled his artwork *Memories*. (24x14) *Bud Golem*

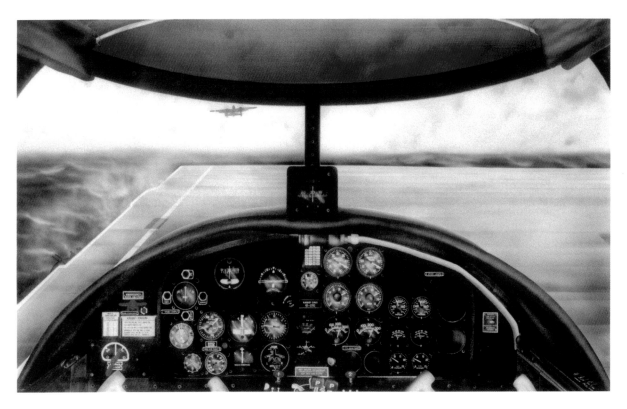

▲ To focus on the high degree of comfort and modern business communications equipment required, designers and artists create interior cabin conference areas.

▼ Passenger aircraft like the Boeing 787 Dreamliner are becoming increasingly stylish, comfortable, and well-equipped. Artistic renderings play an important role in the sales, promotions, and designs of new aircraft.

TOOLS OF THE TRADE FOR PAINTING
The Choices are Yours

↟ *Brushes*: Being led, as most are, by availability, results and budget constraints, asking trusted experts, shopping in trusted art supply stores, and experimentation are the three major avenues to purchasing the paint brushes that will work for you. Natural hairs, bristles, and synthetic fibers are yours to try and compare. *Courtesy of www.mccallisters.com*

As stated in chapter 3, "Start with pencil and paper. Start modestly and work your way to the materials that fit your increasing ability and developing style." Perhaps you added color a long time ago, satisfying your painterly interests with colored pencils, pens, watercolors, acrylics, or oil. It has been stressed that learning to draw was a prerequisite to painting. Now it is time to address the available tools essential for the painter.

If you are not already equipping even a limited area for a studio, perhaps this is the time. In addition to your studies and paintings, you will need space, for example, for brushes. You'll need a variety, all of which will form a pointed tip, have responsive hairs that return in shape after your stroke, and offer a predictable control over paint flow. Your medium choice, whether tempera, watercolor, acrylic, and/or oil, will determine the appropriate brushes. Once you've selected your medium, your brush choices will vary from tips that are round or flat to those shaped like filberts, mops, fans, and/or liners. The artist's website, www.artpaper.com, stated, "With so many art supplies and tools in this high-tech age, it is easy to take brushes for granted. But a great deal of work goes into creating a brush that is suitable for serious artists. While an artist may choose an inferior medium or pigment to save money, there can be no such compromise with brushes. The quality of a paintbrush can determine the overall quality of the final image."

The heads of most brushes used for oils and acrylic paints are round, which carry more paint, although experimentation will determine the best brushes for your uses. Obviously, you'll need larger brushes to cover large areas of an initial composition, while smaller brushes fill the bill for more detailed work. Yet, the designated size number for brushes may differ. Brushes for oil and acrylic paints run larger than watercolor brushes of the same size designations; in other words, a size 12 oil-paint brush can be larger than a size 12 watercolor brush.

Shop for the brushes that will work for you. You might consider packaged sets. For example, McCallister Art Supplies (www.mccallisters.com) offers prepackaged brushes with a variety of handles, ferrules, and head shapes—round, fan, shader, detailers, and extra-long liners, as well as differing head filaments—bristles, hairs, and/or synthetic fibers. Evolving synthetic brushes increasingly rival the best sable hair and bristle heads. Their lower prices and good quality can offer good values to beginning artists.

Be prepared to try several brushes. A bright brush has short flat filaments and is useful for details and creating sharp edges. For rounded, softer edges, a round brush lives up to its name and has staggered lengths to its filaments. A flat brush provides long fluid strokes and strong edges and a fan brush can contribute to soft edges and subtle blending techniques.

Watercolor painting is generally carried out on a level surface, leads to shorter brush handles for closer work. Oil paintings, when created on easels, require longer-handled brushes for the artist who is standing an arm's distance from the painting.

COLOR IN PAINTS

Professor Albert H. Munsell created a color order system that made the description of color accurate and convenient. His *The Atlas of the Munsell Color System,* published in 1915, served as a foundation for subsequent color order systems. Start adding color to your drawings with an array of colored pencils and pastels. When you are ready to start painting, choose paints that will best serve your needs.

Watercolors:

Watercolors are generally acknowledged to be the most challenging medium. Watercolors rely on applying one or more layers of translucent color. Watercolor paper, with its texture and its differing visual appeal, is an integral part of the finished painting. With watercolors, there is immediacy to the painting; it is less forgiving of mistakes, changes, or erasures.

Acrylics:

Acrylics are water-soluble and quick-drying through the evaporation of the water solvent. If the drying is too fast for your purposes, you can use a retarder, which slows the drying time to allow for more manipulation of the painting. Acrylics can be applied in various thicknesses and to various surfaces. They are durable and can be diluted, making them ideal for airbrushing. They retain flexibility and will not yellow with age. When allowed to dry rapidly, successive coats can be applied within a half hour and the finished painting is waterproof and less apt to deteriorate. Many aviation artists choose acrylics, especially those who face short deadlines.

Oil paints:

Oils are opaque or semiopaque and have long been the choice of classic artists for their relative ease of use and great variety of effects. Because oils dry slowly, tones are more easily matched and blended. The artist can apply paint that is based in linseed, poppy, or walnut oils in glazes, washes, spray, impasto, and with a palette knife. Design can be changed and improvised, and color and shading offer rich effects.

When outfitting your studio, visit art supply stores and talk with artists. Ask about: brush storage, brush cleaners, sponges, palettes, painting and palette knives, and specialty brushes, which might include those intended for priming, varnishing, and other uses. Ian Hebblewhite, author of *The North Light Handbook of Artists' Materials,* wrote, "An abundance of tools in the studio is not vital for the creation of good work but will broaden the possibilities open to you for experimenting."

In addition to the list above, you will need painting surfaces. You have many choices and your objectives will be your guides. Paper, boards, and pads have been covered in chapter 3. There also are longer-lasting supports, such as canvases, stretcher bars, and wood and canvas boards.

⬆ *Very high-quality sable-hair brushes*: Coveted for use by watercolorists and oil painters, sable hair is obtained from the Asiatic mink or weasel. Considered the supreme hair, its qualities boast elasticity and softness as well as ease of shaping into a pointed tip and excellent control of the flow of paint. However, sable brushes vary widely. If you have an opportunity, test a brush labeled "sable" by gently washing the brush, then snapping it against your wrist. As Claudia Myers of Spokane Art Supply wrote, "Watch it come to a point. Or not!"
Courtesy of www.mccallisters.com

CANVAS

Fabrics for painting surfaces are as varied as the brushes. Experiment with ramie, linen, and cotton. The former is a good choice if you can find a good supplier. Linen, made from flax, which is also the source of linseed oil, is excellent and is plentiful. It is a strong fabric and displays a resiliency to decay. Cotton is more plentiful than linen, but it falls short when compared with linen's longevity, strength, or appearance. As with brushes, there are synthetics that begin to approximate the stability of linen and cotton. To date, however, most artists choose ramie, linen, and/or cotton for fine-art painting.

It's up to you to decide whether to buy and paint on prestretched, preprimed canvases or to stretch your own canvases. Prestretched canvas is readily available in a wide variety of sizes, but it is sometimes difficult to determine how it has been primed. If the canvas has been primed two or three times, the finish might lead to surface cracks, so watch for this as you shop. If you choose to stretch your own canvases, you can buy stretcher bars in several widths and heights, so you can stretch fresh canvas to the size you want for each painting. For this, you also will need rolls of fabric and cans of gesso, a primer that provides the right properties for paint adherence.

To stretch canvas over stretcher bars, here are basic steps: Slot together the stretcher frame, hammering the corners tightly with a rubber hammer. Cut canvas fabric approximately three or four inches wider than the frame. With a staple gun, attach the canvas to the back of the frame every two inches along one side, using canvas pliers to hold the canvas taut on the opposite side. Repeat these steps for all four sides of the frame, leaving the corners for last. When the canvas is stapled to the frame along all four sides, trim excess fabric and finish the corners as follows: pull the corner of the canvas tightly across the stretcher toward the center of the canvas. Fold a resulting "wing" of canvas to form a tight squarely covered corner and fold the second "wing" over the first. Staple the corner tightly to the wooden frame. To tighten or relax the canvas, use stretchers with small wooden wedges that fit into frame corners.

To prime your canvas, cover the fabric with two or three coats of gesso, making sure it is dry before painting on it. Gesso provides a surface that improves paint adhesion and prevents absorption of oils or acids by the fabric or wood on which you are painting. Although the use of gesso dates back hundreds of years, a water-based acrylic gesso was developed as recently as 1955. This primer is more flexible and can be tinted with watercolor or acrylic paint.

According to www.wisegeek.com, "Some artists question whether modern [acrylic] gesso should be used under oil paint on canvas. Some materials used in oil painting, such as mineral spirits, can leak oil through the coat of gesso and damage the underlying canvas. Because of its relative newness, the archival properties of acrylic gesso are unknown."

▲ *Pastels*: Soft pastels are primarily made of pigment, a binder, a preservative, and some water. They are appreciated for color purity. Oil pastels—oil paint sticks—are similar, but oil is substituted for the water during the manufacturing process. Hard and chalk pastels are also available. Available singly, pastels also come in sets.
Courtesy of www.mccallisters.com

WOOD AND CANVAS BOARD

These panels offer firm bases for your paintings, and are inexpensive and readily available. They are good for study paintings, sketches, and preliminary compositional trials. Some wood panels are pretinted and preprimed. Some can be used for oil painting, but most are designed for tempera, which requires rigid surfaces. Keep several panels available for a ready response to creativity.

CARE AND CLEANLINESS

Proper cleaning and care of your art tools and equipment is important. Develop good habits; for example, clean your brushes as soon as your painting session ends. For regular care, use a brush-cleansing formula followed by a gentle soap lathered in warm water and rinsed completely before reshaping the heads. Dry your brushes before storing them and keep them upright between painting sessions, which is best for the heads. Separate oil and acrylic brushes from watercolor brushes and do not use them interchangeably. It also is advisable to condition the natural hair filaments occasionally with a drop of oil. Rough or textured surfaces are hard on natural hair heads, so it may be more economical and satisfactory to use synthetic filaments for rough surfaces. Excessive use of very hot water will leach natural oil from hair fibers, and excessive pressure to rid a head of color is counterproductive.

For ink drawing, there are three styles of brushes. A flat-head hair brush can be used to cover large areas and it also lends itself to dry-brush techniques. Two round, pointed-hair brushes can be used for fine lines and varying strokes. Using a brush as a drawing tool relates directly to the quality and shape of the filaments. Use black Chinese or India ink, experiment with brush and ink and with dry brush (moving from black to gray as the ink is used up and pressure is exerted), and keep in mind light and shadow, composition, and good drawing.

In addition to watercolors and oils, you may try acrylic paints that hold the pigment in an acrylic resin. Acrylic paints are versatile and fast-drying and can be thinned for use like watercolors or used directly from the tube like oils. Alkyd paints, a derivative of the mixture of alcohol and acid from which they are made, can be another choice. Not water-based, alkyds are to be dissolved in turpentine and mixed with oil. Gouache, a water-based paint, includes the ingredients of watercolor, but has an addition of inert white pigments that give reflective qualities to the paint and result in brilliant and opaque colors. Hebblewhite wrote, "The smooth uniformity of gouache and the fact that one opaque color can be laid on top of another are useful features of this paint. However, some of the particularly brilliant hues are fugitive and useful only where the necessity for permanence is less important."

For airbrush techniques, use a compressed-air atomizer designed to spray paint. Using masks, stencils, or free hand to direct the paint

Paper for painting: There is wide variety of paper that can be purchased in single sheets, multiple pads, or already attached to boards. Your choices include acid-free cartridge paper, the fine parchment known as vellum, Ingres paper, or oil and watercolor papers. Choose your medium and the appropriate paper for your artwork.
Courtesy of www.mccallisters.com

Oil paints: Generally speaking, oil paints are based in linseed, poppy, or safflower oil. Beginning artists can choose their oil paints from student-quality grades while accomplished artists may choose artist-quality paint, which has better pigmentation and contains less extender, allowing a longer drying period. This renders the artist-quality paint better-suited to studio work.
Courtesy of www.mccallisters.com

➤ Starting with finger movements to depress the trigger, there are a number of steps in learning to use an airbrush and in developing spray patterns. Even simple straight lines require practice, as do mastering gradual tones, blending, creating edges, and advancing to freehand painting.
Courtesy of www.mccallisters.com

➤ *Testing brush strokes*: According to Ian Hebblewhite, "Natural bristle and hair consist of a central medulla on which are many tiny scales; they also have small hollows which absorb liquid by capillary action. Natural products, therefore, have considerable liquid-holding capacity." Synthetic filaments are improving. Try a variety and discover for yourself. Obtain information from a knowledgeable source and experiment for your own pleasure.
Courtesy of www.mccallisters.com

➤ Emphasizing the values gained in plein air painting, artist Andrew Whyte carries his supplies out-of-doors to see the effects of light and shadow and the speed with which changing conditions can challenge an artist. The venue at Old Rhinebeck Aerodrome, a museum of antique aviation in Rhinebeck, New York, is an excellent place for aviation artists to hone their skills.

and to prevent overspray on the surface of the painting, an airbrush can deliver color from the width of a fine line to a wide spray pattern. Airbrushes come in a range of prices and capabilities. Some mix the paint and air internally inside the head. Some have a gravity-feed system and some a siphon system. Testing each system will help you decide on the best tool for you.

Chad Bailey, an aviation artist experienced in pigments as well as airbrushes, wrote, "Airbrushes with triggers that control the air *and* the color are 'dual action.' They let you change line width, values, and paint opacity while the hand is in motion. Dual-action airbrushes offer finer control. Though they may be more expensive, they are worth the price."

A gravity-feed airbrush features color cups mounted above the head assembly and, as the name implies, the paint moves downward due to the pull of gravity. In the siphon-feed system, a variety of color cups can be accessed and color can be changed more quickly and easily. A third variety, the side-feed brush, is fitted with the cup on the side, allowing the artist to rotate the assembly and to work on horizontal or vertical surfaces.

As with any tool, the airbrush has its limitations and is only as good as the artist's talent and capability. A website, www.airbrushing-made-easy.com, offers information and suggestions for practice and exploration. The learning curve, as has been mentioned before, starts with drawing. From that auspicious beginning, keep an open mind as you explore your talents as an artist.

Keep an open mind as you explore your talents as an artist.

E very color has a hue. Every color has a range of values. Every color has an intensity. Those are what you play with in color work.
—*Andrew Whyte*

USING COLOR— THE PAINTER'S ART
To Understand Color, Understand Value and Intensity

Light is the source of color. Light, with its waves of electromagnetic energy, interrelates with the surfaces it illuminates and, in conjunction with the human eye, can be translated into a hue or color we can recognize and name. Light, with its spectrum of differing wavelengths, reflects differently from the objects or surfaces it touches. It is this reflection from the visible spectrum that appears to the eye as color. In the absence of light, there is no color. In the absence of light, there is no shadow. Use light to direct interest to the most important part of your drawing or painting and learn to use it sparingly and effectively.

Colors have important qualities and can elicit a variety of emotions. Those containing yellow or red are warm colors. They seem to be solid, to advance toward us, and to expand in size. Cool colors contain blue. They seem to be spacious, to withdraw from us, and to contract in size. Color has three basic properties: hue, value, and intensity.

HUE

Hue refers to a particular color, such as red, blue, or yellow. An artist's color wheel, a tool derived from the natural colors of a rainbow, aids in visualizing colors and their relationships. As black and white are not shown on a color wheel, it is important to know that, in pigment, the absence of color results in white and black is the combination of all colors.

Primary colors are those that cannot be mixed from other elements. Traditionally, the primary colors are red, yellow, and blue; they are currently identified as magenta, yellow, and cyan. The secondary or complementary colors result from the mixture of two primary colors: Magenta and yellow produce orange, the complement of blue. Yellow and cyan produce green, the complement of magenta. Cyan and magenta produce violet, the complement of yellow.

A complementary color is one of two colors whose mixture produces gray. Mixing red with green, yellow with violet, or blue with orange all produce gray. Depending upon what you want to paint and which gray you seek, you can mix those with warmer and cooler results. For example, mixing a French ultramarine with cadmium yellow results in a bluish, cooler gray. On the warmer side, you can create a more orange-colored gray.

It is important to know that complementary colors accentuate one another's hues. For example, a spot of green near a red makes the red look redder. As complementary colors have very different wavelengths, they can seem to quiver when painted next to one another. When two colors are mixed in pigment, they lose some intensity. When two colors are mixed optically, they retain intensity or can even seem brighter.

BURNT UMBER - DARK RED greyed
LAMP BLACK - BROWNISH
IVORY BLACK - NEUTRAL
PAYNES GRAY - MIXTURE OF BLACK + ULTRAMARINE

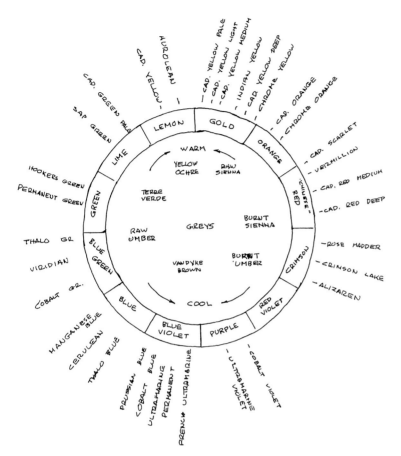

← This special color wheel developed by Andrew Whyte provides a great deal of information in addition to that found on a standard color wheel. Around the exterior circle, he has shown the names of the colors of oil, acrylic, and watercolor paints. These names often reflect the chemical composition of a color. For example, cadmium yellow is cadmium sulfide and cobalt blue pigment consists of a mixture of cobalt oxide and alumina. Note the information shown, inside the wheel, about mixing colors to create grays.

The following color notes also apply: Depending on the area of a painting each color covers with respect to an adjacent color, the colors can change or appear to the eye to have a different tint. A good rule of thumb is to have large areas of muted color contrasted with smaller spots of intense color.

- Red next to orange, the red seems purple and the orange more yellow
- Red next to green and blue makes both colors brighter
- Red next to blue makes red seem orange and blue seem green
- Orange next to green makes orange appear red and green seem blue

→ By mixing complementary colors—those opposite each other on the color wheel—a range of grays can be developed. Cooler and warmer grays can be obtained by mixing the right hues.

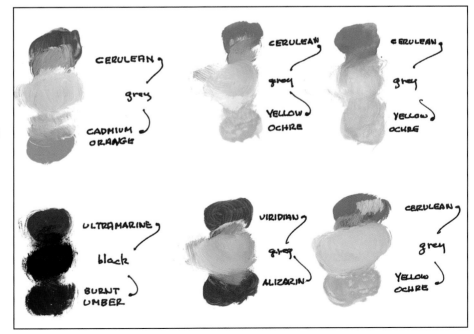

Knowing the location on the color wheel of the paints that you use is important. Accurate color mixing has three steps:

1. Select the color closest to the one you want to use. Mix from adjacent hues, if necessary.
2. Add a little of the hue's correct complement to achieve the desired intensity.
3. Add a touch of white to adjust for value.

VALUE

Value is the range in a single color from darkest—a value of one, to lightest—a value of ten. Some hues, such as yellow or orange, are relatively light in value and others, like purple and brown, are relatively dark. Yet, as do the lightest of hues, the darkest—purple and brown—also have an entire range of values. In differentiating between the darkness or lightness of a particular color, we label those differences as shade and tint. Shade is the relative darkness—a low value on our value scale, and tint refers to the relative lightness—a high value.

Value change can occur gradually, darkening as the object is distanced from the illuminating light. Even if the object is white, there will be value differentiation from a lighter white to a darker white. Note that a color adjacent to the object being drawn will influence the value of that object's color.

Every color, right out of the tube, has a value. Some manufacturers note that value on the tube of pigment. It is up to the artist to lighten or darken it to change the value of the pure hue for his or her painting. An artist can tint a hue to lighten or can shade a hue to darken the value of any color.

Shadows are opposite light sources and occur because an object blocks the light. This will cause color changes in the area of shadow. Remember to lower a color's value in any portion affected by the cast shadow. A good example is seen in the F-86 Sabre in chapter 7.

INTENSITY

Intensity, also called saturation or chroma, refers to a color's purity. A color with the greatest saturation has the greatest purity of tone. It can be grayed to change the intensity from the purest (maximum) to medium to weak, the least intense. The amount of intensity desired for a particular object in a composition is the artist's choice. In drawing and painting aircraft, atmospheric interference normally causes a diminishing brightness with distance. Colors have a greater intensity when they are closer to a viewer. Softening the intensity can cause objects to recede with diminishing saturation to enhance the atmospheric quality and give depth to a painting. Aerial perspective adds the ability to use color, value, and intensity to create depth with a graying of color and/or a loss of value and intensity with distance.

Color has three basic properties: hue, value, and intensity.

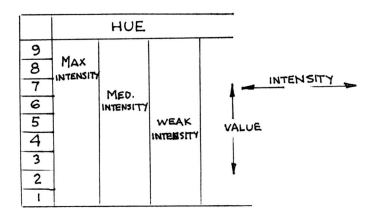

← This diagram provides an overview of the color chart. Here, *value ranges* from nine at the top—the lightest, to one at the bottom—the darkest. (Other books may label values differently, so be aware.) The *hues* arranged from left to right. For each hue there are three *intensities*.

A beginning artist does not need to rush into the purchase of a full array of prepared colors. Some aviation artists use limited palettes. Keith Ferris uses a basic three-color palette with white. Robert Watts uses a basic five-color palette with white. Andrew Whyte uses that same five-color palette, using cobalt blue instead of phthalo blue. Part of the art of painting is involved with seeing and training your eyes to observe color differentiation, and the suggestions in this chapter are intended to help you to do this. Training your eyes to note color variations is as important as perfecting your ability to see the subjects you wish to paint. When you create your colors, you are training your eyes to see color.

Although most artists would agree on the differentiation between red, yellow, and blue, color itself is highly subjective. It is up to the artist to select pigments. Remember that several colors can be found in one object—some of it the actual color of the object and some of it caused by the reflections of other colors. The challenge to the artist is to discover all of the colors that actually are present in objects to be painted.

When painting, learn to link elements together through a judicious use of color. When drawing and painting aircraft, learn to create atmospheric perspective, and practice giving less color definition to objects in the distance in your scene. Keep in mind that all good art begins with good drawing.

↓ The color chart is a valuable exercise for an artist to perform in the personal development of his or her understanding of *hue* (color), *value* (light and dark), and *intensity* (saturation or chroma). To be valuable, these are hands-on exercises. You have to work them; they cannot simply be studied.

The color chart is arranged as outlined in the diagram. For exercise, start by mixing each color, at full intensity, for each of the nine values. Then reduce the intensity in two steps—to medium and to weak intensity—at the same value. Satisfying yourself that you have built a "perfect chart" will take patience and practice. The learning that takes place will make it worthwhile.

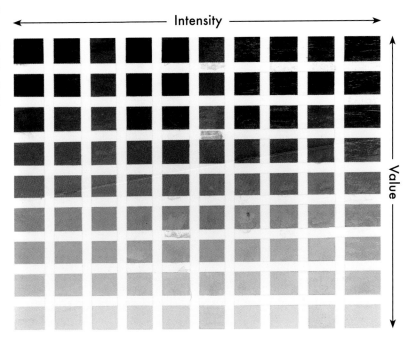

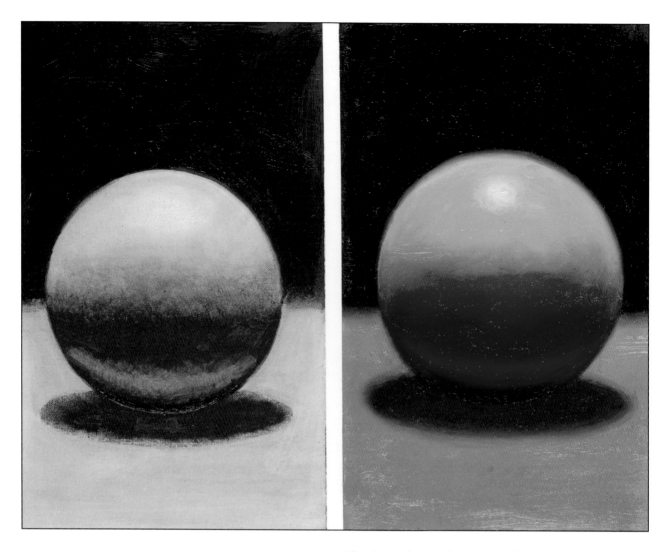

The chart with two spheres is an additional exercise to help you develop your understanding of *value, intensity,* and *soft edges.* The sphere on the left—in yellow—is an exercise in value. It goes from the lightest light to the darkest dark through a full range. The sphere on the right applies color in corresponding values and reduces in intensity as you move toward the edges of the figure. The soft edges help to create the illusion of roundness. The surface on which the sphere rests has the same value from front to back; the color is reduced in intensity to make the surface appear to "lie down."

↟ In 1913, Igor Sikorsky led aviation development by building the first aircraft powered by four engines. One year later he introduced his four-engine bomber, the Ilya Moroumetz, that saw action in World War I. Approximately eighty were built and all proudly honored the name of the Russian folk hero, a legendary and inspiring warrior.

Color—Just One Aspect of a Painting
Kristin Hill

Kristin Hill, trained and skilled in fine arts, is an artist fellow and a past president of the American Society of Aviation Artists. She is an active participant of the U.S. Air Force Art Program. Acutely aware of the world around her, Hill noted, "Visual clues never cease. Research is available everywhere—light, shadow, color, transparency, reflection. Artists work with a visual language as composers work with a musical language."

Hill uses work boards—flats that contain reference photographs, sketches, color samples, mechanical drawings, and models for referral during a painting— that can be quickly stowed to free her to work on another painting. She explained, "I like to have several paintings going at a time so that I can put one down and look at another. The eye physiologically reaches a certain saturation of color and the intense concentration focused on a painting has to be eased once in a while."

In order to view her work in progress each time she refreshes her brush with paint, Hill keeps her palette six to eight feet from the painting. She said, "The artist, whose job it is to see and produce, needs to see *more*."

During the fiftieth anniversary of the U.S. Air Force, Hill elected to paint a tribute to the McDonnell Douglas F-4 Phantom, to its long and respected history of service, and to people who were involved. Having previously had "an impressive flight experience in which the clouds were illuminated from a sun that cast light below them," she drew upon a pen sketch and notations of that scene for this painting.

Hill developed her composition with thumbnail sketches that explored masses and force-lines and followed the quickly executed thumbnails with a color sketch. She said, "Separate, yet one with this fluctuating world in the sky is the beautifully piercing passage of man and machine. . . . The strong and sculptural shapes of the F-4 . . . and the relative positions of sun, cloud, and aircraft allowed the light to strike the F-4 and its contrail. Placing the shadowed cloud beneath the Phantom emphasized the sunlight and the painting of *Gold*. This painting is an example of visual music."

The simple concept inspiring her painting, *School's Out Early,* lies in the excitement generated by early aviation's barnstormers. Having met a contemporary pilot who enjoys flying a Travel Air, Hill selected his aircraft paint scheme for her painting. A second Travel Air owner made his craft available to her for photographs, to study, to excite the senses, and in which to enjoy the sheer pleasure of flight.

Beginning with thumbnail pencil sketches to try a variety of compositions, Hill established the general view of the craft, its flight energy, and the placement of relative values and light and shadow. Selecting the best, the sketch was expanded to a larger format in which she developed the relative placement of values more thoroughly. A rough color sketch followed that fitted the components of the painting to one another and could be changed quickly if necessary. The color sketch was designed to harmoniously bring together the colors, values, composition, aircraft view, energy, and rhythms.

School's Out Early required using a three-view drawing and descriptive geometry to plot the desired view and proper structure of the Travel Air. Hill then created the play of light and color on its shapes and used linear perspective to draw the buildings and aerial perspective to assure the illusion of flight. In addition to observation of the human figures from the open cockpit aircraft, she watched people below from the vantage point of a twelve-story building, seeking all the time to insure the accuracy of her perspective.

***Brush with Gold* by Kristin Hill**

***School's Out Early* by Kristin Hill**

➤ Alaska, where the topography, the abundance of water, far-flung villages, and a widely spaced population requires heavy use of aircraft and float-planes. Depicting such a scene, Andrew Whyte chose the Stinson on floats to depict bush pilots who operate regularly from bodies of water and face the challenges of wildlife, high mountains, steep canyons, and mercurial weather conditions.

➤ According to the Sikorsky company's official website (www.sikorsky.com), "Sikorsky is the most experienced, safest, and reliable company to perform the Head of State / VIP helicopter transport missions. We have flown all U.S presidents since Eisenhower. Whenever the president of the United States is transported by helicopter, it is in a Sikorsky VH-3D or VH-60N [Black Hawk]." Andrew Whyte participated in design of the Black Hawk.

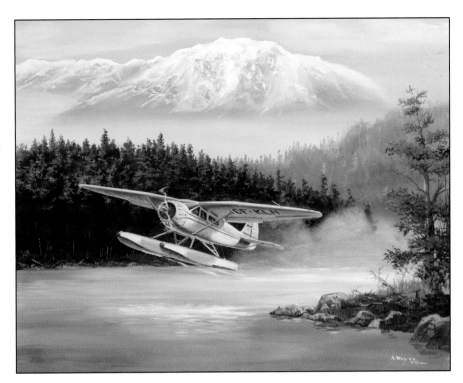

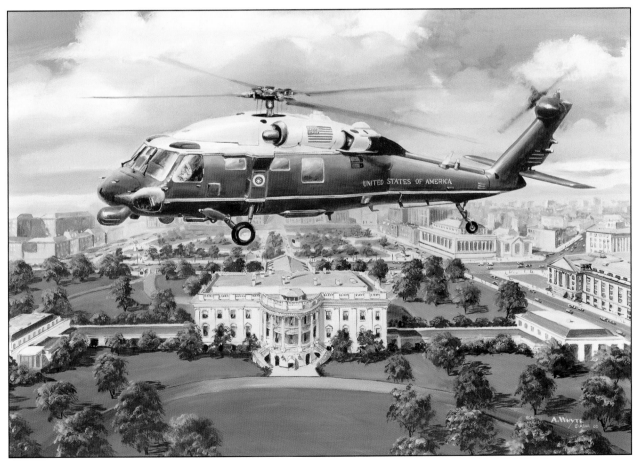

The Importance of Color

Robert Watts

Color is one of the tools in mastering the illusion of space and distance. To use color successfully, gain a working knowledge of values, edges, shadows, and light. Robert Watts is the master of subtlety in the use of color. Here are some of his cogent pointers:

Values

- Values are the lightness, which advances, or darkness, which recedes, of the shapes and elements of a painting.
- Use as few values as possible to describe a form.
- When an object recedes into space, its value should be similar to other values at the same distance.
- Save the darkest dark and lightest light for the center of interest.

Edges

- Edges should soften and become less distinct with distance. This deliberate loss of focus is something we want the viewer to notice less. If the distance is the center of interest, the foreground objects should be less sharply defined.
- Fact: The eye will always focus on the cleanest, sharpest thing it sees. What happens when *everything* is clear and distinct? That's right, no center of interest!

Shadows

- Shadows give structure to a painting.
- Shadows are where we find our darkest darks, one aspect of a full range of values.
- Shadows should look vague and mysterious, *not* full of information.
- Paint shadows with subtlety. Don't draw undue attention to them.
- Opacity is the look of light. Shadow is transparent. To increase the transparency, add a bit of yellow or orange to the shadow. Yellow is the color of transparency.

Light

- The center of interest is in the light or silhouetted against the light.
- If you have a lot of light, take out some of the color. Don't have color and light competing.
- You can never paint your lights too light or your warms too warm. You can always darken or cool them later, but the opposite is more difficult.

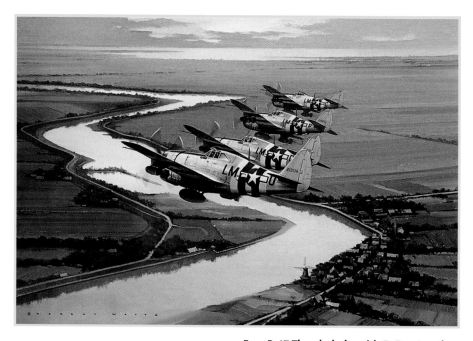

***Four P-47 Thunderbolts with D-Day Invasion Stripes over the Netherlands* by Robert Watts**

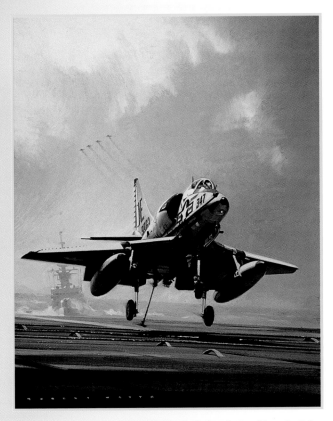

Douglas A-4 Skyhawk Catching the Wire on the Carrier Deck **by Robert Watts**

Local Color
- Local color is the actual color of an object if it were unaffected by any others.
- Local color is usually affected by two sources of light: the sun, warm and yellow, and the reflected light of the sky, cool and blue.
- Local color is usually clear only on an overcast day when neither warm sun nor cool blue sky can have much effect.

Color
- Either put color in one place or de-emphasize color in another place. It is color against the lack of color.
- All three primary colors should never be in the same picture in their full intensities.
- To make something look bright, use more color, less white.
- To make something look lighter, use less color, more white.
- The color of light falling on a scene will and must modify all colors and unify the picture.
- Warm color has a transparent nature and conveys the look of depth in a shadow. Yellow is the color of transmitted light.
- Reserve your most intense colors for the lighted areas.
- Put your color on the canvas and leave it alone. Fussing with it causes chalkiness and the well-known muddiness in the darker tones.
- Try to use a selected color again and again in your painting so that your painting will hold together. If you need a dark, use one that you have already used. Avoid fragments of arbitrary color.

Warm and Cool
- Cool colors have blue in them and warm colors have yellow in them.
- Confusion comes from using a palette of too many colors. Use a palette that contains only those colors you really need.
- White will cool any color and should be used sparingly.
- It is easier to cool a warm than it is to warm a cool. Paint warms first; add cools carefully.
- The eye is drawn to yellow, orange, and red. It sees cool colors only peripherally.
- Warm colors advance toward the eye while cool colors recede from the eye.

Complementary Colors
- Darken a yellow by adding purple or darken a purple by adding yellow.
- Create your darkening complements out of cool colors for the shadow side and warm colors for the lighted side.
- Make lively grays by mixing complementary colors.

A n artistic composition is a spatial relationship that creates an aesthetically pleasing picture and gives the illusion of three dimensions on a two-dimensional surface.

— *Andrew Whyte*

COMPOSITION—
setting the scene

We know our readers consider aviation a dynamic subject; you already appreciate the beauty of flight and the challenges of depicting that beauty in a work of art. Previous chapters have discussed tools, sketching, and line drawing; some research methods and perspective. Previous chapters have addressed some specialized types of drawing, from cutaways, scale views, aircraft interiors and cockpits, to cartoons and caricatures, as well as the importance of light and shadow and values. This section now addresses bringing all of those elements together to compose a completed drawing involving an aircraft. With a basis in fundamental principles, composition is the transforming of the raw material of a good idea into an original artwork.

Well-known aviation artist James Dietz, attributing the observation to the prestigious British artist, the late Frank Wootton, said, "Too often aviation artists are concerned only with painting an accurately detailed aircraft, yet overlooking two very important principles of painting—design and color. An artist must always remember that no amount of detail or attention to the proper number of rivets can correct a boring situation or a flat composition.

"A realistic painting is composed of the basic elements of design, color, and accuracy to life. From an artistic standpoint, the least important of these is accuracy because it is the most easily corrected. Somewhat harder, but not impossible, to correct is color. But, if the composition and design are not exciting to the viewer, no amount of accuracy can make up for it. Of course, this is the most difficult element to achieve."

Award-winning artist Jody Sjogren, who created the remarkable series of prints, *Metamorphosis* and *Metaphor*, breaks her composition planning into four extensive steps:

To get started, she said, "I use the nature, structure, or mission of an airplane as the starting point for my composition." To develop a "personal relationship" with the plane chosen for the composition, she reads extensively, interviews knowledgeable crewmembers, takes many photographs, and, when possible, arranges a flight.

Sjogren gathers resources and begins a series of sketches. She said, "Early in the game, it is rare that I have all of the information in hand and all of the visual problems solved in my mind. Thumbnail sketches are a part of the process of solidifying my message as well as working out a visual composition." For one artwork, she discussed her sketches with and was critiqued by experienced aviators, and it wasn't until the seventh one—a sketch that eliminated what one pilot called a "confusion in the visual geometry"—that the final composition was decided upon.

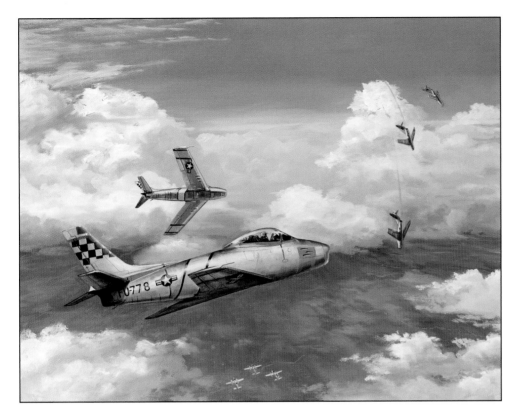

↖ As the war in Korea continued, aerial battles between Soviet-built MiG-15s and U.S. Air Force F-86 Sabres intensified. Covering B-26 medium bombers under attack by MiGs challenged fighter pilots, who fought to attain air superiority.

↓ The artist at work. Seated at his easel at his Norwalk, Connecticut home, Andrew Whyte put finishing touches on the painting depicting the Sabres, MiGs, and the B-26 Martin Marauder.

She pulls it all together looking for "the visual glue necessary to tie all of the elements together successfully." At that point she is ready to paint.

She is finished, she said, ". . . when I like what I see and there's nothing more to do. Knowing when to stop is almost as important as getting a good start."

A COMPOSITION

Reduced to simple terms, a composition is an image formed by a series of lines, shapes, values, and colors. Throughout history, many talented artists and teachers have described and discussed the fundamental principles of composition and all have contributed to our knowledge and understanding. In the following, we give special credit to aviation artist Robert Watts for his application of those principles to compositions. Here are some basics to help your work result in good composition:

GOOD IDEAS

Begin with a good idea, one that has captured your attention as an artist and that inspires the best artistic work possible. The idea can be a portrait of a new aircraft, it can be an historic or current moment in time, or it can be an imaginative scene that you are inspired to draw. The possibilities are limited only by your imagination

➜ With a simple subject like this Learjet, a more complicated background would work. As has been mentioned, the use of differing values will focus attention on the prominent object. To be accurate in your portrayal, pay attention to such singular features as the winglets.

Use the golden mean.

and willingness to work. A good idea usually is one that an artist knows will appeal to an audience and, if appropriate, one that will meet a client's requirements. Ideas offered in this book should help provide a wide range of inspiration. We believe that the natural and man-made world around us, with its constant change, is the primary source of good ideas.

WELL-PRESENTED, WELL-DRAWN

Even the best ideas will fail to capture viewers if they are poorly expressed. There is no substitute for drawing well, which requires hard work and a great deal of practice. If the idea or subject is a simple one—for example, a single aircraft—then a more complex setting will be appropriate. If the subject is complex and includes multiple aircraft, then a simple background will work best.

Aircraft, like actors, have a "best side," wherein their key characteristics are best seen from a particular point of view. Here are two examples of military fighters with distinct wing configurations.

IN A BALANCED WAY

Your job is to create a composition that invites the viewer to focus upon the main focal point of the artwork and to circle through subordinate points before returning to the work's main focal point. Here are some approaches for successfully achieving this goal:

- Divide the space into quadrants in which values change from light in one quadrant, to a darker value in the second, still darker in the third, and very dark in the fourth.
- Divide the space sequentially with changing sizes and changing values in an asymmetrical manner.
- Create a dynamic balance between two sides of your paper, between negative and positive forms. With the repetition of an element—one shape, one color, and one line—objects can be connected visually.
- Use the golden mean, which is based on a specific mathematical equation and has been used for composition in architecture, mathematics, poetry, music, and art.

For aviation art, the placement of the horizon—the eye level of the viewer—is a key consideration. Because flying provides an opportunity to view objects on the surface of the earth in a new way, it is vital that the horizon be consistent within the work of art. There are some key rules

↟ A complex subject would work best with a simple background. As in this DH-9, Andrew Whyte prefers, "to keep the aircraft reasonably tight, to focus on it as the main subject. In a semirealistic way, I like the background, which should be easily identified, to be indistinct and not highly detailed. The background should not detract from the subject."

continued on page 112

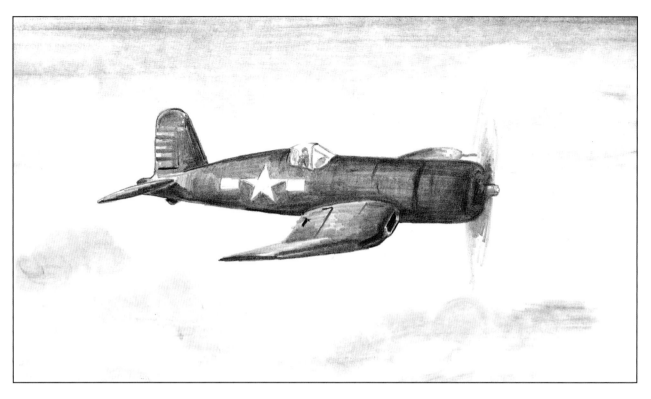

⋏ The outstanding and easily identifiable characteristic of the F4U Corsair is its unique wing, named for the shape of the seagull wing that inspired its design. This gull-wing F4U Corsair is not showing its best side to advantage.

⋎ Highlighting the negative and positive dihedral of the F4U Corsair wing is a better compositional choice. Here the characteristic gull-wing is apparent and the aircraft is easily recognizable.

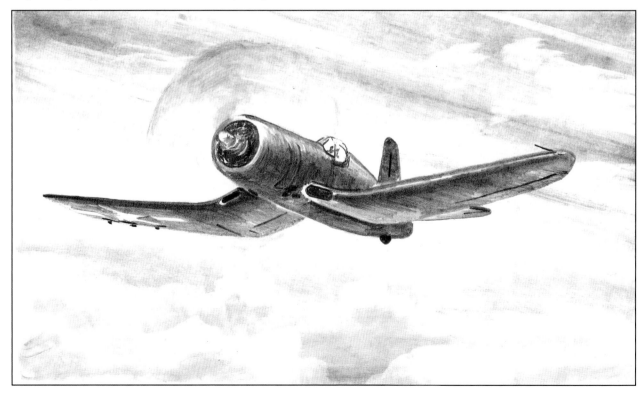

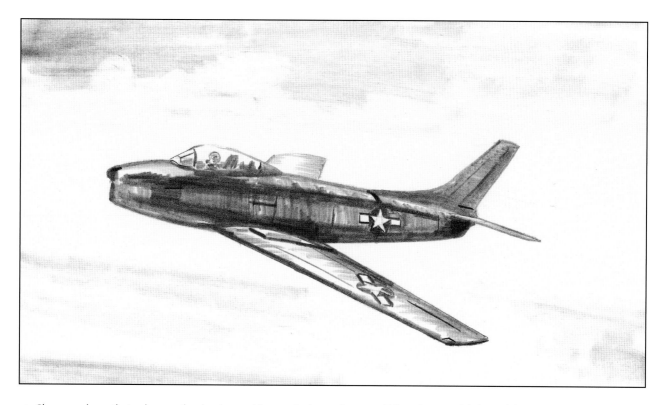

⬆ Choose a shape that enhances the dominant object to the best advantage. When the graceful slant of the F-86 Sabre jet is only partially shown, even if the linear perspective is correct, this doesn't look right to a viewer.

⬇ Showing its best side, the characteristic swept wing of the popular Sabre adds interest to the composition and is more convincing.

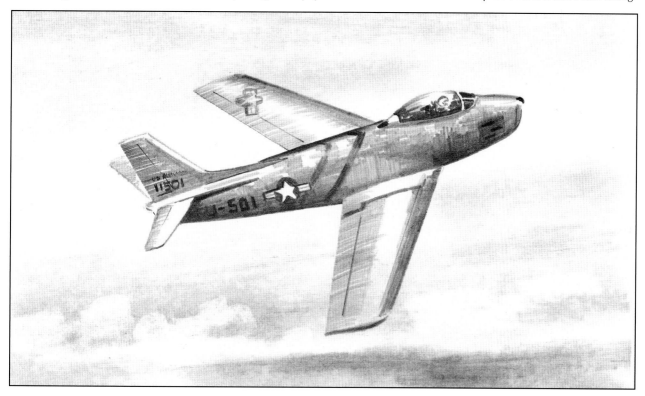

continued from page 109

> An artist's imagination
> is vital.

relating to the placement of the horizon and to the placement of objects with respect to it. Among them are:

- Do not place the horizon line in the center of the drawing.
- Do not position an aircraft on the horizon line.
- Do not place your dominant object directly in the center of your drawing.

An effective aviation art composition will require a dominant figure, other subdominant figures, and one or more different or discordant figures. A single fighter aircraft with a somewhat smaller "wingman" and an enemy shown above a simple landscape, made somewhat indistinct through aerial perspective, is but one example. There are many others discussed throughout this book.

Look to establish a balance throughout the composition. Lines define shapes. As the artist, you determine whether the lines will be faint or bold, straight or curved. Lines can be horizontal, vertical, or on the diagonal, at your choosing. A diagonal line can convey movement and speed. A horizontal line can convey mood and emotion. A vertical line can convey strength. By repetition, the weights and shapes of your lines can unite portions of the drawing that are separate in your drawing.

ACCURATE AND CONSISTENT

Much of aviation art is representational, seeking to present an image of something that exists or once existed in the man-made or natural world. If your drawings are to be representational and not impressionistic or abstract, they must be accurate and, within the drawing, consistent. Accuracy requires careful research into the scene or objects to be presented and proper perspective in the presentation. Be consistent with the sources of light—direct and reflected. Be consistent, too, with the horizon; it should not evenly divide your drawing surface.

This doesn't mean that there is little room for artistic creativity in aviation art. Nothing could be further from the truth. An artist's imagination is vital and inspiration can be depicted in many ways. If, however, facts are presented, they must be presented accurately and consistently. Viewers of aviation art tend to be knowledgeable and precise; if they find a flaw in a drawing, their attention will be lost and the objective of the drawing will be missed.

A FULL RANGE OF VALUES

An effective drawing uses a full range of values for several reasons. The full range adds balance to the drawing and serves to move the viewer's eye throughout it. Using that full range—from darkest darks, which tend to recede, through the full range to lightest lights, which advance in a drawing, also helps create the illusion of depth and enhances the establishment of a foreground, middle ground, and background. Values will help the artist direct the attention of the viewer to the

Golden Mean, a Pleasing Proportion
Andrew Whyte

To give compositions their best proportions, Andrew Whyte suggests using the golden mean. He said, "Although the following information should not be used slavishly, it is worth consideration."

A study of artworks of all genres—paintings, sculpture, pottery, and architecture—revealed that the best proportions were found in what have been attributed to the mathematician Fibonacci and the symmetry found in his sequence of numbers. Fibonacci discovered that the ratio of two successive numbers divided by the number before it gave a ratio of 1.618. (1, 1, 2, 3, 5, 8, 13, 21, 34, 55, 89, 144, 233, . . .) For example, 55/34 = 1.618 and 144/89 = 1.618. This ratio is often represented by the Greek letter Phi: Φ. The decimal value of Phi is 0.618034.

To the artist, then, it means that a finished composition will be the most pleasing if it is proportioned in a ratio of .618X to X. If an artwork is 30 inches wide (X=30), the height should be .618 times 30, or 18.54 inches. If the width of an artwork is 24 inches (X=24), the height should be .618 times 24, or 14.8 inches.

Interestingly, Fibonacci's sequence has been called the principle of dynamic symmetry. A natural phenomenon, there is a rich geometry to the proportions of the golden mean. Starting with a single rectangle (of length Φ and width 1), there is a natural sequence of nested rectangles obtained by removing the leftmost square from the first rectangle, the topmost square from the second rectangle, and so forth.

The golden mean can also offer a pleasant proportion to a painting if one *divides* the canvas with balance and counter-balance. Henry Poore suggested a simple division in his book, *Composition in Art*. On a rectangular canvas, connect two opposing corners with a diagonal. From this diagonal, connect one of the remaining corners with a line that is perpendicular to the diagonal. Through a point on the diagonal where it is met by this perpendicular line, draw two straight lines connecting each side of the rectangle and meeting the sides of the rectangle at right angles. The divisions that result are excellent bases for construction. In addition, they each in turn can be divided by the same means. The painting composed within these golden rectangles will offer the most balanced proportions possible.

By dividing and subdividing a canvas to these proportions, the ratio remains the same in each subsequently smaller rectangle and all of the rectangles can be connected by a smooth and interesting spiral (you can find more on this golden spiral at http://en.wikipedia.org/wiki/Golden_spiral). There is a rich geometry to the golden mean and, when used as the basis for a composition, the viewer's eye is drawn into the artwork with the same dynamic and rhythmic circulation as the symmetrical and beautiful spiral that is the Chambered Nautilus.

Test this theory of balanced proportion in paintings that have stood the test of time and have become classics. Artists may not have consciously chosen to use the concept of the golden mean, but, nonetheless, have created compositions that bear out the principle.

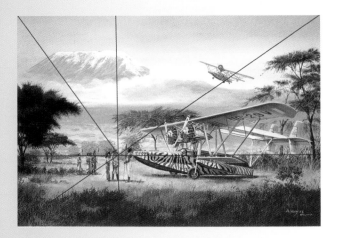 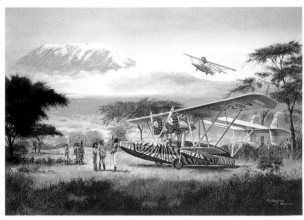

During the early 1930s, Martin and Osa Johnson were the first wildlife photographers. They used two Sikorsky aircraft, S-38 and S-39, for their explorations of Africa and Borneo. Andrew Whyte's painting shows the lines of analysis described by Henry Poore. Note that the center of interest (the Johnsons) falls exactly at the division of the painting and the balance and counterbalance of the dominant and subdominant shapes that complete the composition.

dominant, subdominant, and lesser shapes that make up the complete drawing.

Knowledge of values and of the impact of the surroundings on those values helps the artist create tonal plans for the drawings to be done. Here are four examples of tonal plan development.

Developing your tonal plans—how you plan to utilize the range of values—requires consideration of time of day, weather, and the source(s) of light, as well as compositional planning. Dramatic lighting will enhance your composition and your drawing.

AVOIDING PITFALLS

As with any artistic endeavor, develop an awareness of mistakes while you develop your eye and hand. Here are a few things to work on in this regard:

- Avoid bad tangencies.
- Be sure that vertical objects do not stop the movement and action of your drawing. Use vertical lines to convey strength. Use horizontals to express action and motion.
- Lines drawn directly to the corners of your drawing will carry your viewer's eyes out of the scene. Do not point anything directly toward any corner of the drawing. Do not place objects just touching the sides of the drawing. Any object that overlaps another should clearly overlap.
- Avoid including similarly shaped objects that are the same size and that are evenly spaced.
- Beware of inaccurate perspective, often brought on by excessive reliance on photographs. Take a second look at the F6F Hellcat in chapter 5.
- Be diligent and accurate in doing your research, in depicting the correct movement and position of aircraft control surfaces, and in showing the way light illuminates aircraft surfaces. Look again at the B-24 Liberator in chapter 3, at the Mustang and Spitfire in chapter 1, and at the "imaginary plane" in chapter 5.

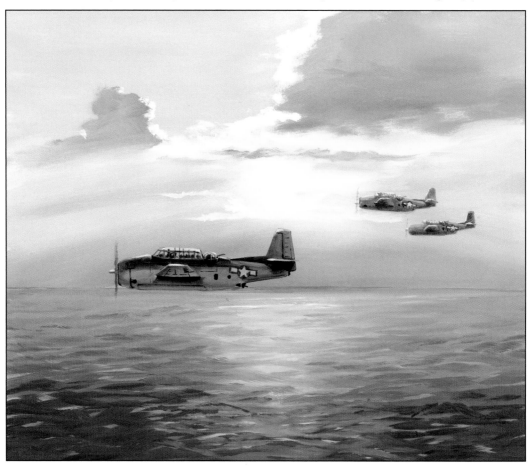

⬆ Pay attention to the location of your primary subject. This torpedo bomber is "perched" directly on the horizon line—a compositional error to be avoided. Place your objects above or below the horizon and avoid having the object and the horizon exactly parallel one another.

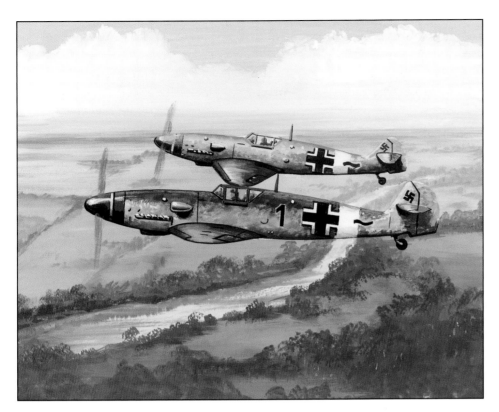

✦ Among the pitfalls to be avoided are bad tangencies—the contact of a line, curve, or surface touching but not intersecting another. One aircraft's wingtip should not exactly touch the top of the canopy of an adjacent aircraft in formation. The lower edge of the vertical stabilizer and rudder should not align with a row of trees in the distance below. Don't allow a paint stripe on the fuselage of an aircraft to match the width and location of a stream meandering far below. Don't allow the spinner on the propeller to abut a distant road or vertical line.

← Horizontal lines contribute to forward motion, diagonals give the illusion of speed. Vertical lines, especially those that intersect the dominant subject, bring an abrupt halt to the action you are trying to portray. This B-24 Liberator seems to be stopped in midair by industrial smokestacks.

▲ Avoid creating lines directly to the corners of your image. They will draw the viewer's eye away from the scene. Avoid having any part of the dominant subject just touch the edge of the paper. See that overlapping subjects clearly overlap.

THUMBNAIL SKETCHES

Remember as you quickly create thumbnails: a good composition starts with a good idea, is well-composed, dramatically lit, and well-drawn. There is no focal point if all of the objects of your composition are the same size. The elements of your composition—its key shapes—must be placed appropriately in relation to one another.

Making thumbnail sketches, as described in chapter 4 in *Putting Your Pencil to Work*, will be valuable when preparing your composition and will help you avoid pitfalls. The sketches need not be detailed, but you will need to produce enough of them to prove to yourself that your idea is well-presented and balanced, uses a full range of values, and has successfully avoided the pitfalls that make drawings fail.

ASAA artist fellow Richard Allison, an art teacher and an award-winning artist, spent a stint in the U.S. Army. He has worked extensively in pencil drawings and has considerable experience in alkyd media and with oils. He said, "The mark of a successful aviation painting is how aircraft and nature complement each other. Artwork with a blank or indifferent background becomes only a rendering. A painting consisting of aircraft and environment harmonized in an effective composition is true aviation art."

↓ Similarly shaped objects of the same height and evenly spaced from one another should generally be avoided. Aircraft flying in formation or parked in a line on an airfield ramp are an exception to that rule.

◄ Drawings like these enable the development of a tonal plan for a drawing and assist in using a full range of values in the foreground, middle ground, and background. In general terms, low values would be used in the dark sector, middle values in the sector shown in gray, and high values in the white area. Value drawings can give you practice in creating good compositions. Tonal drawings help you become consistent with the placement of objects in relation to the horizon and in respect to the light source, its resultant shadows, and reflections. In this daylight scene, the darkest darks or lowest values are in the shadowed foreground. The subject, the aircraft, is located in the middle ground.

◄ A night scene with a dark sky, which is a lower-key drawing, the middle and foreground are lighted. Note the aircraft's higher values on the wings, canopy, upper fuselage, and tail surfaces.

◄ In this composition, a daylight scene, the middle ground—lower in value—is in dark shadow.

◄ When the composition requires a night scene, select your lighting carefully and be consistent. Here the composition is fully lighted in the middle ground with midrange values in the foreground.

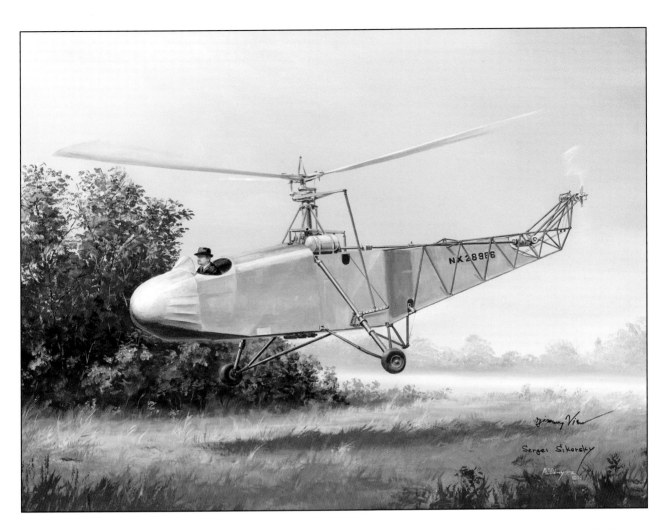

▲ Sikorsky's VS-300, the first practical helicopter in the United States, was flown with Igor Sikorsky at the controls. First flown tethered to the ground in 1939 and untethered in May 1940, the prototype was modified and upgraded repeatedly. It flew for over one hundred hours before being retired to a museum. It proved to be the forerunner to the R-4, the world's first production helicopter, which saw service in World War II.

Putting the Picture Together

Robert Watts

If you don't know how to draw like gangbusters, you'd better get hot on that project. There is no substitute for good drawing!

— *Robert Watts*

Robert Watts, while talking about making a composition, said, "Planning—the muscle in your brain gets stronger as you use it. . . . Look into every aspect of your proposed painting. . . . It never ceases to amaze me what can go wrong with a composition. It is part of the mystical process. The fatal error is not seeing those mistakes once you have done them."

Watts insists that a good composition starts with a good idea. It must be well-composed, well-drawn, and made up of good shapes—the overall shapes that form the picture. It should be dramatically lit and with a full scale of values. Historical accuracy, technical accuracy, and/or degree of detail can enhance the effect, but are not the primary components.

Watts suggests mentally imagining the scene to begin. Consider how weather, light, values, and shadows will enhance the scene. Repeat this process for several arrangements.

Gather photographs of the aircraft you plan to paint and include photographs that might give additional arrangement possibilities. Gather cloud and background photo references appropriate to the respective arrangements. Clip and file reference material often for just such planning purposes.

Work up a series of simple thumbnail sketches. (Watts uses Prismacolor gray markers with a fine and broad tip on one pen that keep an artist from getting too fussy about detail.) Watts said, "Get the darkest dark down and let the white of the paper work for highlights. Prevent the markers from becoming muddy by using a good grade rag marker paper that doesn't bleed."

Once a good composition is established, use a tracing paper overlay to experiment with background and cloud shapes. Select two or three thumbnails to enlarge to preliminary drawings, perhaps to 8.5 inches by 12 inches. This is the stage that determines whether the composition is worthy of becoming a painting. When the picture has good composition, pleasing relationships, shapes, balance, and believability, Watts said, "Go back to reread the rules. If the picture has none of the pitfalls, do a fairly tight drawing. When satisfactory, have that drawing Xerox-enlarged on bond paper to the final size, preserving the exact relationship of all the elements. On good-quality vellum, overlay the enlargement and do a finished detail drawing."

Watts has created a list, a basic rules of composition, with the admonition, "Violate at your own risk." Among his basics, he suggested avoiding tilting the horizon and the subject in the same direction, yet recognizing that, when nothing is parallel to the edge of the page, action is implied. Avoid intersecting the aircraft with anything approaching a 90-degree angle. Avoid too many similarly sized, similarly shaped (excepting a formation of aircraft), and similarly spaced objects (trees, clouds, and so forth). Avoid overcrowding.

Compositions have the chance of success when:

- An artist starts with a good premise, a believable image, and good composition.
- A full range of values is used.
- Perspective is correct.
- The picture is well- and imaginatively lighted.
- The elements are linked through value and placement.
- Good shapes are selected.
- Hard and soft edges are appropriate.
- Atmospheric perspective exists.
- A sense of movement exists.
- A sense of drama exists.

Learn to draw with these concepts in the back of your mind. Check the basics again after your composition is nearing completion.

Watts added, "There are no shortcuts. If you follow this somewhat rigorous approach, you will be doing better work than you thought possible."

Dicing the Wall: In this depiction of a P-38 Lightning patrolling German defensive fortifications, note artist Robert Watts' mastery of creating a foreground, middle ground, and background in his paintings. Note, too, his successful use of dominant, subdominant, and sub-subdominant objects in each of his paintings. *Robert Watts*

↟ A biplane airliner, the Curtiss Condor made a debut at the same time as the Boeing 247 and the Douglas DC-2. Serving fledgling airlines in the United States and abroad, its useful life was cut short by the sleek and faster all-aluminum monoplanes.

⬆ As the U.S. Air Defense mission aged, the Air National Guard—represented by a pair of New Jersey Air National Guard F-106 Delta Darts—assumed the mission from the active U.S. Air Force. This was a significant step toward today's total force.

I hope [the information to] follow will help illuminate for you what making art in the computer is all about and decide if going digital is right for you.

—John Ennis,
Going Digital: An Artist's Guide to Computer Illustration

TOOLS OF THE TRADE FOR DIGITAL ILLUSTRATION

All art begins with an idea. The artist is the creative source, whether drawing, painting, sculpting, dramatizing, or writing. Sometimes the idea springs from artist's imagination or is triggered by a scene or event the artist witnesses. An idea may come from a client seeking a depiction for a particular purpose, such as, a portrait or a book cover. Given the idea and the artist's concept of how that idea is to be expressed, the artist's next challenge is to decide which medium to use. The work could be a pencil or pen-and-ink drawing, a painting in watercolor, oil, or acrylic done with a brush or an airbrush, or a digital depiction using computer-based software. This chapter and the next will discuss the tools—hardware and software—and the techniques of digital illustration.

TRAINING

Inevitably, you will experience a learning curve with a new tool, which may be steep depending on your computer experience or expertise. You may need outside help, such as basic computer courses in predominant application software packages such as Adobe Photoshop. These courses are offered by community colleges, commercial schools, or local adult education classes. Prices, schedules, and course lengths vary; shop around, starting with the Internet. If you have computer experience, you might take appropriate online courses; interactive courses allow you to ask questions and get feedback. As always, better courses with better instructors will save you time and money in the long run.

You will want to research specific hardware and peripheral manufacturers and software packages. If using Internet sources, be sure to crosscheck the various websites for the most accurate and up-to-date information.

Finally, some software programs have online tutorials to help clarify issues or address problems you are facing. Other program users occasionally submit alternative suggestions that might be of use to you. As you gain expertise, you can start submitting your own solutions to become part of an information-sharing network among program users.

COMPUTERS

The computer probably will be your most important and expensive tool for digital illustration. Digital illustrators recommend that you comparison-shop before buying the fastest, latest, most comprehensive model you can afford. In the rapidly changing computer marketplace, carefully compare and understand prices, features, and available support; all will influence

your choice. Buying a computer is somewhat like buying a car; you can learn the prices, features, reputation, resale value, and warranty details rather easily; but, until you test-drive it, you may not be convinced. It is also somewhat like learning to fly, to sail, or to ski; the equipment you learn on may well be the one you like best. Use the Internet to investigate all that you can; talk to other artists about their experiences; and try to test several models to see what will best meet your needs for speed and for memory space.

Computer memory comes in internal and external forms and some programs commonly used by artists require computers with a large storage capacity and good organization systems. Computers constantly are being built with larger memory capacities. For example, the basic hard-drive memory provided by Macintosh and Dell is 250 gigabytes, expandable in one case to 500 gigabytes, and in the other to one terabyte, which is one trillion bytes. In 2008, a minimum of 160 gigabytes of hard-drive space seems to be the norm. Hard-drive memory can be enlarged internally at the time of purchase and later supplemented externally with several devices. The hard-drive memory is often described as the computer's filing cabinet where key elements of your work—programs, records, text, photographs, and artwork—are stored. Pixel- or bitmap-based programs use large amounts of hard-drive memory. You need enough to store your programs and your art. After you have been using your computer for a while and storage space has become limited, you can check on removable data storage devices, such as CD and DVD disks and external hard drives. All can provide added memory and valuable organization for your records and your art.

RAM—random access memory—is the computer's active memory, the one used to run programs. Here, too, pixel-based programs use lots of RAM whereas vector-based programs, like Adobe Illustrator, need less. In 2008, software manufacturers were providing two gigabytes of RAM, which is expandable to four gigabytes. It is relatively simple to do your homework on computer speed and memory, but it may be more challenging to understand the ramifications of the numbers. Training, study, and discussion with other artist users will help. Don't scrimp on memory capacity.

An additional consideration is the computer's video card, which is responsible for generating and outputting graphics to the computer monitor. The computer's specifications will indicate whether the video card provided is recommended for graphics software. If not, upgrading is possible.

The computer's speed is a function of the processor; current computers incorporate a range of processors. At this writing, dual-core processors are built into some personal computers and quad-core processors are becoming available. With the help of reputable retailers and knowledgeable artists, determine which processor is best for your needs and buy the fastest you can afford.

All art begins with an idea.

PROTECTION

We have mentioned preserving your files with two basic types of devices. Computer disks—CD-Rs, DVD-Rs, CD-RWs, and DVD-RWs—offer different storage capacity. You may want to use some of each. It is vital to keep records so you can retrieve material quickly. You will want to understand your computer's disk burner and the system software that controls it.

External, portable hard drives also can protect work stored on your computer. Two reasonably priced devices are the SmartDisk FireLite, which provides forty gigabytes or more, and the Maxtor Peripherals personal storage device that provides eighty gigabytes to one terabyte of additional memory. The smallest and most portable memory supplement, one that is gradually replacing computer disks, is a USB flash drive. This small device can hold more data than a disk and is more reliable because it does not rely on moving parts. Understand the several types of extra memory so you can plan and organize your work and take it with you if needed.

The second hazard to your computer and peripherals is an electrical-supply disruption. A lightning strike, the worst case, can destroy everything in your computer, but brownouts due to electrical system overloads can be damaging, as can temporary voltage spikes. A good surge protector (also known as a transitory volt suppressor) provides some insurance, or you may want to invest in an uninterruptible power supply (UPS) device, which provides a short-term battery backup in the event of a power failure, giving you some time to save your work. If there is lightning in the area, turn off your computer and peripherals and disconnect them from the electrical power supply. Above all, remember to save your work regularly.

PERIPHERALS—MONITORS, KEYBOARDS, AND MICE

Essential peripheral equipment often will be offered as a package with the computer. But, you still may have to choose among a variety of monitors, video RAM, a keyboard and a mouse, among other things. Monitors come in many sizes, although twenty-inch flat-screen monitors seem to meet most illustrators' needs and provide essential color choices and views of your work. They require a large amount of video RAM (VRAM) to make possible a huge range of colors. When considering purchase, shop carefully and opt for the biggest and best that fits your budget. Choose the keyboard that is best for you, and consider mouse options, connected or wireless, that work best for you. A mouse is relatively inexpensive and easier to upgrade over time as your needs change.

PRESSURE-SENSITIVE GRAPHICS TABLETS

Although it is possible to draw using a mouse, it is easier and more satisfying to use pressure-sensitive graphics tablets. These devices come in a variety of sizes in drawing surfaces and in the footprint required on your studio workstation. For example, one tablet with a 6x8-inch surface

You'll need to do your homework.

has a 10x13.5-inch footprint. Modern computers provide the necessary USB interface capability required by most graphics tablets.

In addition to the size and the interface, the pressure sensitivity of the tablet must be considered. Pressure sensitivity ranges upward from 256 to 1024 pressure levels. The higher sensitivities offer greater control over line thickness, transparency, and color, and a more responsive and natural feel during use. Tablets come with a variety of pens or styluses; some require batteries and they may be tethered to the tablet, making misplacing them less likely. Some manufacturers offer additional pens to meet different programmable needs.

So, once again, you'll need to do your homework. The website www.graphicssoft.about.com provides good information.

PRINTERS

It can be as challenging to choose a printer as it is to choose other computer hardware devices. First determine what your printer's primary use will be. Do you want black-and-white text or color graphics? How much volume will you need to produce? Laser printers, which can be more expensive, produce very sharp text; ink-jet printers are reputed to be superior for color graphics. Prices vary with capability, and overall costs must include the ink cartridges you will need. The old adage "pay me now or pay me later" applies to printers and ink cartridges. Here, too, check out Internet search engines such as Google for current descriptions of specific printers on the market. You may want to consider the multifunction printers (MFDs) that include copying and scanning capabilities. These can save space on your studio desktop, if that is important to your planning. You also may want to consider using a lab or service bureau that can produce the highest quality and greatest size range you need. In addition to using the Internet, ask the experts what they use and why; many are very willing to share their expertise.

SCANNERS

Scanners enable a user to upload text, graphics, and photos into the computer. Flatbed scanners, some of which are incorporated into MFDs, permit direct insertion of almost any form of text, photos, artwork, and book pages. They are rated in terms that define the numbers of bits per channel that they can handle, and newer ones use USB interface. Although there are several types of scanners, the flatbed is generally the most useful.

SOFTWARE

Hardware devices cannot do much without operating systems and software, which are the applications programs that direct them. Each software program lists system requirements, spelling out computer features required to operate that program. Hardware is the most expensive, and software requires the most time to learn, practice, and

It is vital to keep records
so you can retrieve material quickly.

continued on page 130

Lockheed U-2 Illustration

John Luchin III

At the National Museum of the USAF, a commemoration of the fiftieth anniversary of the Lockheed U-2 high-altitude reconnaissance aircraft was being planned. In addition to the artifacts to be exhibited, a large-scale illustration of the aircraft coming toward the visitor was desired, and one of the exhibit designers was charged to create such an illustration.

Step 1: A thumbnail sketch of the aircraft was done to show the exhibit planners what the artist had in mind. The concept was approved.

Step 2: This reference photograph was taken of the U-2 hanging from the ceiling in the museum's Cold War Gallery and facing away from most visitors.

Step 3: This line drawing was created from the reference photo. The notes shown and the sketch of the engine intake were made on site.

Step 4: The line drawing was then scanned into the computer and opened in Adobe Illustrator. The basic shapes and lines were then traced on top of the scanned-in pencil drawing.

Step 5: Basic color was added to the shapes created from the line drawing.

Step 6: Highlights and shadowing details were then created on top of the basic shape layout to provide dimension.

Step 7: Final details like the small red light on the lower fuselage are added to the computer-based illustration and the high-altitude background environment is added using a gradient fill in Adobe Photoshop.

Step 8: When finished, the illustration was saved as an EPS file and sent to a contractor for reproduction. This is the fiftieth anniversary exhibit as it appears today with the 15x4-foot painting hanging in the background above the physical artifacts associated with the aircraft and its military mission.

Images courtesy of the National Museum of the USAF

continued on page 127

Continue improving your craftsmanship . . .
and keep drawing.

use. Because of the rapid growth in the use of personal computers of all types and sizes, the range of software programs has proliferated. While it would be impossible to provide a complete and current list of all programs useful to artists interested in pursuing digital illustration, there is one family of programs provided by a single manufacturer that is widely used, plus two programs provided by other vendors that have also proven useful to illustrators seeking a 3D capability.

Adobe Systems Incorporated, based in San Jose, California, continues to improve its entire family of individual software products and to package them in a variety of focused suites. Creative Suite 3 Design (CS-3) consists of six application programs of value to artists and designers. Chief among the six are the trademarked Photoshop and Illustrator. The former is a bitmap- (or pixel-) based image editing system with sizing, color selecting/ correcting, layering and other capabilities. The latter is a vector-based art-creation program. These two programs can work together and with the other programs in the CS-3 Design package. Adobe provides training, trials, and support, and prices are readily available. The website www. Adobe.com and detailed user guides provide introductory and advanced information; both are highly recommended.

Another useful program for digital illustrators is LightWave 3D produced by NewTek of San Antonio, Texas. This program, which also is upgraded frequently, provides sophisticated features for the creation of three-dimensional effects. The website www.NewTek.com provides descriptive material including available training, trials, and prices. This is a complex tool, requiring skill and experience.

A fourth program with 3D features is Google SketchUp, which you can access directly on the Google search engine and download to try it out. It is advertised to provide both design utility and fun.

As you seek the right software for your needs, be patient. All current programs are powerful, with a great many features, and all of them take time and effort to learn. Become familiar with your computer and its peripherals and then challenge yourself with the first of your software programs. Talk to an expert or seek the assistance of a pro. Don't rush it.

BUYING DIGITAL ILLUSTRATION TOOLS

In a rapidly changing computer marketplace, you cannot anticipate, or wait for, each new hardware device or software package to come along. Try to define your needs, be prepared to question, and listen.

Retail stores specializing in electronics usually stock a range of products and may allow potential customers to give them a trial run. Be prepared with an idea of your needs, and ask questions. While retailers are motivated by sales volume and profit margins, your motivation is to get the best product for you for the best price. You may want to stick with known brands with good reputations for quality and support. Many products are discounted, especially for students, and, if you qualify, take advantage of those discounts and sales.

Shopping online can be efficient and cost-effective. You can find manufacturers' full product range, and online shoppers may find such added incentives as training materials and trials. Many online discount and retail stores also offer a wide range of products, putting you in a good position to comparison-shop.

Meanwhile, as you shop for and learn about digital illustration, continue improving your craftsmanship with pencil, pen-and-ink, charcoal, and paints, and keep drawing.

> Become familiar with your computer and its peripherals.

Son Tay Raid Illustration

John Luchin III

In 1970, President Nixon approved a Pentagon plan to rescue prisoners of war from the Son Tay prison in North Vietnam. This top-secret rescue was to be made at night in near-total darkness. An exhibit of the Son Tay prison was planned as part of a larger tribute to U. S. prisoners held in captivity by the North Vietnamese. An illustration to introduce the rescue mission was to be prepared even in the absence of photographs of the rescue attempt.

◄ *Step 1:* **As part of the research for the illustration, the artist obtained this photograph of a training flight that simulated the plan. He also talked with one of the mission's leaders and researched the weather and the terrain features encountered.**

Step 2: This sketch and the study painting in oil were done to finalize the composition and the limited lighting. At this point, it was decided to create the final illustration as a digital painting in Adobe Photoshop.

Step 3: A scan of the original sketch was opened in Photoshop and a flat color was added to the background layer.

Step 4: On a new layer, basic shadows were painted on top of the two background layers.

Step 5: More shading was added to the basic shapes.

Step 6: Highlights were added to capture the moonlight and terrain features using the texture brushes in Photoshop. Those same texture brushes added to the sky as well.

Step 7: This is the final illustration as it appears on the exhibit panel on display.

RESCUE ATTEMPT:
THE SON TAY RAID

In 1970, US forces attempted to rescue POWs from captivity in North Vietnam. American officials decided a daring operation in the heart of North Vietnam was worth the risk, and President Richard Nixon asked the Pentagon to explore "some unconventional rescue ideas."

SOME DIGITAL ILLUSTRATION TECHNIQUES

↟ Museum exhibit designer John Luchin III sits at his computer workstation, which boasts key elements: the personal computer, keyboard, monitor, printer, and a pressure-sensitive graphics tablet. On the staff of the National Museum of the USAF, he contributes his talents with digital illustration to new and varied exhibits. *Courtesy of John Luchin III*

Now that you are introduced to digital illustration tools, you will begin another learning curve. This chapter introduces a variety of techniques to produce your art.

PAINTING

You draw or paint with a computer essentially the same way you do with pencils, pen-and-ink, and a whole variety of brushes. But with the computer, you paint with a pen, or stylus, and a pressure-sensitive tablet (and some may use the less-efficient mouse to paint). What you draw or paint on the tablet is displayed on the computer monitor. You can instruct the pen to act like drawing implements from a range of brushes to airbrushes, pencils, charcoal, chalk, markers, and more. Because the tablet is pressure-sensitive, you can vary the darkness and thickness of the lines you are drawing and achieve the edges you wish. And you can undo anything you have done if you are dissatisfied. You don't have to start over.

COLOR

The full Pantone color chart is available on command with Adobe's Photoshop and Illustrator. Available palettes also permit mixing colors although it may take time and practice before you have a full understanding of it. You will find the "undo" command useful as you experiment with various color combinations and decide which ones you do and don't like.

COLOR CORRECTING

In addition to the undo command, which requires you to pick a replacement for that segment you've undone, you also can adjust the hue, value/saturation, and lightness of a color in Photoshop's Hue/Saturation dialog box. If you choose, such color-correcting can be done for single layers or for specific segments of a layer. The flexibility is powerful.

LAYERS

When painting with natural media, such as oil paint, many artists apply paint in layers, starting with the background and moving forward to the foreground the focus of the painting through the middle ground. In this way the middle ground appears to be in front of the background and the foreground in front of the middle ground. This is one of the ways in which depth is developed in a two-dimensional depiction. The same thing can be done in digital art, but with greater flexibility. Each layer, which is visualized by the artist as a separate entity, is independent of the others until the final illustration is assembled. Because of this layering, each segment or layer can be edited and modified without affecting the others and the artist remains uncommitted to each layer until choosing to group them together. The creative skills to visualize and define the several layers in a digital illustration are supported by each of the mentioned software programs and by the experience of the artist.

MASKING

Prominent software programs for artists also offer masking capability, which allows the artist to isolate a specific portion of a work while protecting the remainder of the image from his or her actions. In using natural media, this is done with masking tape, which requires experience, skill, and a clear idea of the reason for the mask. The same is true in the digital world, except that on the computer you can undo unsatisfactory work with a single command. Full command of the computer's capabilities will come with training, experience, creativity, and, perhaps most importantly, patience. Experienced artists who have worked for a long time with natural media tend to forget how long it took them to become proficient with those tools and may feel impatient with the time it takes to become equally proficient in the digital world.

You will find the "undo" command useful as you experiment.

IMPORTING AND EXPORTING

Because of advances in technology and intraindustry cooperation, this subject is not as important today as it once was. Older computers and peripherals such as scanners required greater interface efforts than do current hardware and software components. The user guides for the Adobe line of applications programs continue to provide interfacing instructions for cases in which they are necessary. The interface between Macintosh and personal computers, once difficult and time-consuming, is no longer a problem and the once-troublesome flow between software programs has been greatly improved. As you acquire software and hardware components be aware of the required speed and memory characteristics and insure that your purchased components meet those requirements.

For example, in 2008 in a Windows platform, Adobe Photoshop CS3 requires an Intel Pentium 4 (or equivalent) processor with Microsoft Windows XP or Windows Vista; 512 MB of RAM; 64 MB of video RAM; 1 GB of available hard-disk space; a DVD ROM drive; and a 1024x768 color monitor with 16-bit color video card. A Macintosh platform requires PowerPC G4 or G5 or Intel multicore processor; Mac OS X version 10.4.8-10.5 (Leopard) software; 512MB of RAM; 64MB of video RAM; 2 GB of available hard-disk space; DVD ROM drive; a 1024x768 color monitor with 16-bit color video card. Both platforms require additional hard-drive space during installation and both have added requirements.

SAM Breaks Illustration

John Luchin III

In preparation for an exhibit at the National Museum of the USAF, the exhibit designer created this technical illustration, part of an overall tribute to the air crews who flew the Republic F-105 Thunderchief fighters to hunt and destroy Soviet-built surface-to-air missile (SAM) launch sites in North Vietnam. Known as Wild Weasels, these air crews learned to evade SAMs fired at them; they called the evasion maneuvers SAM Breaks.

Step 1: Consultation with researchers and a former Wild Weasel pilot led to the creation of the thumbnail sketches that became the basis for the final composition.

Step 2: The plane and missile elements of the illustration were created as separate files. Plastic models of the F-105 and SAM were photographed and the photos were the basis for drawings created in Adobe Illustrator. Additional consultation with the Wild Weasel pilot helped finalize the positions of the aircraft and the missile.

Step 3: The background for the illustration was created using a gradient fill for the sky and a halftone filter for the ground. The halftone pattern was distorted into the correct perspective and a blur was added to blend the earth into the sky.

Step 4: The plane and missile elements were copied and pasted from their respective files on top of the background layer.

Step 5: The motion trails were created using the pencil tool to trace out the motions of the plane and the SAM. The trail shapes were then moved to a layer behind the F-105 and the SAM, and the transparency of the layer was lowered to give it a ghostly effect.

Step 6: Detailed technical drawings of the F-105 and the SAM were copied and pasted into the upper right corner and the text boxes and number buttons were added.

Step 7: Finally, the text was imported from a Microsoft Word document and added into the text boxes. The text color, font, and sizes were determined in Illustrator after the import and the final illustration was complete.

Images courtesy of the National Museum of the USAF

Lockheed-Martin F-22 Raptor

John Luchin III

The first public display of the United States Air Force F-22 Raptor, built jointly by Lockheed-Martin, Boeing, and Pratt & Whitney, began in January 2008. This production-model aircraft was used for extensive testing prior to the initial fielding of America's first fifth-generation fighter. The illustration was created in conjunction with the display's opening.

Step 1: **This mural illustration combines Adobe Photoshop with NewTek's LightWave 3-D modeling software. Sometimes more than one program is needed to accomplish the desired illustration technique. In this case, the first step was to create a basic sky in Photoshop using cloud filters and the airbrush and eraser tools.**

Step 2: **The next step was the creation of a three-dimensional model of an F-22 in LightWave. This model will be used to create the basic composition and lighting reference for the final illustration.**

Step 3: **This F-22 digital model was then opened in Layout in order to add the lighting effects for the illustration. Color and textures can be added to the model in this program, but the purpose of this model is to serve as an underpainting in Photoshop. Once the lighting and camera are correct, the snapshot is saved as a tiff.**

Step 4: The two snapshots of the same F-22 model at different angles are then pasted into the sky background that was created in Photoshop earlier. The model's details are only roughed out because they will be painted over in a new Photoshop document.

Step 5: Combining the airbrush tool with masking and using filters, the two F-22s begin to take shape.

Step 6: Small details like camouflage were added to the background F-22. The sky was also lightened in the upper left corner to follow the shading on the F-22s.

Step 7: The illustration was cropped and final details were added. Colors were refined on both the F-22s and the sky to create a more cohesive atmosphere. Warm highlights were added to balance the cool blues of the sky and the airplane's bodies. The sky was darkened to create more contrast in the background and the final texture details were added to the F-22s.

Images courtesy of the National Museum of the USAF

T here are no "tricks" involved in painting. Some beginning artists think that all they have to do is learn tricks from a professional and their job is made easier. That is simply not true.

— *Andrew Whyte*

CREATING PAINTINGS
Aviation as Inspiration— A Modern Art

From earliest times, birds with wings outstretched have imbued humans with a longing to share their realm. Awed by the natural world, the artistic have wished to translate beauty to visual works. In choosing to paint aircraft, you have joined a chorus of aviation artists creating art that excites and intrigues. You are among like-minded people who share your love of the skies and who create fine art devoted to that sky and the machines designed to operate there. You are welcome to share their passion and to be inspired.

If you have doodled pictures of airplanes on the edges of your school papers, enjoyed building aircraft models, found fascination with aircraft of all types, and now seek to represent their beauty and speed in art, you share many qualities with the world's best aviation artists. With few exceptions, all of them started with a sincere interest in flying, eyes that scanned the skies at the sounds of overhead engines, model aircraft building, and drawings that might have distressed their schoolteachers. If only those teachers could see their works now and recognize the successful artists they became. Just like you, they share a deep reverence for the mystery and the awe of flight and of the exploration of outer space.

As you perfect your skills drawing aircraft and creating aviation paintings, start to think of yourself as a storyteller. Aviation and the chance to view the world from high altitudes introduced this relatively new artistic career field. Landscape artists long have used shape, line, color, tonal values, and texture to produce sensations of light. Aviation offers a new way of viewing the world and moves mankind from an earthbound perspective to flying through the galaxy, to space where human life can adapt and remain. It has added impetus to finding ways to show vast reaches of space, atmosphere, speed, and motion.

A PAINTING IS CREATED

To bring together all of the information from previous chapters, Andrew Whyte has chosen historic incidents he recreated in works that tell a visual story. He researched carefully, created thumbnail sketches, made descriptive geometry layouts, completed a value sketch and a color rough, and finally addressed his canvas.

RESEARCH

When commissioned to create an artwork for *Aviation History* magazine, Whyte started researching the facts and details of the story he was assigned:

- The aircraft was a Martin pusher biplane, built in 1912, powered by a Curtiss engine.
- The ship, *General Guerrero*, plied the waters of the Gulf of California from Guaymas, a major port in the state of Sonora, Mexico.
- Pilot Didier Masson obtained his pilot's certificate at the Martin Flying School and was offered use of the biplane and a good salary to fly for Colonel Alvaro Obregon, a leader of rebels fighting forces of the Mexican Federal Government.
- In 1913—in one of the earliest uses of an aircraft in the attack on a ship at sea—Masson, with his bombardier and mechanic, an Australian named Thomas Dean, piloted the biplane in five sorties against the gunboat, scoring, at best, one near-miss.
- The attempts themselves were early harbingers of air attacks of the future.

↟ *A Pioneering Airstrike*: Glenn L. Martin's 1912 Martin pusher biplane figured in one of the earliest airstrikes against a ship at sea. During the Mexican Revolution, the Martin was hired by rebels to attack a Mexican Navy's gunboat in the harbor at Guaymas, Sonora, Mexico. Maintaining two thousand feet to avoid the business end of the ship's guns, mercenary pilot Didier Masson, a Frenchman, failed to score a hit, but was credited with a near-miss. Changing values in the sea and the mountains give the necessary shading to create the distances involved. The elements at the central focus—the aircraft, the ship below, and the water spout caused by the bomb tossed by Masson's passenger and bombardier—tell the story.

START WITH THE PRELIMINARIES

Start with thumbnails, sketches, and an initial drawing. Make several studies and create a drawing, focusing on composition, proportions, perspective, and tonal values. When you have a drawing that pleases you, transfer it to the canvas or panel with a light pencil, charcoal, or a thin wash of a neutral color. Some artists use a translucent tracing paper, some project the drawing onto the surface to be painted, and some draw freehand after having divided the drawing via a grid system to help keep the shapes accurate.

Limit your color choices. By mixing your own grays, browns, and other earth tones, you will be able to better manage your cool and warm colors and avoid the prospect of muddy results. Choose the palette of colors and remember that complementary colors will enliven one another. Don't underestimate the power of negative space. Seek balance in your composition and in your choice of colors.

Rather than concentrate on drawing firm edges to outline your objects, allow background color to meet the color of the object and shape the form without a line. Pay attention to your source of direct light and to the reflected light. Establish your darkest tonal values and lightest tonal values in your center of interest.

In oil painting, you can speed up drying time by adding drier or solvents. Conversely, you can slow it with oils as the thinning agent. In layering either acrylics or oils on the surface, use the thinner, faster-drying additives for the undercoats and use the slower-drying combinations for the outer layers. In concentrating on your center of interest, be sure that you don't neglect the other portions of the canvas.

Try to get your aircraft to seem to soar or to move through the surrounding air. If it looks as if you can cup your hand behind your aircraft, you have successfully created the important atmospherics inherent in the world of flying and in the realm of aviation art. As renowned artist Robert Grant "R. G." Smith has written, "I like to put an airplane *in* the picture, not *on* it."

THE HUMAN FACTOR

As you become more adept at painting your favorite machines, you will notice that all aircraft operate with humans in and around them. Make an effort to learn to draw humans from life, posing models in different stances to capture the nuances of the human figure in three dimensions. Identify your light source and choose highlight, light, shadow, core shadow, reflected light, secondary highlight, and the cast shadow. Recognize that virtually all lines in the human body are gently sweeping curves. When using a model, improve your drawing skills by drawing single parts, such as the hand, the arm, or the torso. Enhance your powers of observation by making sketches focusing on particular areas of tension in the human form that indicate gestures, such as the folded arm or the outstretched hand.

Practice applying linear perspective to the figure to show changes that occur when limbs reach toward the viewer and must be foreshortened. You often will use the foreshortening technique to correctly depict the airfoils of aircraft; the same perspective applies to the human figure that is approaching the viewer or moving away. With this method an artist can add depth and drama and show a figure at various angles.

Also learn the muscles and skeletal armature of the human body that give shape and form. This understanding better prepares you to correctly depict the human form and the other aspects of the scene. Study the works of several artists who are known for their excellent drawings that feature the human involvement in aviation.

Whyte was commissioned by the U.S. Coast Guard (USCG) to create a painting depicting a daring rescue of the *Olo Yumi*, a thirty-five-foot pleasure boat that was swamped during the Mariel Boatlift from Cuba in 1980. The scene was to include a primary helicopter, a coast guard cutter, and, overhead, a C-131 aircraft. After conducting his research, drawing thumbnails sketches, deciding upon his composition, and painting his work, his completed art

was presented to the coast guard at the Coast Guard Academy, New London, Connecticut, in December 2007.

The story was compelling. In April 1980, as Cuba's economy took a sharp dive, tensions rose and Cuban President Fidel Castro agreed to an impromptu exodus of Cubans seeking to relocate to the United States. The Mariel Boatlift was a rescue operation organized by Cuban-Americans willing to sail to the port of Mariel on Cuba's north coast to pick up and deliver as many exiles as possible. Beginning on 21 April, boats in Key West and Miami crowded the Straits of Florida. In May alone more than eighty-six thousand refugees came north. The U.S. Coast Guard was severely taxed to manage the sea traffic.

Unfortunately, at about 0800 hours on 17 May, the *Olo Yumi* was swamped by six- to eight-foot seas. As an engine quit, fifty-two passengers and crew rushed to the stern to help, overloading the stern. Waves swamped the boat and most of those aboard slipped into a gasoline-soaked ocean. Only a few had life jackets; some clung onto the *Olo Yumi*, others to wood and debris. They were in serious trouble.

At about 1100, a patrolling coast guard HH-52A helicopter spotted the sinking boat and moved to the rescue, bringing eleven survivors to safety before the hoist burned out. Three other helicopters arrived to continue the rescue, while the initial chopper with three crew and eleven exiles returned to USCG Cutter *Courageous*. The *Courageous* and the cutter *Vigorous* were proceeding to the scene. Both continued the rescue by launching life boats, and when further action was impossible, survivors were ferried to USS *Saipan* for medical treatment. Fourteen people died, but thirty-eight of the original fifty-two people on board *Olo Yumi* were saved. In all, the Mariel Boatlift resulted in bringing almost 125,000 Cubans safely to the United States.

GETTING STARTED IN AVIATION ART

How do you establish a reputation as an aviation artist? Most practicing artists would suggest:

- Start small.
- Have faith in your ability.
- Be willing to put in the hard work that it takes to succeed.
- Do your homework. Prepare a portfolio that demonstrates your best work.
- Give yourself time to grow in skill.
- Begin with small goals. Produce.
- Work on quality.
- Acquaint yourself with other artists and join a group like the American Society of Aviation Artists (ASAA), a group to which you can contribute and with which you can communicate, learn, and grow.

Many accomplished artists have tales of perseverance, of determination, and a bit of luck. Your curiosity sparked your motivation to learn to draw aircraft. That is the spark that attracted the masters of the genre and keeps them interested and creative. Learn from them and continue to work at your drawing and your painting. Enjoy what you see and what you translate into a work of art.

⚓ Marine art and aviation art combine in Andrew Whyte's *Rescuing* Olo Yumi, a depiction of the rescue of people thrown into the sea when the *Olo Yumi* was swamped during the 1980 boatlift of Cuban refugees from the port of Mariel. There was loss of life, but in a tribute to their valor, heroes of the U.S. Coast Guard saved thirty-eight individuals from drowning when the boat capsized. Similarities exist between portraying the atmosphere and depicting water—both constantly moving and changing challenges to an artist. As you can see, historical paintings that depict the romance and the hazards of the sea and the air can be complementary and even combined.

Aerial Combat, World War II

To bring together all of the previous chapters and prepare to create a painting, Andrew Whyte chose a World War II incident. Based on interviews with Bill Harford, one of the pilots involved with the incident, Whyte learned that during the U.S. invasion of the island of Okinawa, the Japanese launched intensive Kamikaze attacks on the navy ships supporting the landings. VMF-222, a U.S. Marine Corps unit equipped with F4U Corsairs, was one of the U.S. fighter squadrons charged with foiling these attacks. In April 1945, during the invasion of Okinawa and subsequent battles to reclaim the island by the U.S. Army and Marine Corps, Lieutenant Harford served as a pilot in this unit under Capt. Ken Walsh. On 14 June 1945, Lieutenant Harford was preparing to fire on a Mitsubishi B5M, nicknamed "Kate," a torpedo bomber diving to make an attack on the fleet when Captain Walsh, then the Marine Corps' leading ace, waved him away and downed the "Kate."

With the scene in mind, Whyte prepared a description and the drawings to show a step-by-step process that can be used to depict this particular historic event. He brought together research material, thumbnail sketches, compositional layouts, a value sketch, a color rough, and final paintings in acrylic and in oil.

Thumbnail sketches: Six rapidly sketched drawings were done to evaluate shapes, values, and composition.

Research: Bill Harford gave a valuable description of the mission, the weather conditions, and the time of day. Andrew Whyte researched descriptive data, including scale drawings and photographs of the U.S. and Japanese aircraft, and other background information.

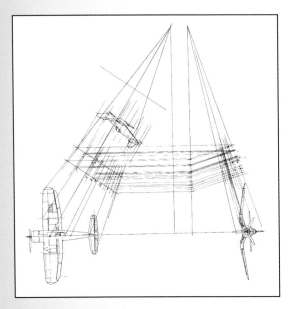

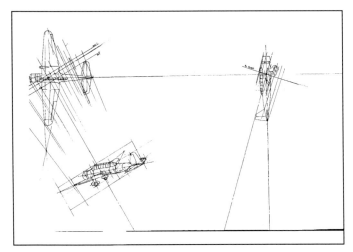

Composition: Having selected the sketch to be used, Whyte prepared layouts to insure proper perspective and a representational scene including the three aircraft involved—two F4U Corsairs and the Japanese torpedo bomber "Kate."

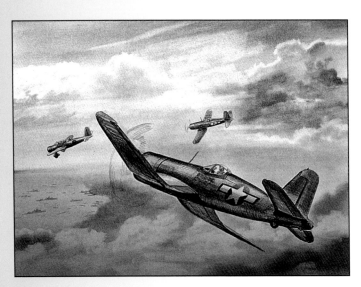

Pencil sketch: Whyte prepared a large pencil sketch to establish values in the foreground, middle ground, and background. This sketch also helped with the establishment of the horizon and the light source.

Color study: To move from black and white, Whyte prepared a color "rough," a study that helped him validate the lighting and the values.

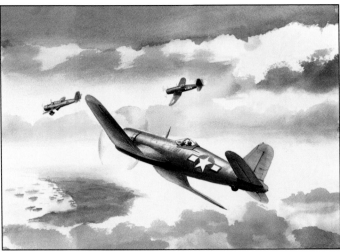

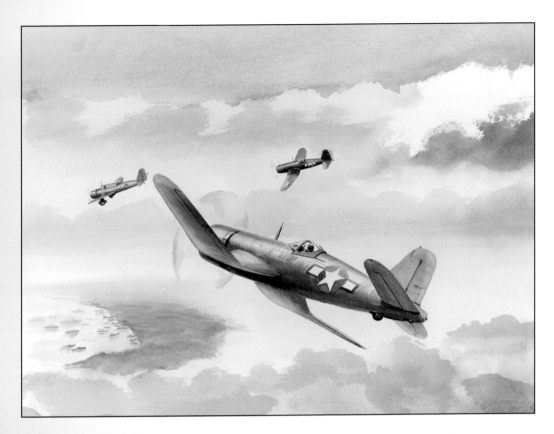

Final paintings: **For this book, Whyte prepared two finished paintings of the scene over Okinawa—one in acrylic and one in oil. The results of his careful research and thorough preparation are apparent in each one.**

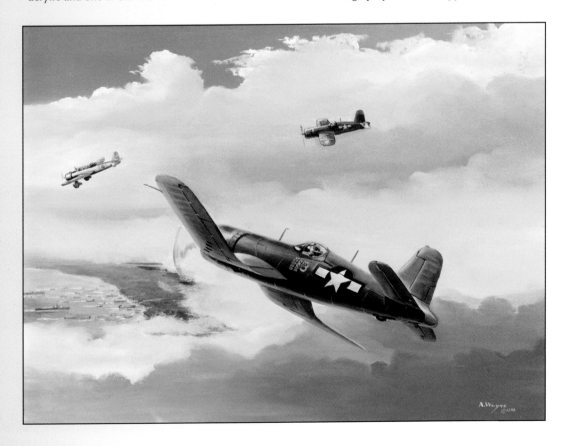

I n aviation art, cartoons can be used to advertise, to educate, to caution about safety, to amuse, and/or to poke fun at aviators and aviation.

—*Andrew Whyte*

CARTOONS

In the mid-1700s, a *cartoon* was an artist's initial drawing to develop a painting, mosaic, fresco, or tapestry. The cartoon was preliminary to the creation of a work of art. Within a hundred years, and with the coming of political satire and caricatures that emphasized outstanding features of well-known figures, the cartoon came to refer to pictorial humor. A cartoon became a visual statement found in editorial sections of newspapers and magazines. Over time, a cartoon became a mockery and a form of public ridicule—a captioned or uncaptioned humorous drawing. Today a cartoon, and collections of printed cartoons in a series, has developed into an art form for animated films and comic strips.

Few cartoonists achieve the renown of the beloved late Charles Schulz. In a review that explores Schulz' *Peanuts* cartoons as a force in pop culture, writer Bill Watterson stated, "The overwhelming commercial success of the strip often overshadows its artistic triumph; but, throughout its fifty-year run, Charles Schulz wrote and drew every panel himself, making his comic strip an extremely personal record of his thoughts. It was a model of artistic depth and integrity. . . . Schulz blazed the wide trail that most every cartoonist since has tried to follow." Study Schulz' thought processes and artistic approaches as he had Snoopy face combat in countless battles with the Red Baron. His clever drawings of Snoopy, with his doghouse-shaped aircraft smoking badly and riddled with antiaircraft fire, have graduated from the comics to theater productions and electronic sites, such as PlayStation, YouTube, and modern PC Games and are an unending source of inspiration.

In contemporary terms, a cartoon is a single drawing or a series of drawings that focuses upon a point or tells a joke or story about such subjects as human activities, fads, fashions, sports, and political or historical events. In aviation art, cartoons can be used to advertise, to educate, to caution about safety, to amuse, to intrigue, and/or to poke fun. Cartoons often exaggerate, but differ from caricatures that distort figures and emphasize certain features or peculiarities. Cartoons can be captioned or can contain dialog. Cartoons can be anthropomorphic, ascribing human characteristics to animals or machines, with the intention of emphasis, attracting attention, informing or motivating; but, above all, amusing.

During World War II, the staff artists of Walt Disney Productions were responsible for the creation of over one thousand imaginative and appealing designs. Prepared for military units, civilian defense, and industrial workers, the uplifting insignia and cartoon characters were

Appendix
THE LIGHTER SIDE OF AIRCRAFT ART

⊀ In Dot Swain Lewis' cartoon of a World War II member of the Women Airforce Service Pilots, her WASP on the flight line at Avenger Field in Sweetwater, Texas, humorously displays the ubiquitous oxygen mask and chest-pack parachute. *Dot Swain Lewis*

among Walt Disney's generous contributions to the war effort. Disney knew what it meant to serve. In World War I, when only sixteen, he drove ambulances for the Red Cross in France. In 1933, a Naval Reserve Squadron requested a military insignia design; the first of the many that followed. An exhibition of the creations of Walt Disney Productions is featured at the National Museum of the USAF in Dayton, Ohio. Some incorporated the ageless and beloved Mickey Mouse and Donald Duck and celebrated flight training, bomb squadrons, night fighter squadrons, mechanics, paratroopers, and many more. Others, like Fifinella, the winged sprite created uniquely for members of the Women Airforce Service Pilots, were original works of cartoon art.

Cartoons were introduced to the public through the printed page. By the nineteenth and twentieth centuries, cartoons were established as legitimate forms of commentary. During the early 1800s, they became more widespread as lithography eased the costs and availability of reproduced drawings. In the twentieth century, cartoonists like Thomas Nast, Milton Caniff, and Bill Mauldin became famous. Drawing attention to U.S. fighting forces of World War II, Caniff drew *Mail Call* for Camp Newspaper Service, popularized *Terry and the Pirates*, and started his series that featured *Steve Canyon*. Milton Caniff, of Dayton, Ohio, had a Bachelor of Fine Arts degree from Ohio State University and served as an in-house staff artist with the Associated Press. Greatly admired and often copied, Milton Caniff is celebrated in Dayton's National Museum of the USAF, one beneficiary of his work.

Bill Mauldin, a U.S. Army sergeant, was a combat cartoonist who drew two main characters, Willie and Joe, a pair of combat infantrymen. In 1945, Mauldin's World War II cartoons won the Pulitzer Prize. He was quoted as saying, "I drew pictures for and about the soldiers because I knew what their life was like and understood their gripes. I wanted to make something out of the humorous situations that come up even when you don't think life could be any more miserable." Fifty-five years later, as the year 2000 and a new century began, the G.I., popularized by Mauldin's Willie and Joe, was listed among *Time* magazine's list of the most influential people of the century.

Within two years of Mauldin's Pulitzer award for his combat art, the female G.I. was illustrated by Dorothy Swain Lewis. She drew cartoon illustrations for *We Were WASPS*, the first book about World War II's women pilots, published in 1945. Like Mauldin, she knew her subjects, having taught members of the WASP (Women Airforce Service Pilots) to fly and having graduated from the program herself with the Class of 1944–1945. Dot's cartoons poked fun at the situations of pilot training for the first women to fly for the U.S. Armed Forces, situations that were stressful at the time, typical of most pilot candidates—male or female—and best faced with a hearty dose of humor. Her cartoons are also featured in her biography, *How High She Flies*, and have adorned note cards, T-shirts, and WASP memorabilia.

↟ Military insignia patches.
Charlie and Ann Cooper

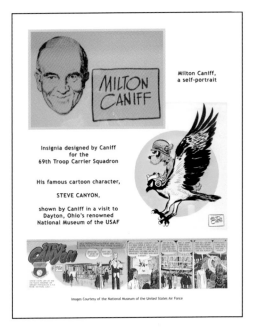

↟ Milton Caniff, who called Dayton, Ohio, home, felt a particular loyalty to the National Museum of the USAF. His choice of artistic expression, after training in the fine arts, was comic strips and cartoons. Culture critic John Cawelti stated, "A work possessing more invention than formula will be a greater work," and Caniff demonstrated that concept. *Images Courtesy of the National Museum of the USAF*

CARICATURE

Caricature generally is based on an easily identifiable person with distortion or enlargement to a particular characteristic. Some of the best-known caricaturists drew pictures that emphasized particular physical or facial features, dress, or manners to create a ridiculous effect. They were directed at individuals, at political, religious, and social situations or institutions, and/or at actions by various groups of society.

Caricature of a particular aviator or aircraft might focus on a distinguishing trait or characteristic. The flamboyant air racer of the 1930s, Roscoe Turner, and his pet lion, Gilmore, could easily have inspired a caricature.

Creating a humorous depiction of a person or of an aircraft requires a close observation of the subject, and, with an aircraft, an intimate knowledge of its form and its respective parts, before one can distort its outstanding or unique features. If one chose the Fairchild Republic A-10, one might exaggerate its deadly General Electric Avenger 30mm seven-barrel cannon. The very names of the Super Guppy, its enlarged fuselage ballooning over the cockpit, the Cobra helicopter, or the Dreamliner bring caricatures to mind.

STUDY SUCCESSFUL CARTOONISTS AND CARICATURISTS

If you are interested in cartoons or caricatures, study successful works. Consider drawing logos and emblems. In recent years, they have been created as cartoons, as has the signage of many reputable museum displays. They are eye-catching, colorful, attractive, and popular. Designed to provide identity and to encourage traditions, they have been used by corporations, athletic teams, and military organizations. For example, artist fellow of the American Society of Aviation Artists Paul Rendel was commissioned to create a logo for the Air Force Materiel Command at Wright-Patterson Air Force Base and ASAA artist Mark Pestana created several patches for NASA's Space Shuttle missions.

Study the artwork of the highly successful Hank Caruso. Look, learn, and laugh, and recognize the copious research, knowledge, and dedication to precision that underlies each Caruso Aerocature and remember, there are no shortcuts! Learn to draw. Research your subject and free your imagination to create cartoons and caricatures. Then draw.

↟ *Bugs in Engine:* The National Museum of the USAF in Dayton, Ohio, prides itself as the "keeper of their stories." This museum motto is demonstrated by a vast reservoir of artifacts of military history, especially those provided by the people who lived that history. Among the artifacts and displays are cartoons, which were a popular diversion for men and women in harm's way and represent the use of humor during the realities and horrors of warfare. *Courtesy of the National Museum of the USAF*

How to Draw Aerocatures

Hank Caruso

Outstanding caricaturist Hank Caruso has established a unique niche in aviation art. His trademarked Aerocatures exaggerate and highlight both the physical features and the "attitude" of a particular aircraft. Caruso said, "I view my art as portraits of how aircraft, physical forces, and human attitudes come together and interact. My drawings are based on reality: real people, real objects, and real stories. I rely on extensive research and firsthand observations to achieve a careful balance between realism and exaggeration."

Caruso addresses eight specific issues: story, anatomy, geometry, physics, pose, lighting, surface and contour, and props. He advised, "Have a clear vision of the story that you want to tell. If the story is simply an airplane portrait, choose the aspect of its character that you want to emphasize—perhaps its speed, size, use, or lethality."

In creating either a caricature or a serious rendering, he suggested, "Have a thorough understanding of the aircraft's anatomy and operating features. Be sure to research unique design and construction aspects, being aware, for example, that the left side of the fuselage might differ from the right. Accuracy is important."

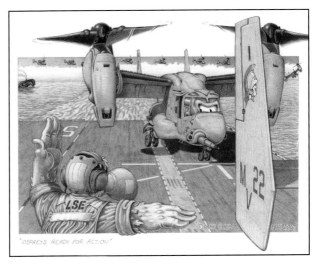

"OSPREYS READY FOR ACTION"

Completed artwork *Hank Caruso*

During development testing, landings of nine MV-22 Osprey tiltrotor aircraft on the USS *Bataan* made history. Hank Caruso created his Aerocature to commemorate that remarkable feat. The initial sketch (rendered in felt-tip pen) shows the major elements to be included: one primary aircraft, one tail close-up, and a Landing Signal Enlisted (LSE) deck crewmember—a "yellow shirt"—providing guidance. The seven remaining aircraft are shown in the distance so that they don't conflict with the foreground elements. The distant aircraft show the aircraft's transition from forward flight to hover. *Hank Caruso*

The center pencil sketch shows more of the near vertical tail to allow for squadron identification. The layout has been revised to create an image that is less square. In the final ink drawing, the vertical tail has been reduced in size again, this time to show more of the aircraft landing behind it. The LSE has been given a more dynamic pose and reduced in size to make the relative proportions of the different picture elements more believable. The focus aircraft is now looking at the LSE, not the deck. Various structural features of the aircraft have been tweaked based on reference material and visits to view an actual aircraft. *Hank Caruso*

The finished color image builds on the black-and-white ink rendering, using the shading as a form of underpainting to give more depth to the shadow areas. The use of Prismacolor pencils on a hard surface allows for the application of smooth, dense color layers that don't have a traditional "pencil look." Light-colored pencils were used to blend layers of different colors and to create gradual and even transitions from dark to light tones. Note, however, how the black-and-white shading in the ink version can suggest the different colors, reflections, and contours depicted in the color version. *Hank Caruso*

Caruso said, "Decide how you will position the aircraft and other elements in your drawing, choosing where the viewer will be positioned with respect to them. Proper perspective is critical to the correct geometry."

The physics of the situation is important, although it may not be obvious. "Any depiction of an aircraft should be appropriate for its maneuver," said Caruso. "If you fail to consider the proper bank angle, the forces of gravity and lift, or make other subtle violations of the laws of physics, the picture might not look right to the viewer even if he or she can't describe why."

Pose the craft appropriately and be sure that the lighting enhances the story that you're telling. Caruso added, "Where is the light coming from? Will significant areas of the craft be in shadow so that shape rather than detail is important? Is the lighting directional or diffuse? Is it consistent for all of the elements of the drawing?"

When focusing on surface and contour, Caruso explained, "Capturing the differences in surface types and subtle variations in contour can make a drawing much more accurate and interesting. Ask yourself, 'Which surfaces are reflective and which are not? If the drawing is black and white, how can shading suggest different surface types and paint colors? Do rounded surfaces show up as round or flat? Are complex, but characteristic, surface contours accurately depicted?'"

In his award-winning style, Caruso imaginatively selects props that enhance his drawings and add emphasis to the caricature that he is depicting. His choices of props complete the picture and give it interest. He said, "Props may provide important information needed to understand the story. Too few and the story may not be apparent. Too many and the picture might be cluttered and confusing. Make sure that the props selected are appropriate for the operational conditions and time period. Be subtle. Prominent props compete for attention with the picture and the story elements."

Caruso uses pen and ink. He said, "I particularly like the degree of control over each line that pen and ink gives me. I'm fascinated that simple lines can create the impression of contour and suggest a variety of surface types (wood, water, clouds, metal). As an aerospace engineer, I started with and continue to use Rapidograph drafting pens. I use the finest point when I begin inking, in case I make a mistake or change my mind. The thin ink line is relatively easy to remove with a sharp razor blade.

"As much as I like black-and-white line images, the picture comes alive with color and I use Prismacolor colored pencils directly on the black-and-white rendering. I like the close control of the colors and the way colors can be overlaid and blended to create smooth tonal changes that are unlike most people's expectations of a pencil rendering."

Using a hard, smooth surface, Caruso works on a pad of smooth Strathmore or Bienfang one-hundred-pound Bristol. He admitted, "The main drawback to working in ink and colored pencil is that it is time-consuming to fill a large space. My originals typically range from eleven inches by fourteen inches to nineteen inches by twenty-four inches."

He starts with felt-tip pen sketches. "I don't work from photographs or models when I begin to sketch. I believe that if I can't create an effective preliminary drawing out of my head, I probably don't understand my subject well enough." For correct detail, he uses numerous reference materials later. Caruso believes that an initial drawing from reference materials results in bad copies of photographs and that they lack life and originality.

Whether black-and-white or in color, Caruso's unique Aerocatures fill a special niche in aviation art. His methods are worthy of careful study.

Preliminary sketch *Hank Caruso*

"TWO THUMBS UP!"

Final Aerocature *Hank Caruso*

Two Thumbs Up! by Hank Caruso

The Society of Experimental Test Pilots commissioned Hank Caruso to create *Two Thumbs Up!* for presentation to aviation pioneer Burt Rutan in recognition of his SpaceShipOne becoming the first privately developed manned spacecraft to fly into space. SpaceShipOne pilot, Brian Binnie, later an FAA astronaut, recommended that the historic flight be shown in its unique "feather mode," with its tailbooms raised for reentry. The shape of the spacecraft's actual tail surfaces closely resembles the thumbs-up gesture, mirroring the jubilant pose of the spacecraft's pilots upon their return from space. The aircraft is "wearing" the same visor and oxygen mask used by the SpaceShipOne pilots, and FAA astronaut's wings are pinned to its "chest." The spacecraft's flight trajectory is suggested by the vapor trail shown behind the spacecraft.

CONTRIBUTING ARTISTS/ ACKNOWLEDGMENTS

THANK YOU!

"How to" books require outside support, even when they are being produced by an expert artist and two experienced writers. In preparing *How to Draw and Paint Aircraft Like a Pro* for publication, we have had some wonderful cooperation from a number of talented people and we want to thank each of them.

Andrew Whyte's nephew, Douglas Whyte, an experienced professional photographer, photographed all of Andrew's paintings and digitized them for use in the publication. His valuable assistance should insure that the color in the paintings is accurately reflected in the book.

A number of talented aviation artists have graciously agreed to the use of their work in sidebars, we are grateful to them all:

- Gerald Asher, Fort Worth, Texas*
- Hank Caruso, California, Maryland*
- Gil Cohen, Doylestown, Pennsylvania*
- Keith Ferris, Morris Plains, New Jersey*
- Konrad Hack, Niles, Illinois*
- Kristin Hill, Lancaster, Pennsylvania*
- William S. Phillips, Ashland, Oregon*
- Sharon Rajnus, Malin, Oregon
- Robert Watts, El Cajon, California

Staff members at the National Museum of the United States Air Force at Wright-Patterson Air Force Base in Dayton, Ohio, have been most helpful. In particular, we are appreciative of the time and talent and his patient and knowledgeable help provided by exhibits designer John Luchin III. His contributions to the material on digital illustration in chapters 12 and 13 have been invaluable. Museum staff photographer Jeff Fisher has made valuable contributions to the material on cartoons, and we are grateful to him.

McCallister Art Supplies in Dayton, Ohio, gave us free rein and locater help as we worked on the "Tools of the Trade" sections. They could not have been more cooperative.

Sergei Sikorsky grew up in Connecticut witnessing the construction of his famous father's flying boats, meeting aviation greats who visited their family home, and seeing his father pilot the first Sikorsky helicopter, the VS-300. During World War II, he served as a helicopter mechanic in a joint coast guard, navy, and Royal Air Force helicopter development squadron, and participated in development and testing of rescue hoists. He retired from Sikorsky as vice president of special projects in 1992 and continues to work as an aviation consultant. He lectures often on the story of the development of aviation and the helicopter as seen through the eyes, thoughts, and words of his father, Igor. Sergei and his wife, Elena, live in Arizona. We thank him for the Introduction.

We would like to thank the folks at Zenith Press—Steve Gansen, acquisitions editor; Mary LaBarre, publishing assistant; and Steve Daubenspeck in specialty sales. They have been helpful and supportive, and we appreciate all they have done.

From the heart, we thank Pat Whyte, a great photographer and a wonderful woman. Her patience never wore thin. She has our admiration and love.

— *Andrew C. Whyte, Ann Cooper, and Charlie Cooper*

* Artist Fellow member of the American Society of Aviation Artists (ASAA).

ABOUT THE AUTHORS

Andrew Whyte was born in Bridgeport, Connecticut. He grew up with a love for aviation inspired by his father, who served in the Royal Flying Corps and later in the Royal Air Force. Andy spent World War II in naval aviation as a flight engineer/gunner in SBDs (dive bombers), Consolidated PBYs (amphibious aircraft), Martin PBMs (patrol bombers), and Lockheed PV-2s (patrol bombers). After majoring in mechanical engineering at the University of Oklahoma, he joined Sikorsky Aircraft in the advanced design group. He melded engineering and art to produce configuration studies and hundreds of paintings for engineering and marketing efforts. After retiring from Sikorsky Aircraft, he continued his career as an artist, both for Sikorsky and a growing number of clients. He has won numerous honors for his art, including the prestigious R. G. Smith Award for Excellence in Naval Aviation Art awarded by the Naval Aviation Museum, and awards by *Aviation Week & Space Technology* magazine. He continues to do extensive commissioned work, including paintings for the U.S. Coast Guard and a growing list of clients.

Ann Cooper is an accomplished author and writer, with twelve books and more than seven hundred articles published in such magazines as *Private Pilot*, *Sport Pilot*, *Kitplanes*, and *Aviation History*. Her latest book, *Stars of the Sky, Legends All*, was co-published by Zenith Press and Women in Aviation, International. She was the longtime editor of *Aero Brush*, the quarterly magazine of the American Society of Aviation Artists. She has been a rated pilot for more than thirty-five years and is currently an instrument-rated Certified Flight Instructor with more than two thousand flight hours logged.

Charles "Charlie" Cooper entered the U.S. Air Force in 1955, retiring in 1991 as a two-star general with well over four thousand hours logged as an air force master navigator. He joined the New York Air National Guard in 1962, rose rapidly through operations and command positions, and served for seven years as its commander. He is a member of numerous aviation-related and veterans' organizations and a member of the Board of Managers of the National Museum of the U.S. Air Force. Ann and Charlie Cooper have authored four books together; their latest is *Into the Sunlit Splendor*, featuring some 170 paintings by William S. Phillips.

GLOSSARY

Acrylic: Water-soluble paint made from pigments and a plastic binder.

Aerial or atmospheric perspective: Creating a sense of depth in drawing or painting by imitating the way the atmosphere makes distant objects appear less distinct and more bluish or grayish than they would be if nearby.

Aquatint: An etching technique in which a solution of asphalt or resin is used on the plate. Aquatint produces prints with rich, gray tones.

Caricature: An artwork that humorously exaggerates the qualities, defects, or peculiarities of a person, an idea, an object, or a machine. Aerocatures are the trademark of Hank Caruso.

Cartoon: A humorous sketch or drawing usually telling a story or caricaturing a person or action. In fine arts, a cartoon is a preparatory sketch or design for a picture or ornamental motif to be transferred to a fresco or tapestry.

Carving: In sculpture, the cutting of a form from a solid, hard material such as stone or wood, in contrast to the technique of modeling.

Casting: In sculpture, a technique of reproducing a work by pouring a substance, such as plaster or molten metal, into a mold where it hardens.

Chiaroscuro: The rendering of light and shade in painting; the subtle gradations and marked variations of light and shade for dramatic effect.

Collage: A composition made of cut-and-pasted pieces of materials, sometimes with images added by the artist.

Colors—primary, secondary, complementary: Primary colors are red, yellow, and blue, the mixture of which will yield all other colors in the spectrum but which cannot be produced through a mixture of other colors. Complementary colors are those at opposite points on the color scale; for example, green and red, orange and blue, and purple and yellow are complementary. Secondary colors are produced by a mixture of two primary colors—for example, orange (a mixture of red and yellow), green (a mixture of yellow and blue), and purple (a mixture of red and blue).

Composition: The organization of forms and colors within an artwork.

Drawing: The technique of making lines, figures, and pictures as with a pencil, pen, or brush on a surface.

Drypoint: A technique of engraving, using a sharp-pointed needle, which produces a furrowed edge resulting in a print with soft, velvety lines.

Engraving: The art of producing printed designs through various methods of incising on wood or metal blocks, which are then inked and printed.

Etching: The technique of producing printed designs through incising on a coated metal plate, which is then bathed in corrosive acid, inked, and printed.

Figure: A representation of a human or an animal form.

Foreshortening: Reducing or distorting in order to represent three-dimensional space as perceived by the eye, according to the rules of perspective.

Fresco: Meaning "fresh" in Italian. The technique of painting on moist lime plaster with colors or pigments dissolved or suspended in water.

Frieze: A band of painted or sculpted decoration, often at the top of a wall.

Genre painting: A realistic style of painting in which everyday life forms the subject matter, as distinguished from religious or historical painting.

Gesso: Ground chalk or plaster mixed with glue and used as a base coat for tempera and oil painting.

Gouache: A method of watercolor painting that is prepared with a thicker base (more glue-like) and produces a less transparent effect.

Highlight: On a represented form, a point of most intense light.

Horizon line: In perspective, this represents the line in nature where the sky appears to meet the earth.

Impasto: Paint applied very thickly. It often projects from the picture surface.

Landscape: A drawing or painting in which natural scenery is the subject.

Linear perspective: A mathematical system for creating the illusion of space and distance on a flat surface.

Lithography: A printing process in which ink impressions are taken from a flat stone or metal plate prepared with a greasy substance, such as an oily crayon.

Modeling: In sculpture, the building up of form using a soft medium such as clay or wax, as distinguished from carving. In drawing and painting, using color and lighting variations to produce a three-dimensional effect.

Monochrome: A drawing or painting executed in a single color.

Monotype: A single print made from a metal or glass plate on which an image has been represented in paint, ink, etc.

Mural: A large painting or decoration done on a wall.

Oil: A method of painting with pigments mixed with oil, producing a vast range of light and color effects.

Orthogonal lines: Straight diagonal lines drawn to connect points around the edges of a picture to the vanishing point. They represent parallel lines receding into the distance and help draw the viewer's eye into the depth of the picture.

Palette: A flat board used by a painter to mix and hold colors, traditionally oblong, with a hole for the thumb; also, a range of colors (limited or extensive) used by an individual painter.

Pastel: A soft, subdued color; also, a drawing stick made of ground pigments, chalk, and gum water.

Perspective: A method of depicting three-dimensional volumes and spatial relationships on a flat surface to produce an effect similar to what is seen by the eye.

Polychrome: A painting using a variety of colors.

Polyptych, diptych, triptych: In painting, a work made of several panels or scenes joined together. A diptych has two panels; a triptych has three panels.

Realism: The style of art in which the artist strives to make the painted scene look as real and natural as possible.

Relief: In sculpture, the projection of an image or form from its background. Sculpture formed in this manner is described as high relief or low relief (bas relief), depending on the degree of projection. In drawing or painting, the apparent projection of parts to convey the illusion of three dimensions.

Stenciling: A method of producing images or letters from sheets of cardboard, metal, or other material from which forms have been cut away so that ink or paint applied to the sheet will reproduce the pattern on the surface beneath.

Still life: The representation of inanimate objects in drawing, painting, or photography.

Tempera: A painting technique using pigments mixed with egg yolk and water. Tempera produces clear, pure colors.

Texture: The visual and tactile quality of a work of art based on the particular way the materials are handled; also, the distribution of tones or shades of a single color.

Three-dimensional: Having height, width, and depth. A box is three-dimensional.

Two-dimensional: Having height and width only. A painting of a box is two-dimensional.

Tone: The effect of the harmony of color and values in a work.

Tortillion: A soft gray paper spiral wound tightly to a point at one end. Tortillions, or stumps, are used to blend pencil, charcoal, pastels, and other artist media for shading and tone.

Value: The degree of lightness or darkness in a color; the scale from darkest dark to lightest light.

Vanishing point: The single point in a picture where all parallel lines that run from an object to the horizon line appear to come together.

Wash: A thin layer of translucent color.

Watercolor: Painting in pigments suspended in water. It can produce brilliant colors and transparent effects. See also gouache.

Woodcut: A print made by carving on a wood block, which is then inked and printed.

BIBLIOGRAPHY

BOOKS

Blake, John, G.Av.A., and John Hellings, G.Av.A., *Members Instructional Manual*. London: The Guild of Aviation Artists, 1998.

Caruso, Hank. *Seabirds, An Unofficial Illustrated Encyclopedia of Naval Aviation*. Virginia: Howell Press, 1995.

Daugherty, Charles, ed. *How to Draw (Famous Artists School: Step by Step Method)*. New York: Henry Holt & Co., 2000.

Ennis, John. *Going Digital: An Artist's Guide to Computer Illustration*. New York: Madison Square Press, 1997. Fargis, Paul, editorial director. *The New York Public Library Desk Reference*. 3rd ed. New York: Simon and Schuster Macmillan Company, and The Stonesong Press, Inc., 1989, 1993, 1998.

Hebblewhite, Ian. *The North Light Handbook of Artists' Materials*. Cincinnati, OH: Writer's Digest Books, 1986.

Poore, Henry Rankin. *Composition in Art*. New York: Dover Publications, Inc., 1976.

Ruskin, John. *The Elements of Drawing*. With notes by Bernard Dunstan. New York: Watson-Guptill Publications, a division of BPI Communications, 1997. Originally published by The Herbert Press Ltd., 1991.

Whyte, Andrew C., Ann L. Cooper, and Charles S. Cooper. *How to Draw Aircraft Like a Pro*. St. Paul, MN: Zenith Press, an imprint of MBI Publishing Company, 2001.

WEBSITES*

www.aviart.info

www.homeofheroes.com/novosel

www.miltpriggee.com

www.pleinairamerica.com

www.wcgcomics.com/articles/caniff.html

*Other websites consulted generally have been listed as part of the text.

ARTICLES

Cohen, Gil. "Art of Flight." *Aviation History*, July 1993.

———. Quoted from his talk at the eighth annual forum ASAA, American Airlines C. R. Smith Museum, Dallas/Fort Worth, TX. *Aero Brush, The Newsletter of the American Society of Aviation Artists*, Vol. 7, No. 3, Summer 1994.

Cooper, Ann. "Getting Started in Aviation Art." *Aviation Illustrated*, Vol. 1. No. 1, January 1996.

DeMarco, S. Joseph "Joe." "Spatial Composition with APM (Artists' Perspective Modeler)." *Aero Brush*, Vol. 20, No. 4, Fall 2007.

Dietz, James. "Jim Dietz, EAA Master Artist." *Sport Aviation*, September 1998.

Ferris, Keith. "The Precise Painter." *Private Pilot*, Vol. 25, No. 9, September 1990.

Grover, David H. "Pioneering Air-Sea Engagement." *Aviation History*, September 1998.

Hill, Kristin. "The Missed First Flight." *Private Pilot*, Vol. 25, No. 12, December 1990.

Hurley, Wilson. "Asymmetrical Thrust." *Aero Brush*, Vol. 7, No. 1, Winter 1993–1994.

McCall, Robert. "Solar Power From Space." *Aviation Art Showcase*, Vol. 1, No. 1, Fall 1995.

McCarthy, Doris. "Wisdom from Experience," quoted in *Aerial Views, Newsletter of the Canadian Aviation Artists Association*, May 2002.

O'Neal, Michael. "Henri Farré, The Fequant Paintings." *Aero Brush*, Vol. 19, No. 4, Fall 2006.

Parkhurst, Daniel Burleigh. "Values, The Painter in Oil." *Aero Brush*, Vol. 19, No. 3, Summer 2006.

Phillips, William S. "Eye of the Wingman." *Private Pilot*, Vol. 24, No. 8, 71-73, August 1989.

———. "Landscapes, Skyscapes, and Aerial Machines." *Aviation Illustrated*, Vol. 1, No. 1, January 1996.

Thompson, Charles, GavA, ASAA, MGMA. "The Circle in Perspective." *Aero Brush*, Vol. 13, No. 4, Fall 2000.

Watts, Robert. "Color Principles for Successful Paintings." *Aero Brush*, Vol. 10, No. 1, Winter 1996–1997.

———. "Putting the Picture Together." *Aero Brush*, September 1995.

———. Quoted from his talk at the eighth annual forum ASAA, American Airlines C. R. Smith Museum, Dallas/Fort Worth, TX, 1994.

Wenman, Pete. "The Internet and the Aviation Artist." *Aero Brush*, Vol. 20, No. 4, Fall 2007.

Whyte, Andrew C. "Art of Flight." *Aviation History*, March 1994.

INDEX

Other **Zenith Press** titles of interest:

**HOW TO DRAW
CRAZY CARS & MAD
MONSTERS LIKE A PRO**

ISBN 978-0-7603-2471-4

**HOW TO DRAW
CHOPPERS LIKE A PRO**

ISBN 978-0-7603-2260-4

**HOW TO DRAW CARS
LIKE A PRO**

ISBN 978-0-7603-2391-5

**SPACESHIPONE
AN ILLUSTRATED
HISTORY**

ISBN 978-0-7603-3188-0

**AIR FORCE
AN ILLUSTRATED
HISTORY**

ISBN 978-0-7603-3308-2

ZENITH
PRESS

Find us on the internet at
www.ZenithPress.com

**FLYING THE SR-71
BLACKBIRD**

ISBN 978-0-7603-3239-9

TUSKEGEE'S HEROES

ISBN 978-0-7603-1084-7

**WAR IN
PACIFIC SKIES**

ISBN 978-0-7603-1189-9

**STARS OF THE SKY,
LEGENDS ALL**

ISBN 978-0-7603-3374-7